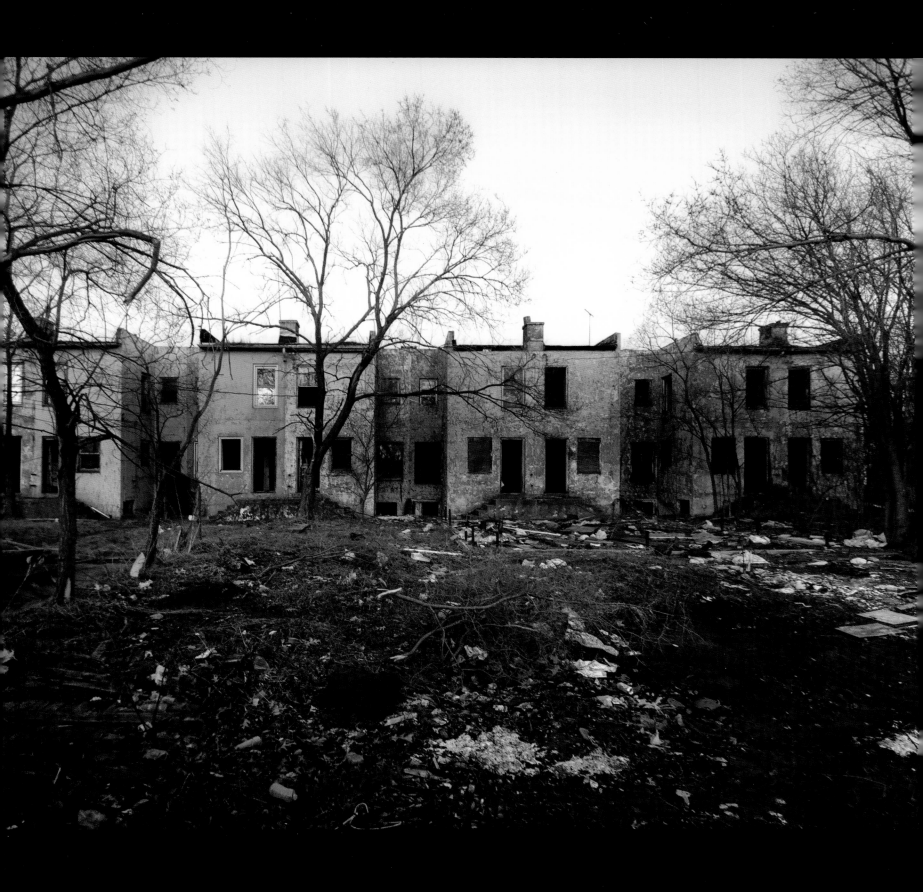

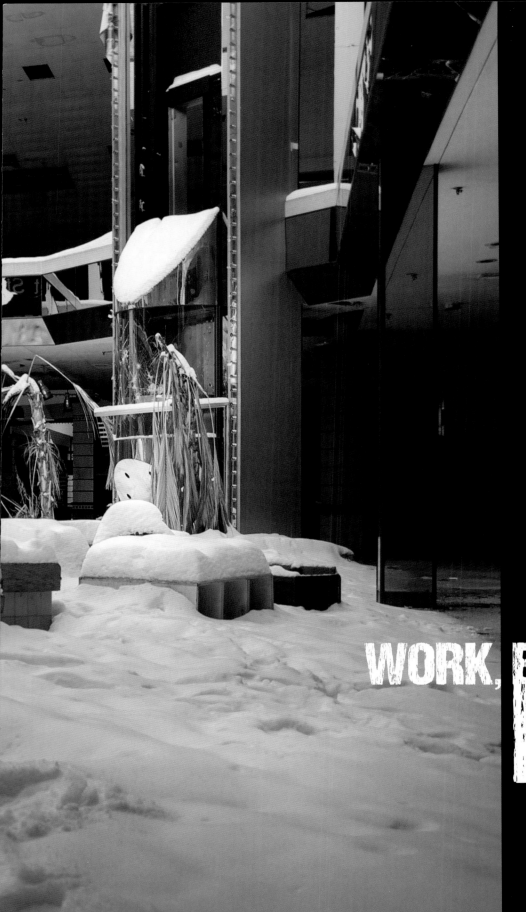

WORK, BUY, CONSUME
DIE

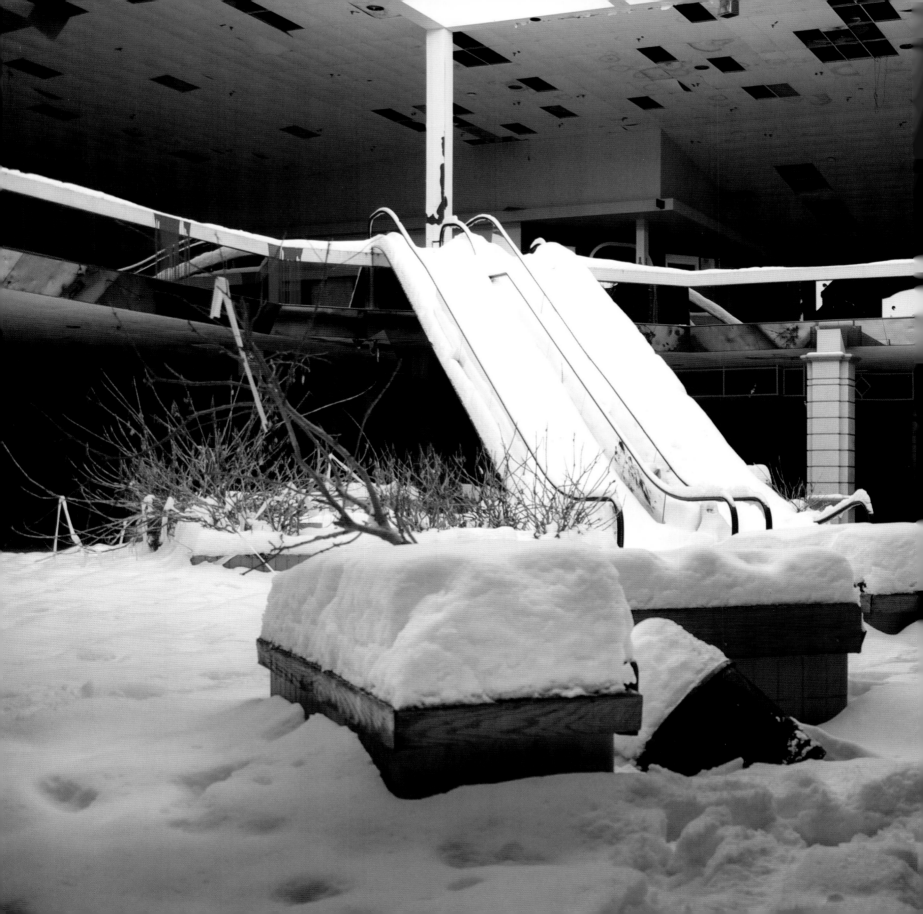

DEATH OF A NATION

Over my lifetime I've watched globalization destroy entire American cities, reducing them to absolute ruins. Similar to globalization, a tidal wave of automation will soon hit the world economy, driving down the cost of goods and services at the expense of millions of jobs, which will have widespread ramifications of catastrophic proportions throughout the entire World. This wave of automation has the propensity to devastate the American economy.

Perhaps no other nation will suffer the burden of automation more than the U.S., based largely on the fact that America hasn't addressed the issue or devised a proper course of action for dealing with it, as it continues to be ignored by politicians, the media, and the general public.

Many financial experts believe the threat of automation is inevitable, and has the potential to destroy our economy, our capitalist system, and our way of life.

The reason America will suffer the most from this potential tragedy is because the U.S. epitomizes capitalism, and that governing structure is doomed to fail when the crisis of widespread automation takes hold causing millions of Americans to lose their jobs, and there are no new jobs to offer them. The rift between the rich and poor will grow astronomically, and tensions will rise to unprecedented levels across the U.S.

Capitalism in America has led to monumental successes, as well as catastrophic failures. The rise of automation in America could mean the demise of capitalism in America, as it will cause the economy to collapse in on itself, and there is no plan in place to recover or survive.

If that happens, blood will be on the hands of the avaricious American capitalists and greedy politicians that enabled the capitalists to thrive at the expense of the betterment of the American people.

Seph Lawless

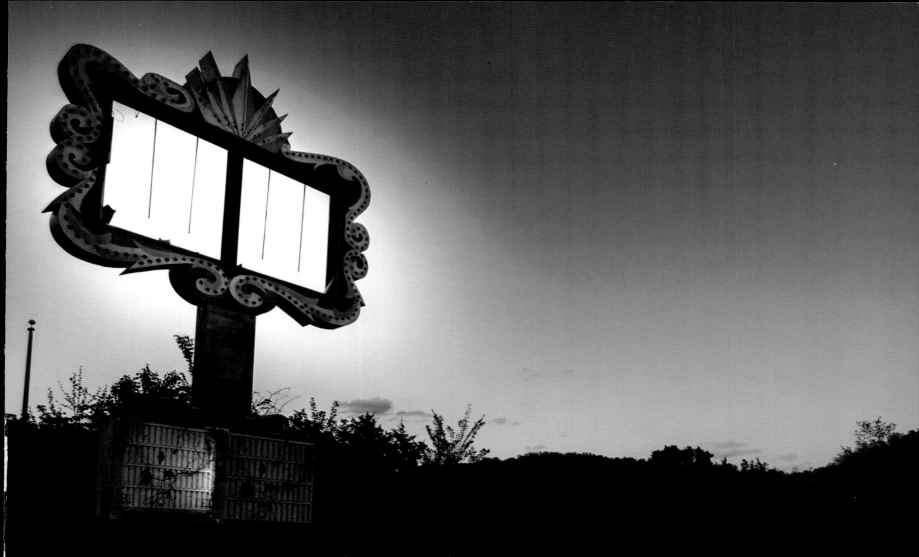

AUTOPSY OF AMERICA

SEPH LAWLESS

DEATH OF A NATION

AUTOPSY OF AMERICA
SEPH LAWLESS

A catalogue record for this book is available from the British Library.

First Edition 2017
First published in Great Britain in 2017 by Carpet Bombing Culture.
An imprint of Pro-actif Communications
www.carpetbombingculture.co.uk
email: books@carpetbombingculture.co.uk
©Carpet Bombing Culture. Pro-actif Communications

Photography by: Seph Lawless
Foreword by: Michael Goldfarb

ISBN: 978-1908211-49-1

CARPET
BOMBING
CULTURE

www.carpetbombingculture.co.uk

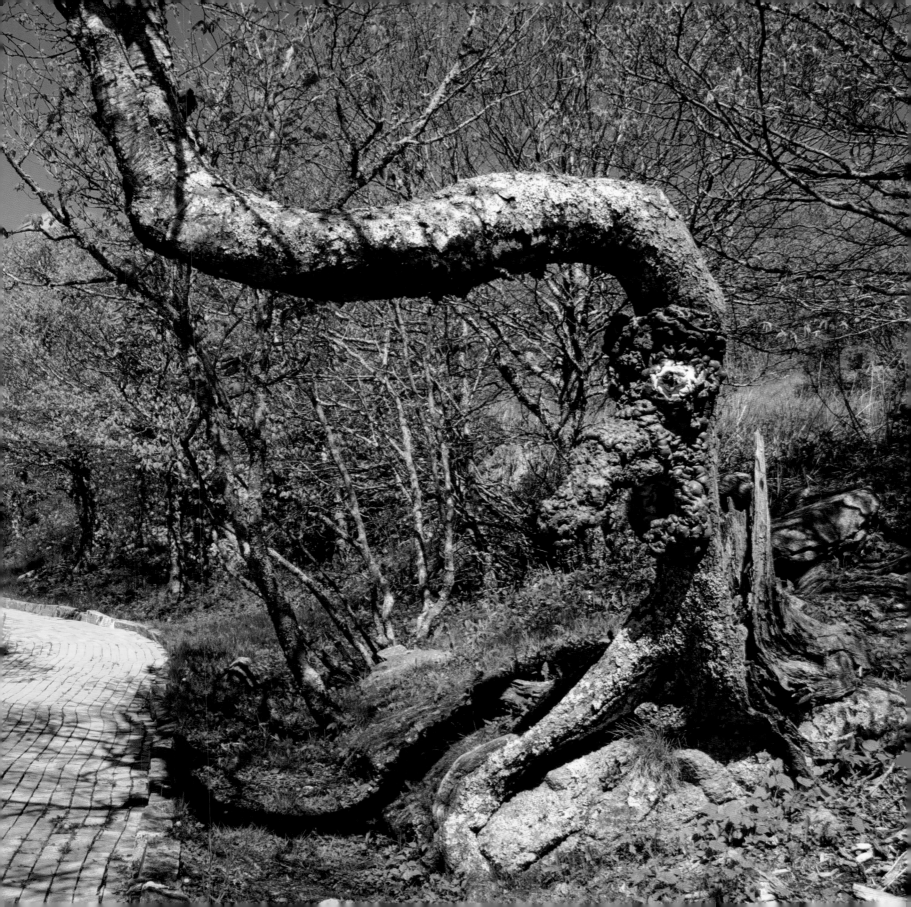

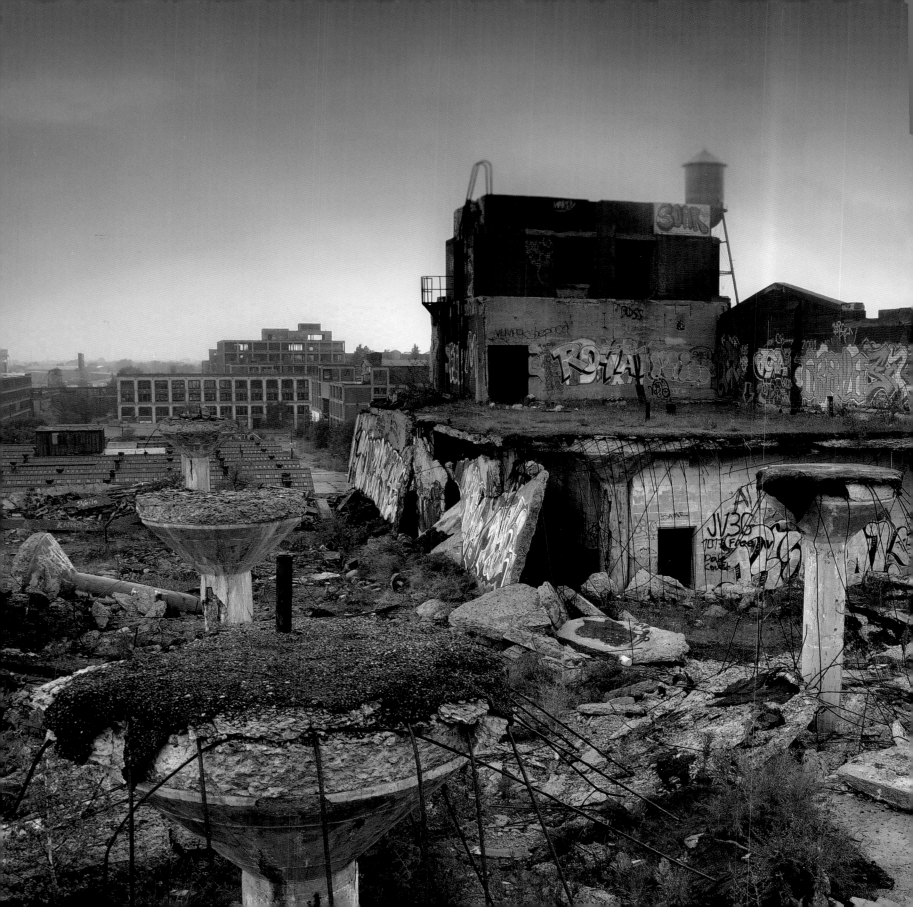

EVERY PICTURE TELLS A STORY

by Michael Goldfarb

Look at Seph Lawless's photographs. What story do they tell you? Choose one of these bleak and beautiful shots of ruins and imagine the objects as they were not so very long ago. The pictures are still but narrative time flows through them.

Throughout the Northeastern United States and the Great Lakes you will find ruins like this. Too recent for archeologists to bother with but wreckage of a vanished civilization worth studying. The America that produced these buildings is receding. The America of Donald Trump looms over us now.

Most of these photos were made in Ohio, where Seph lives.

I know Ohio well. I went to Antioch College in the southwestern part of the state near Dayton between 1968-1972. I knew these buildings when they were humming with workers. I saw some of these shopping malls when the land they stand on was being graded and their foundations being poured.

A few summers after I graduated, before I began my grown up life in earnest, I drove west to the Rockies one last time. I got off the interstate and passed through high plains towns that had emptied out, their buildings falling apart. Ghost towns are part of the American psyche. They are mythologized in westerns.

They are places where hopes were crushed by catastrophe. The scale of a ghost town is small, though. You never expect the catastrophe to hit a city like Akron or Johnstown or Toledo or Cleveland. But that is the story of the last 40 years in the Rust Belt.

Nor do you think that in your lifetime the world you entered as an adult would be reduced to ghost towns, unless there was a catastrophe on the scale of a war. Yet that is what has happened in western Pennsylvania, Ohio, and Michigan. The war was waged by America's economic system on its own people. And nobody called it out, much less stopped it.

I met Seph Lawless in June 2016, shortly after Donald Trump became the Republican nominee for President. I was making a radio documentary for the BBC on Ohio's independent voters. Ohio has picked the winner in every election for the last half century and most voters in the state are now independents.

I came across Seph in the modern way. I googled post-industrial Ohio or some such and up came these startling photographs. I knew some of them, like the snow filled inner atrium of the shopping mall. I contacted him and he agreed to meet me at the remains of what had been the largest clothing factory in Cleveland, Joseph and Feiss. The company had been

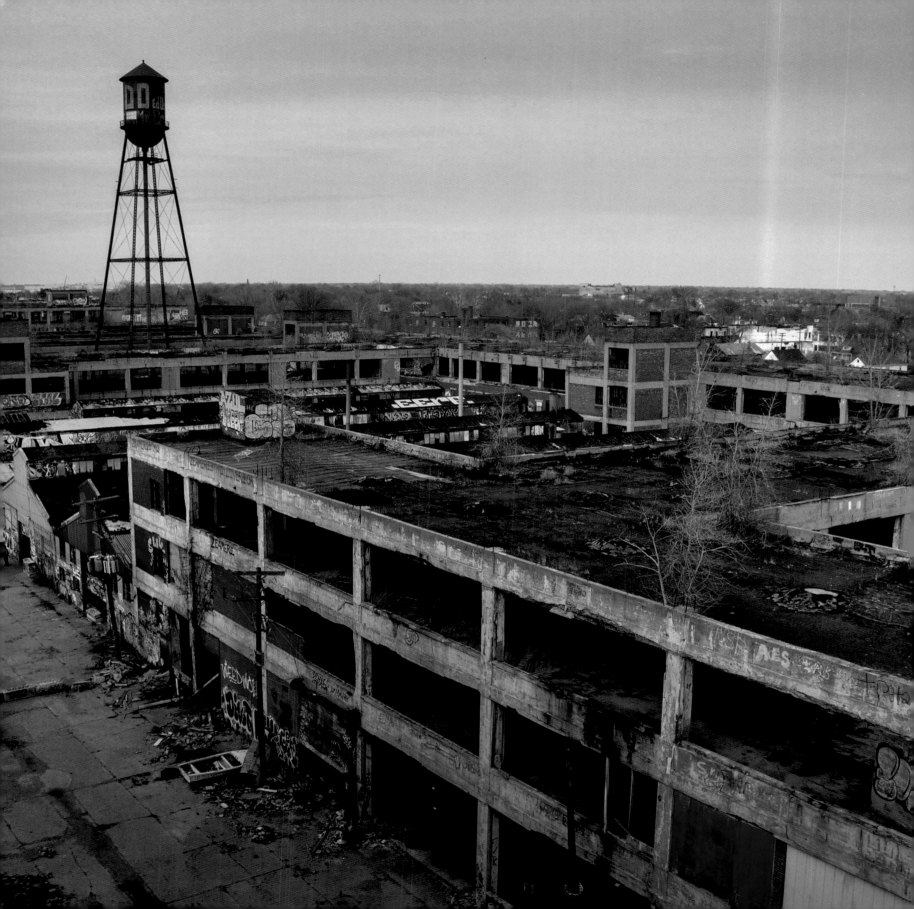

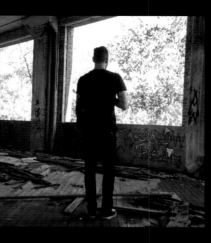

founded in the 1840's. He showed me around the hulk of the building, the overhead cords that once hooked up to irons that pressed the finished clothes before they were packaged still dangled from the ceiling. The graffiti was like a full-body tattoo all over the building.

We listened to traffic roaring by on I90. I thought to myself, how can hundreds of thousands of cars go by this place every day and people in them not think about what this building symbolizes. Maybe they had a relative who worked here. Even 20 years ago, the factory had 800 employees working decent paying union jobs. Didn't they know what has been lost? Weren't they angry?

Seph explained they were and more than that, he thought many people who you might not expect to vote for Donald Trump were considering doing so. This world in which all the jobs go and the buildings are left as rotting memorials to times of stability and economic growth had produced an anarchic, cynical anger among even young people. Trump had a shot at winning, Seph told me. He was right.

Seph Lawless's photos are documents of the recent past. They are history without words. They are explanations of how America got to Trump.

If I was your history teacher I would give you an assignment. Choose a photo and imagine the building or the mall or the movie theatre or the merry-go-round 40 years ago. Think of the people, the society in which the building was in use. Now write a short story that starts then and ends in this abandoned wreckage. You will have told the history of America over the last four or five decades.

That's what Seph Lawless has done. Admire these images for their craft, technique and bleak beauty but remember they are also the history of the United States in the Age of Trump.

Michael Goldfarb is the host of FRDH Podcast at www.goldfarbpod.com

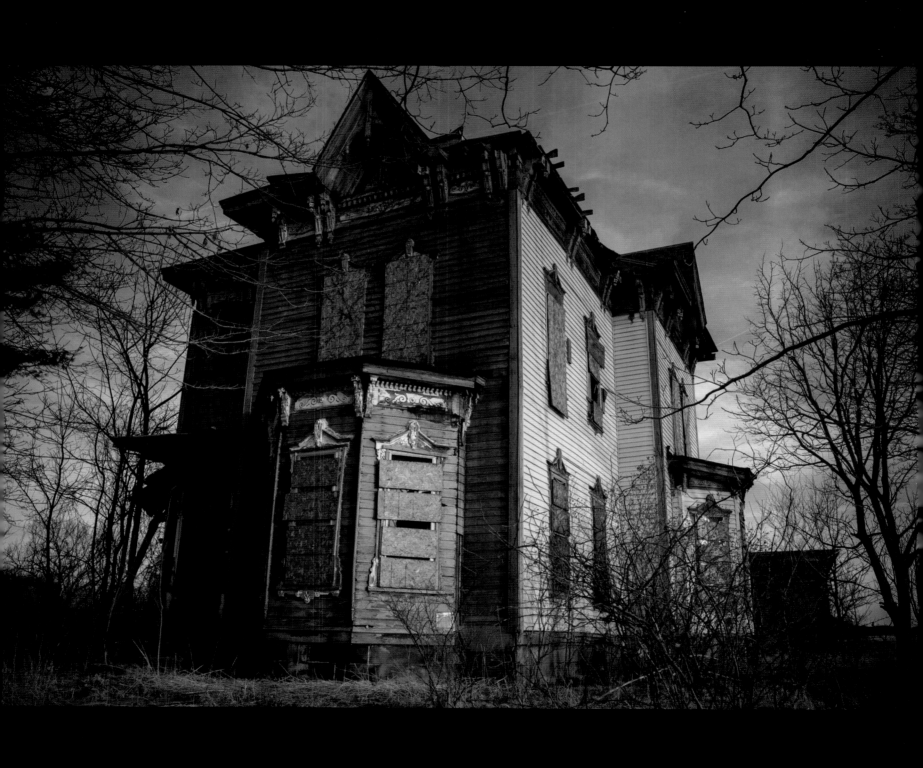

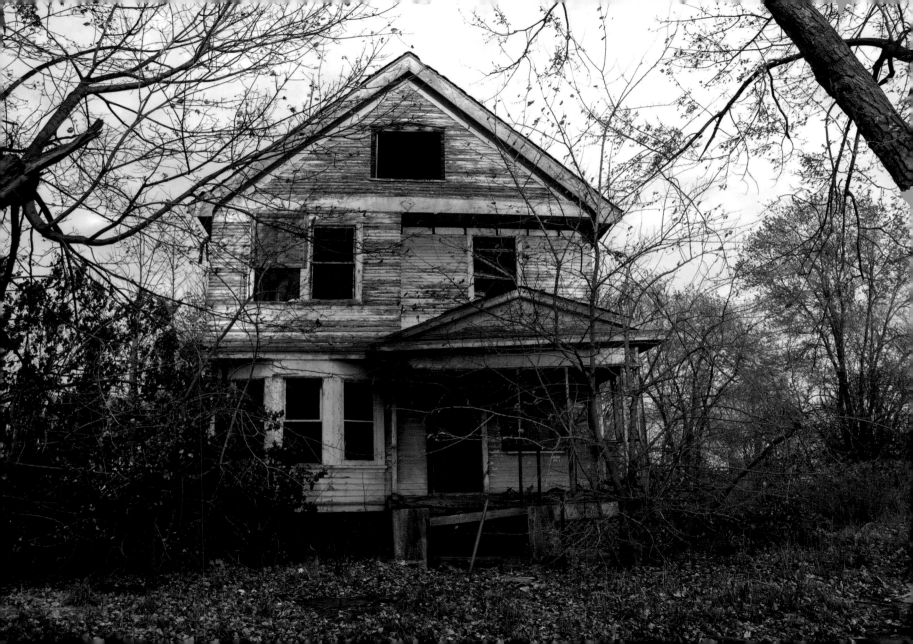

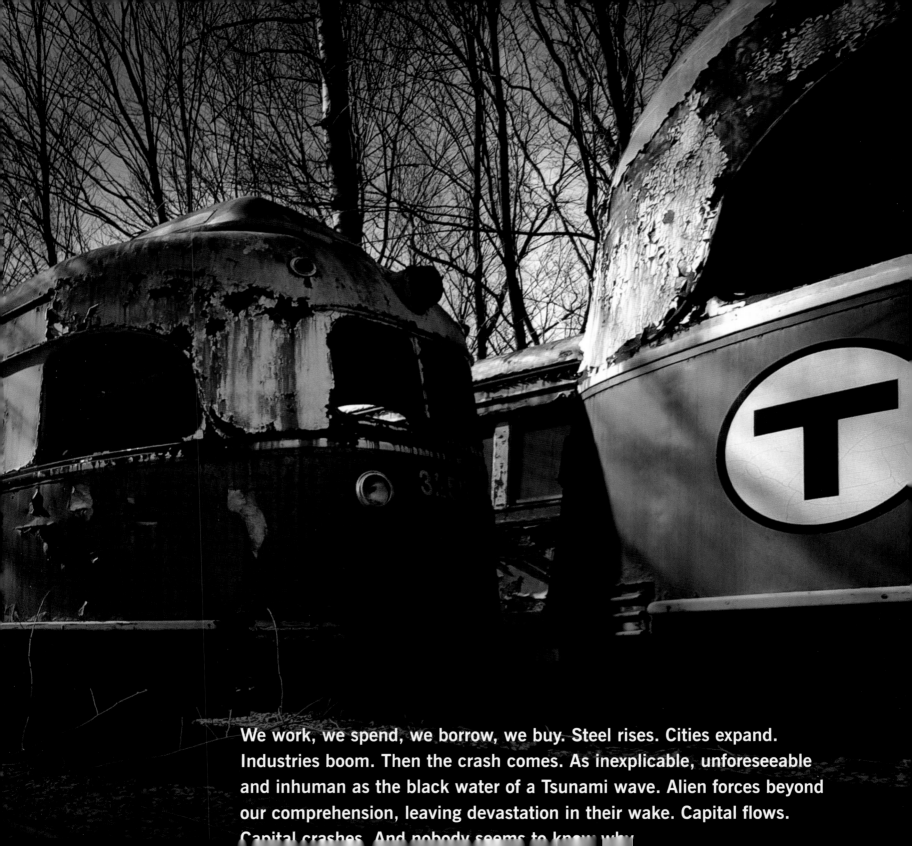

We work, we spend, we borrow, we buy. Steel rises. Cities expand. Industries boom. Then the crash comes. As inexplicable, unforeseeable and inhuman as the black water of a Tsunami wave. Alien forces beyond our comprehension, leaving devastation in their wake. Capital flows. Capital crashes. And nobody seems to know why.

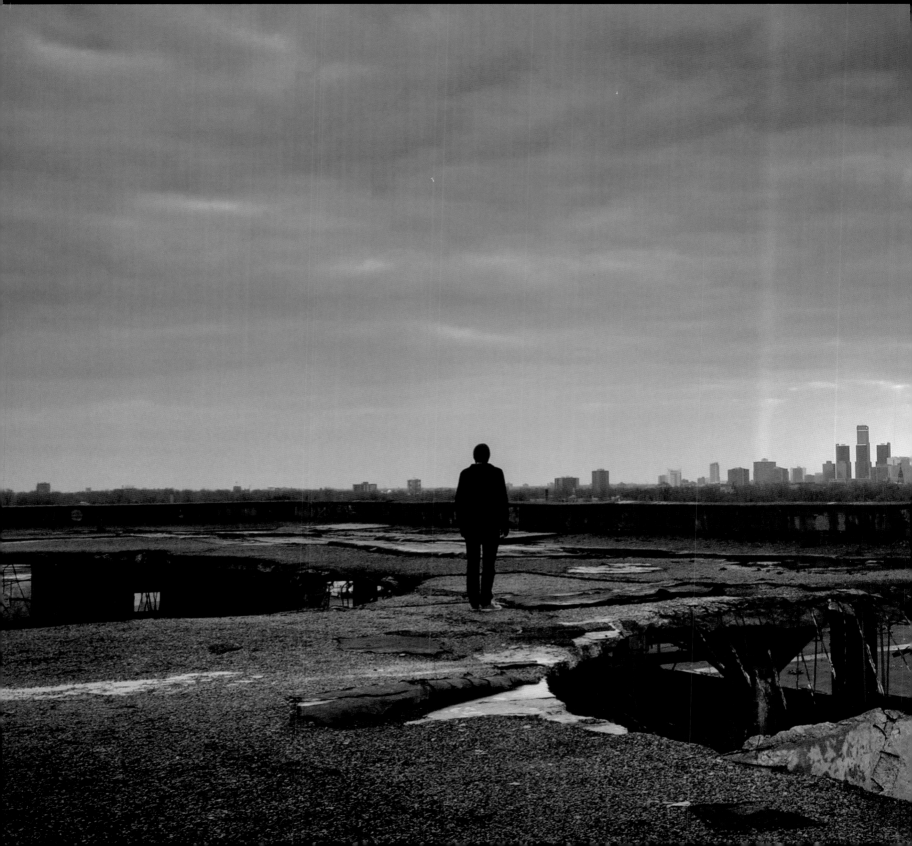

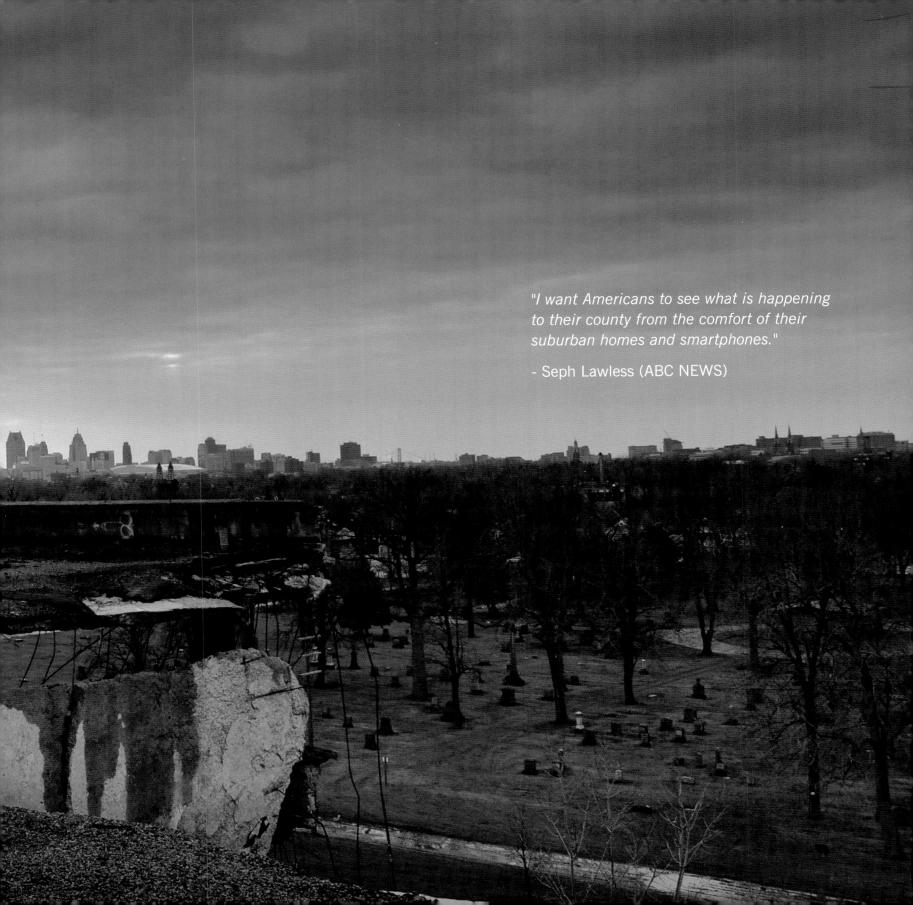

"*I want Americans to see what is happening to their county from the comfort of their suburban homes and smartphones.*"

- Seph Lawless (ABC NEWS)

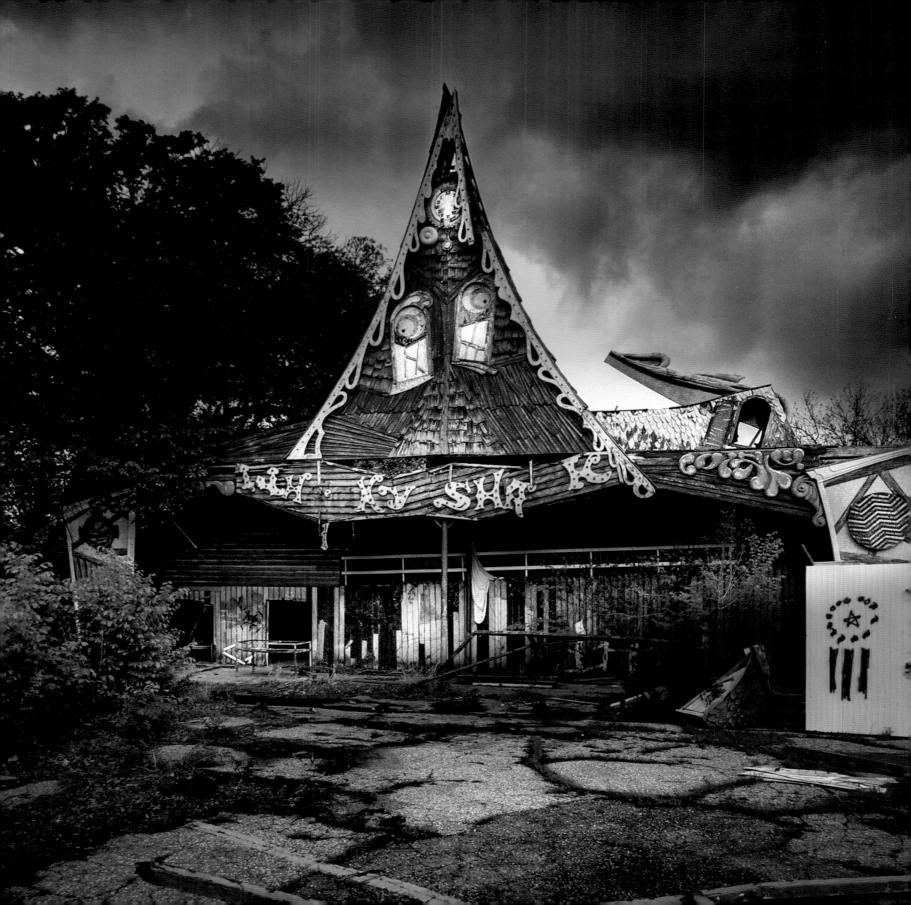

This body of work is a cold current in the swimming pools of Silicon Valley. Will we one day shoot the abandoned monoliths of Apple HQ or Google?

The immense factories and warehouses of the rust belt stand like the pyramids - now difficult to imagine the sheer effort that threw them up.

The same forces that raised these edifices, shut them down, leaving them for nature to reclaim. The abandoned buildings in these photographs ask questions. How is it that what is valuable can become worthless overnight? How is it that the richest country in the world is so powerless in the face of urban decay?

We work. Capital happens. It moves.
We don't control it.
Our leaders don't control it.

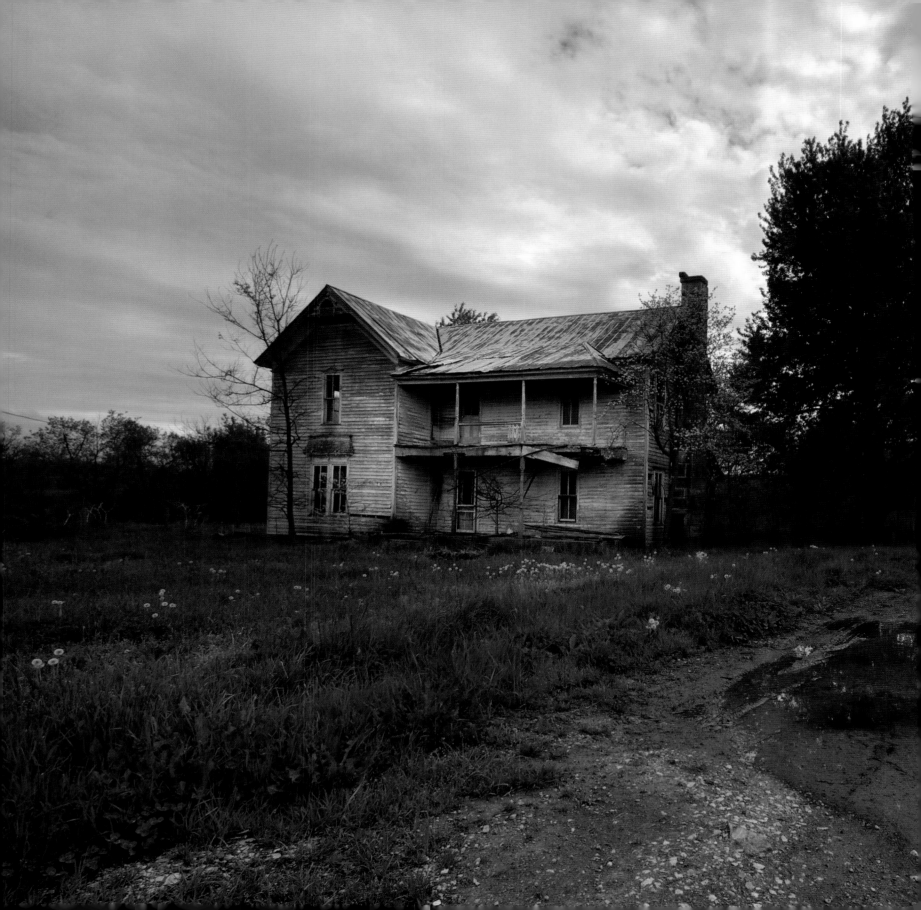

We are confronted by the sum power of all
our efforts as if it were a power outside of
human control. We've got the labour, the
tools, the skills and the resources - so how
come we can't use them? How come we
can't save our neighbourhoods? We ask the
experts. They don't know or won't tell. They
act surprised. They will act surprised when
happens again. Been like that for time.

Is this just another recession?
Or is it the beginning of the end?

Black water rising - every month the
mortgage check gets bigger, till you can't
keep your head above the water, till you
drown in the debt repayments, till the
sheriffs and the bailiffs come, suddenly
you're a criminal. A squatter in your
own home.

The abandoned homes pictured here strike
deep chord with contemporary America.
Whole communities washed away by
obscure financial tides. Echoes of the
gold rush.

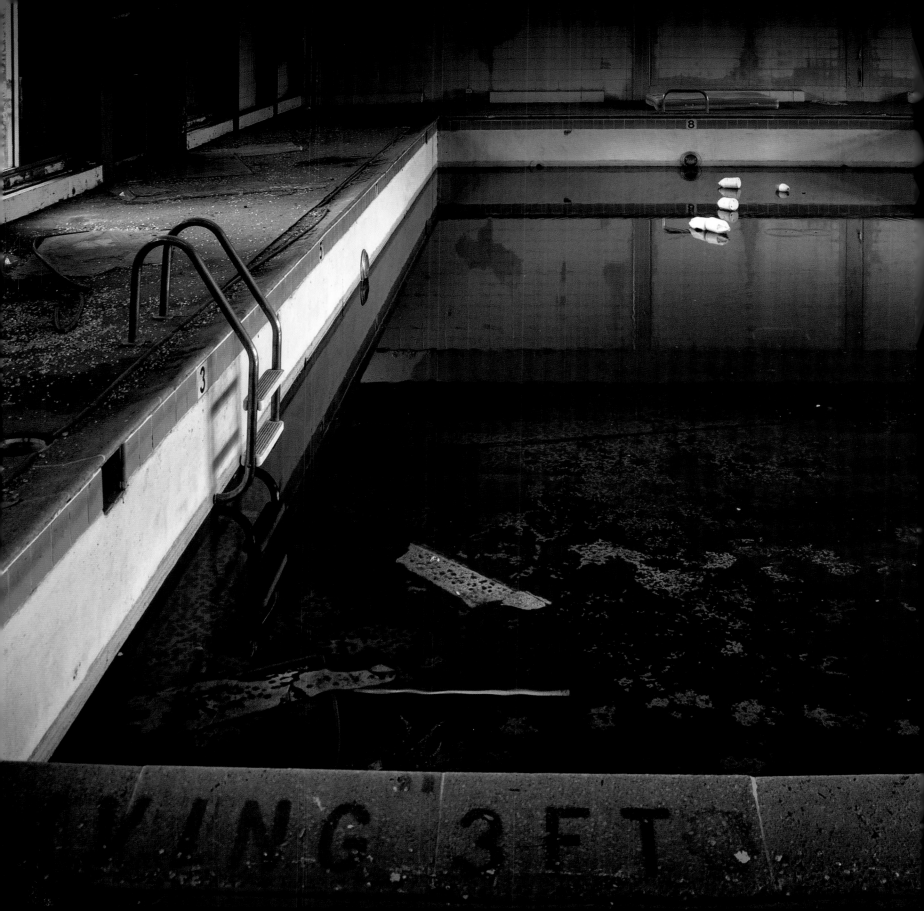

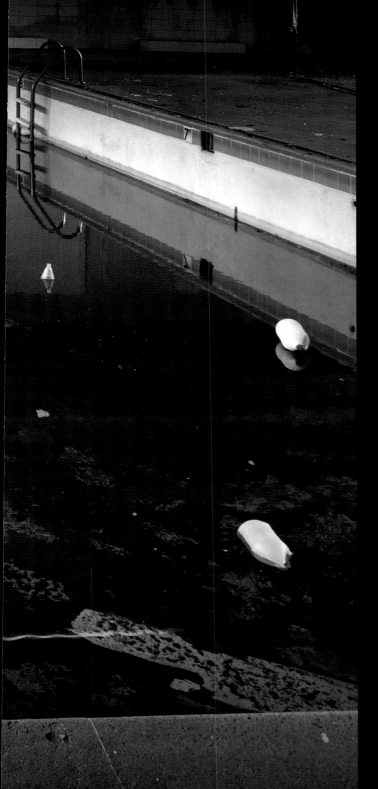

THE WATER KEEPS RISING

With their ivy league degrees and computer algorithms, they never saw it coming. No wonder the experts are no longer trusted. People turn to popular clowns, promising things they can't deliver, offering scapegoats to kick and witches to hunt.

America. The land of opportunity. Where anyone can become a king. A king of nothing. Ozymandias. Look on my works ye mighty and despair. All empires fall. Atlantis lies at the bottom of the ocean.

Never forget the decline of the West.

America is a man falling off the roof of a skyscraper, and as he passes every floor he says to himself...

...so far so good.

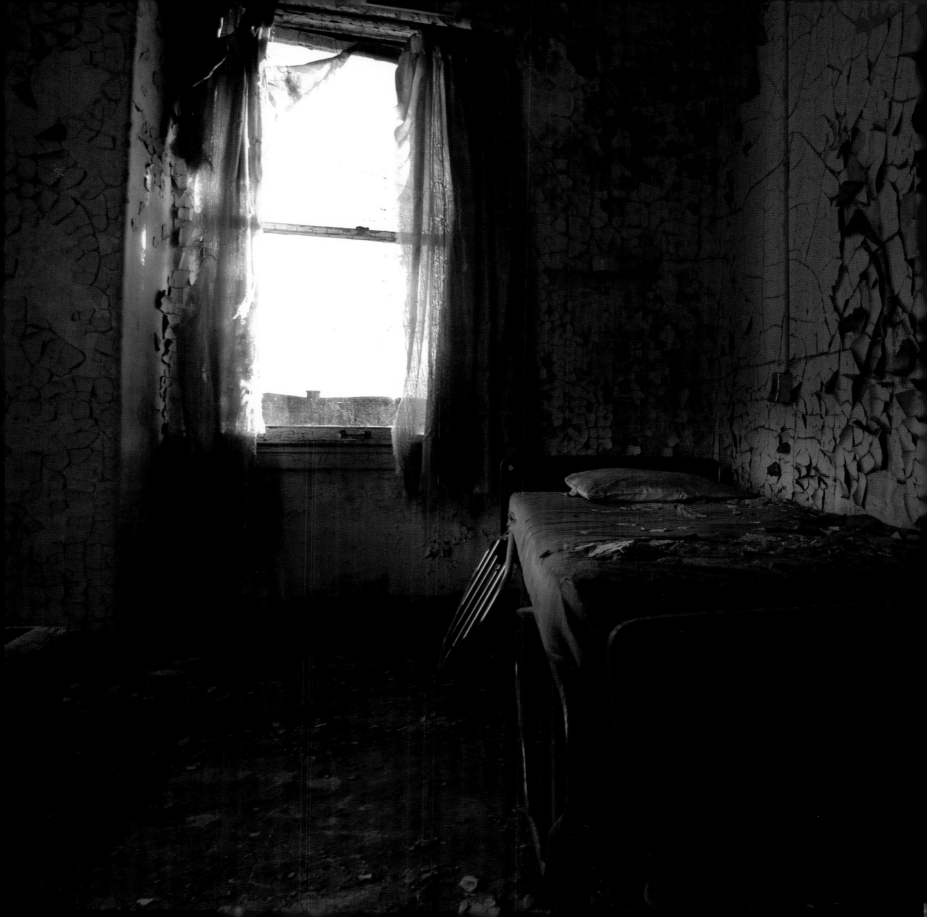

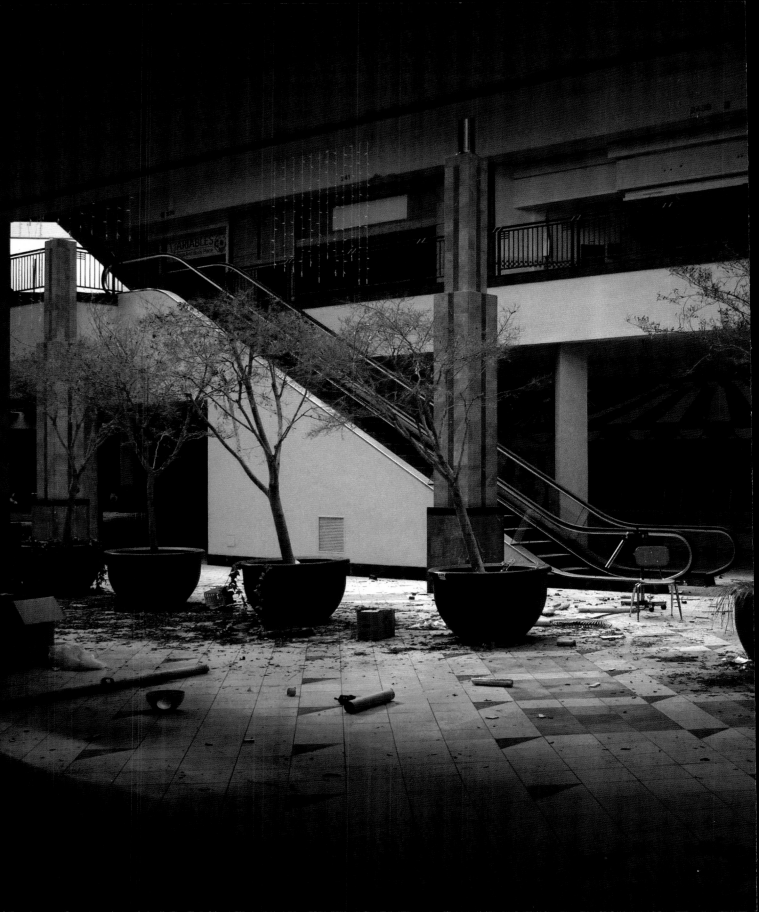

DEAD
MALL CALLING

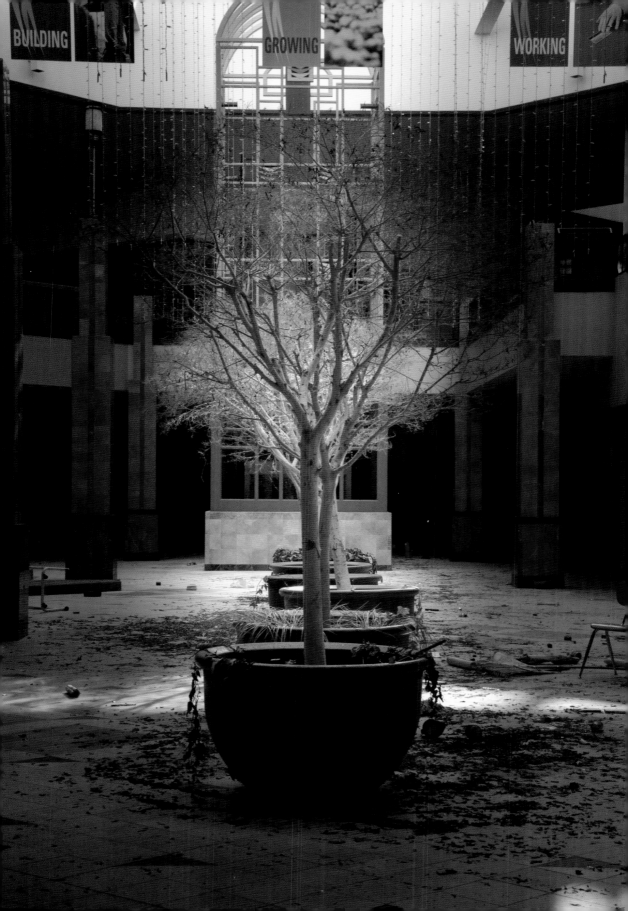

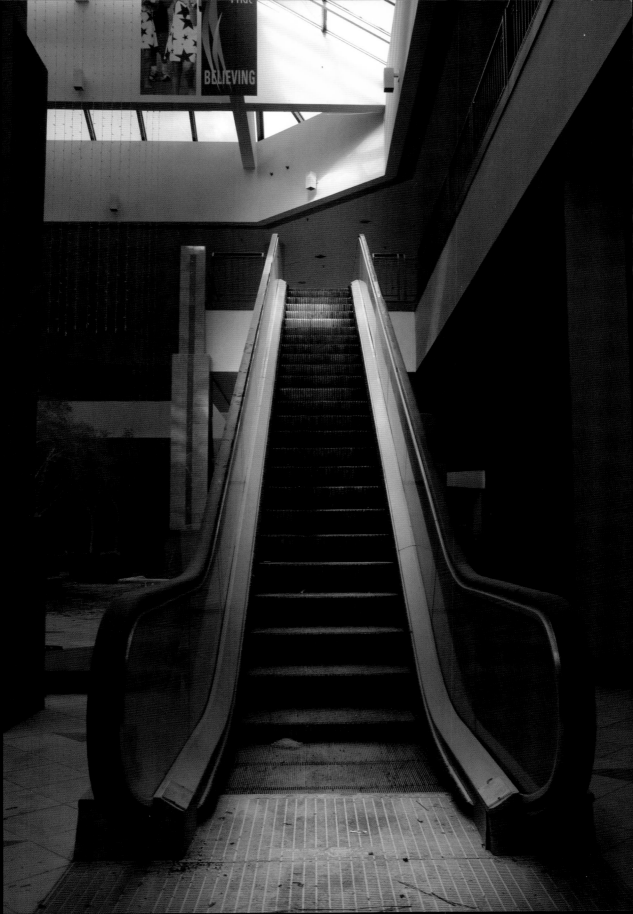

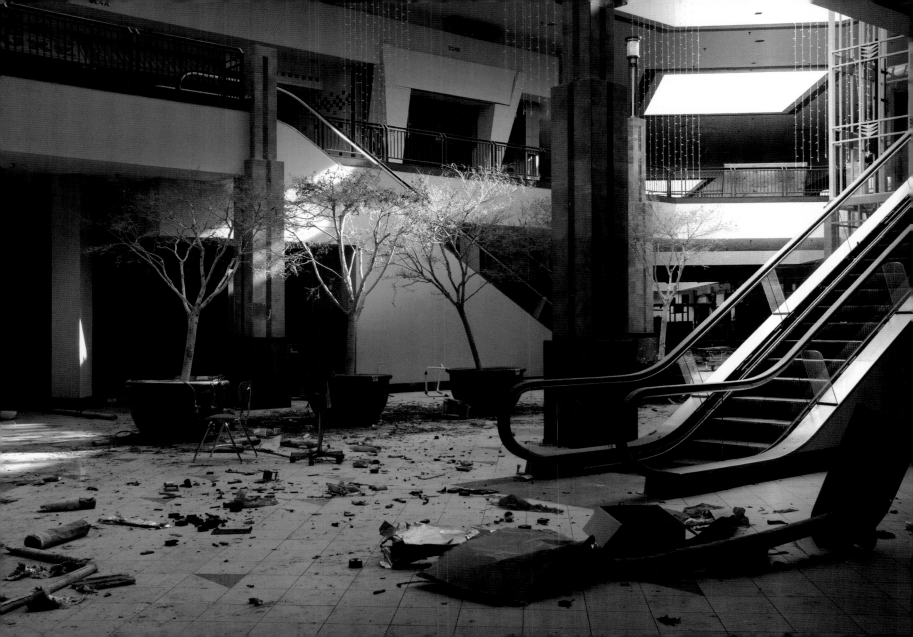

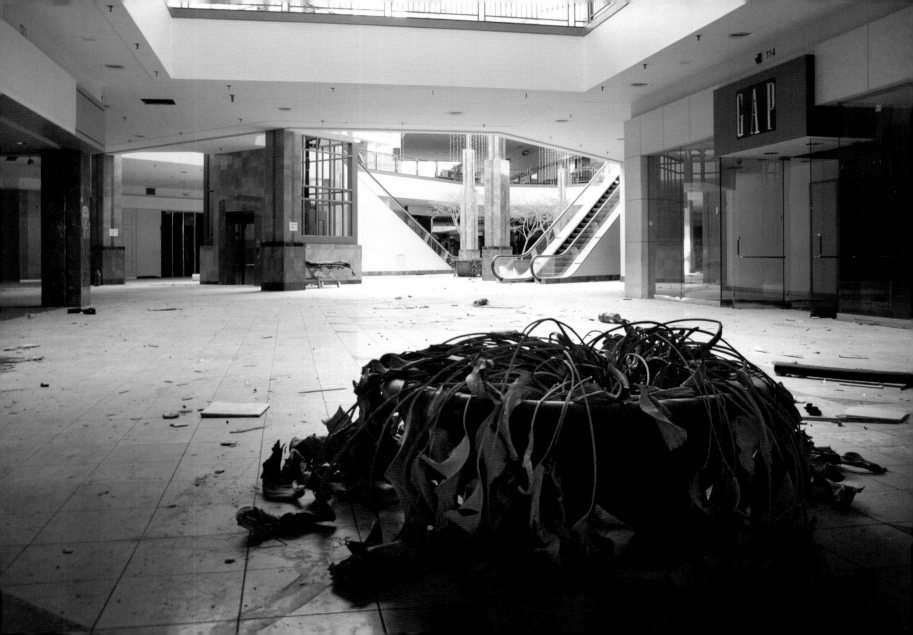

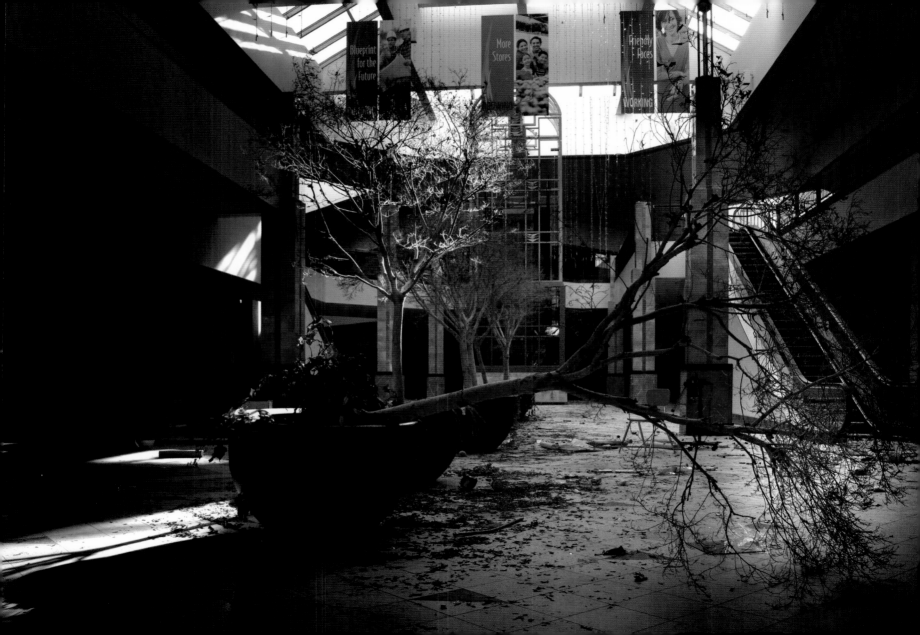

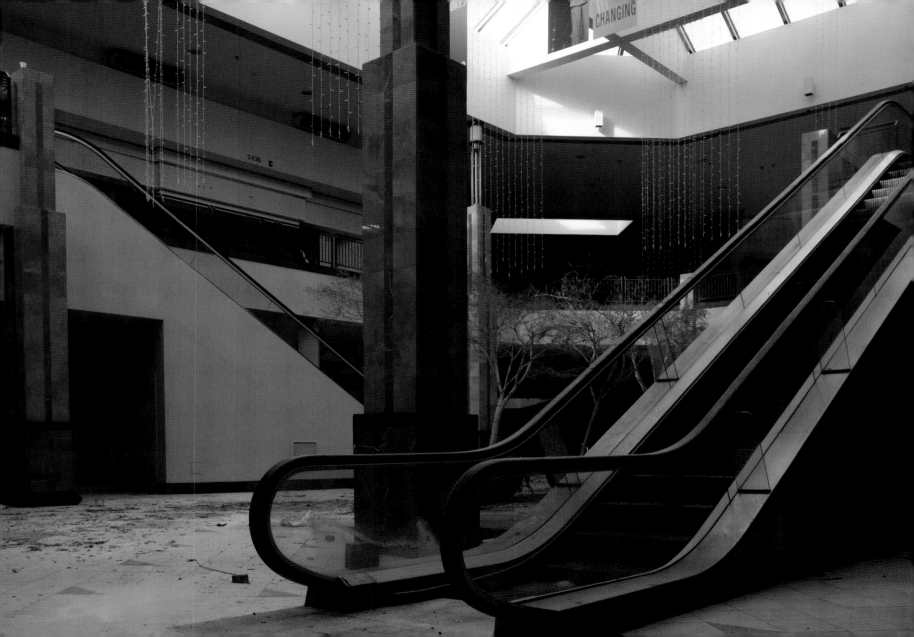

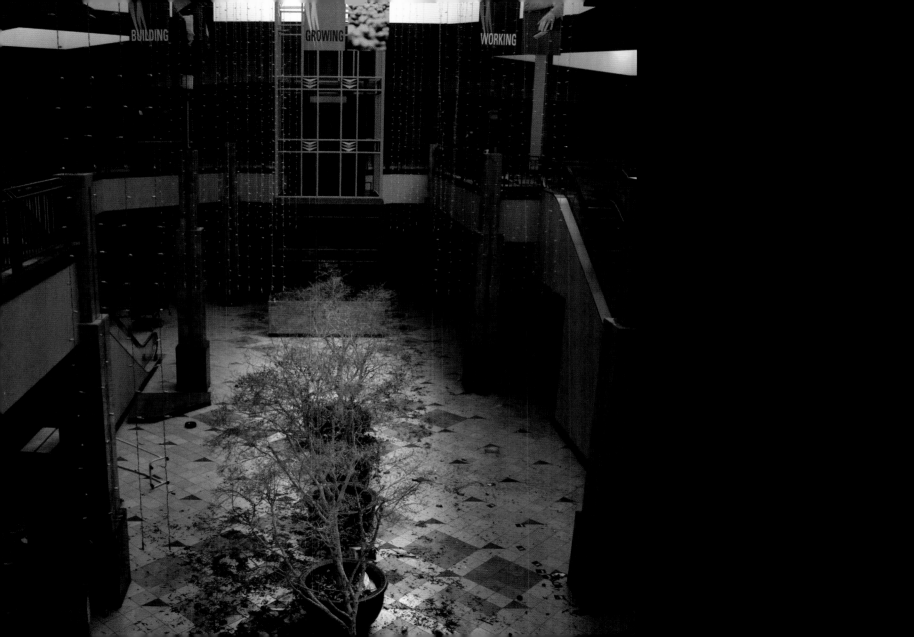

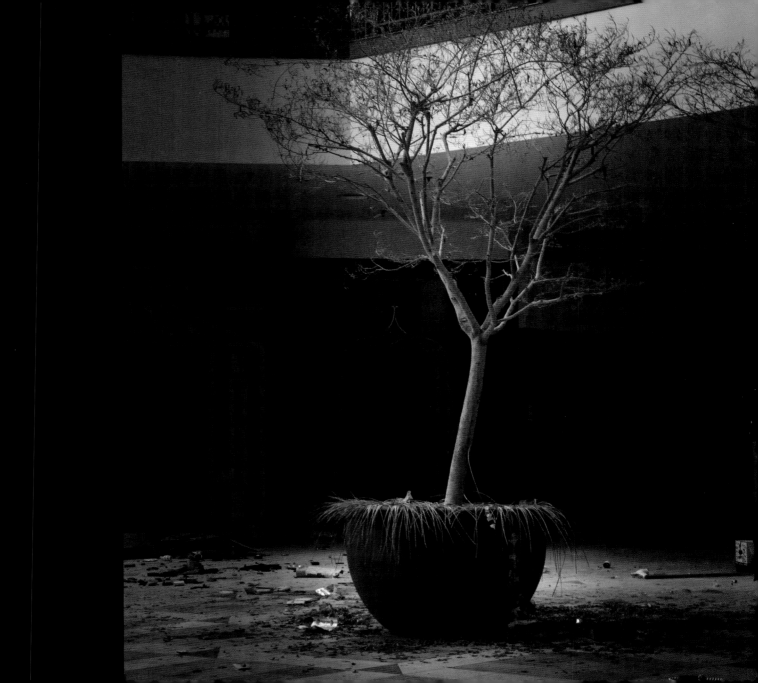

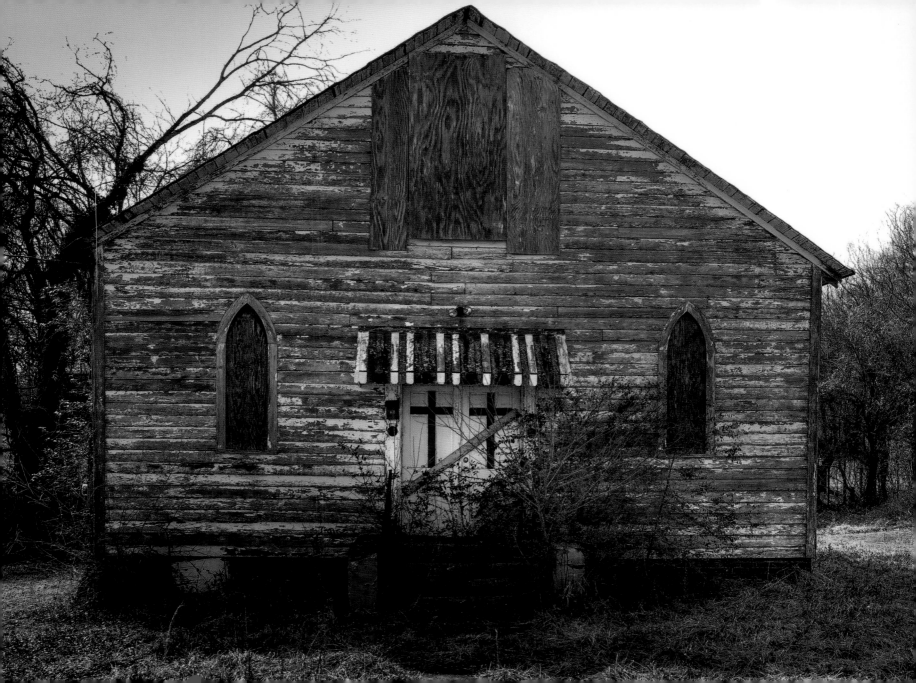

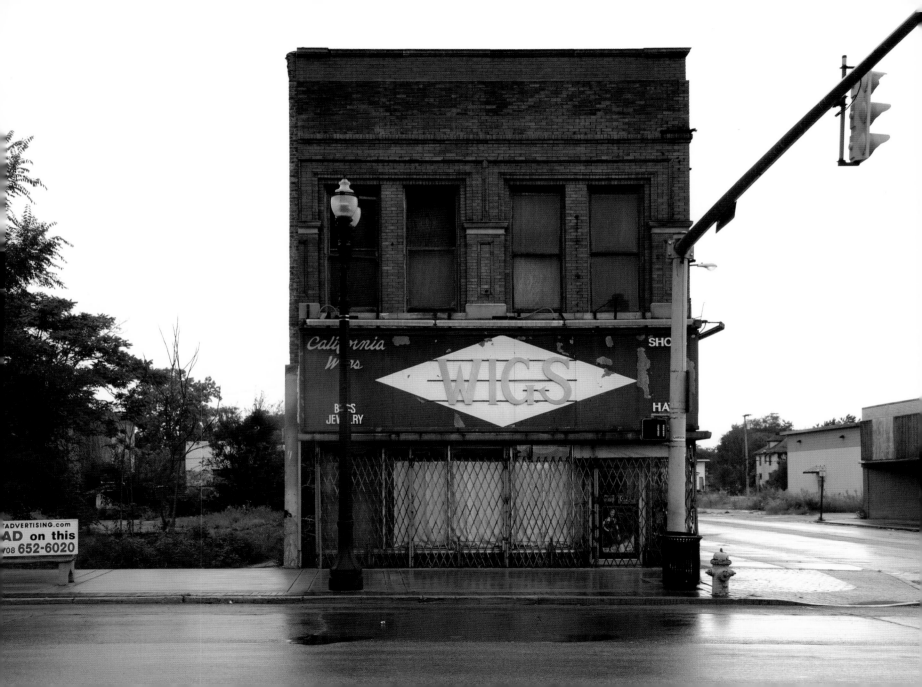

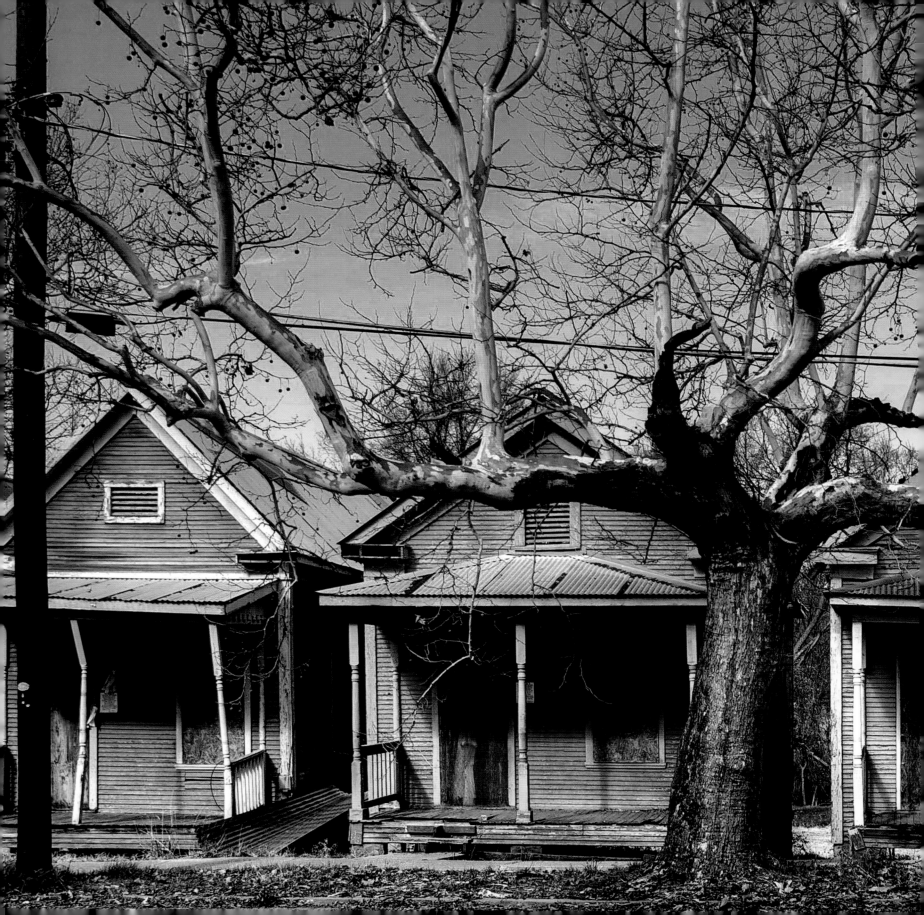

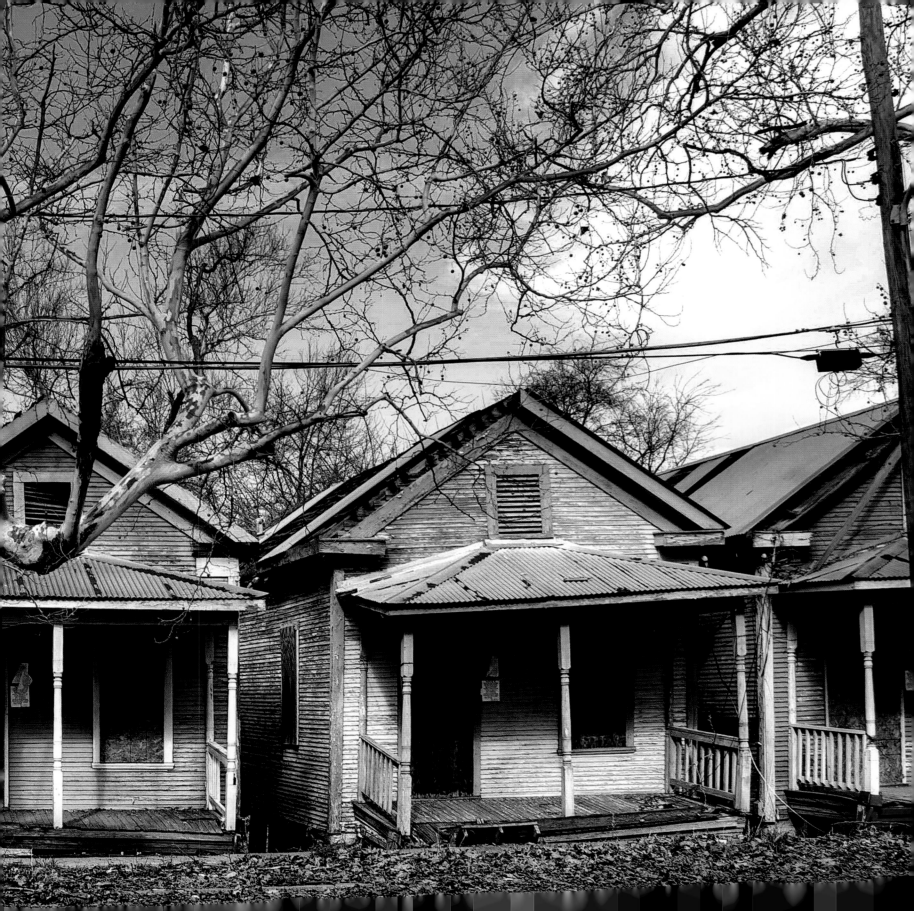

AUTOPSY
REPORT CASE #83-1611
United States of America

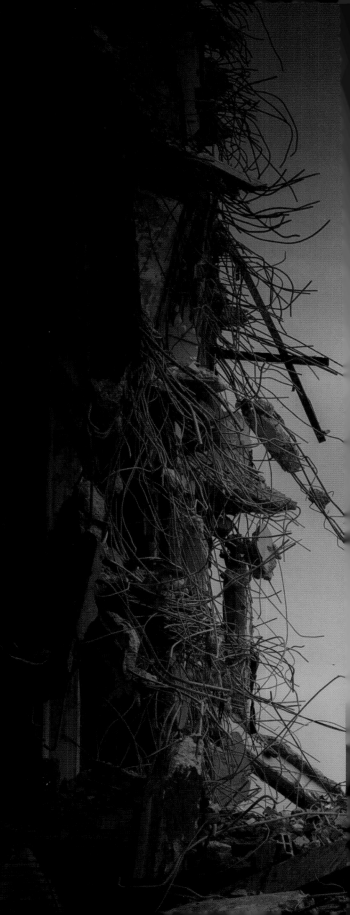

I performed an autopsy on the body of **the United States of America**

at **the DEPARTMENT OF CHIEF MEDICAL EXAMINER-CORONER**

 Los Angeles, California

on **APRIL 10, 2016 at 1430 HOURS.**

From the anatomic findings and pertinent history I ascribe death to:

**(A) EMETINE CARDIOTOXICITY DUE AS A
CONSEQUENCE OF**

(B) NERVOSA; STARVATION

Anatomical Summary:

I. Pulmonary edema and congestion.
II. Nervosa (clinical).
III. Cachexia.
IV. Distended abdomen.
V. Dehydration.
VI. Congestion of liver and spleen.
VII. Hyperplasia of lymph nodes.
VIII. Distention of bowel.

**(C) I conclude that the United States of America died from a
broken heart.**

Seph Lawless

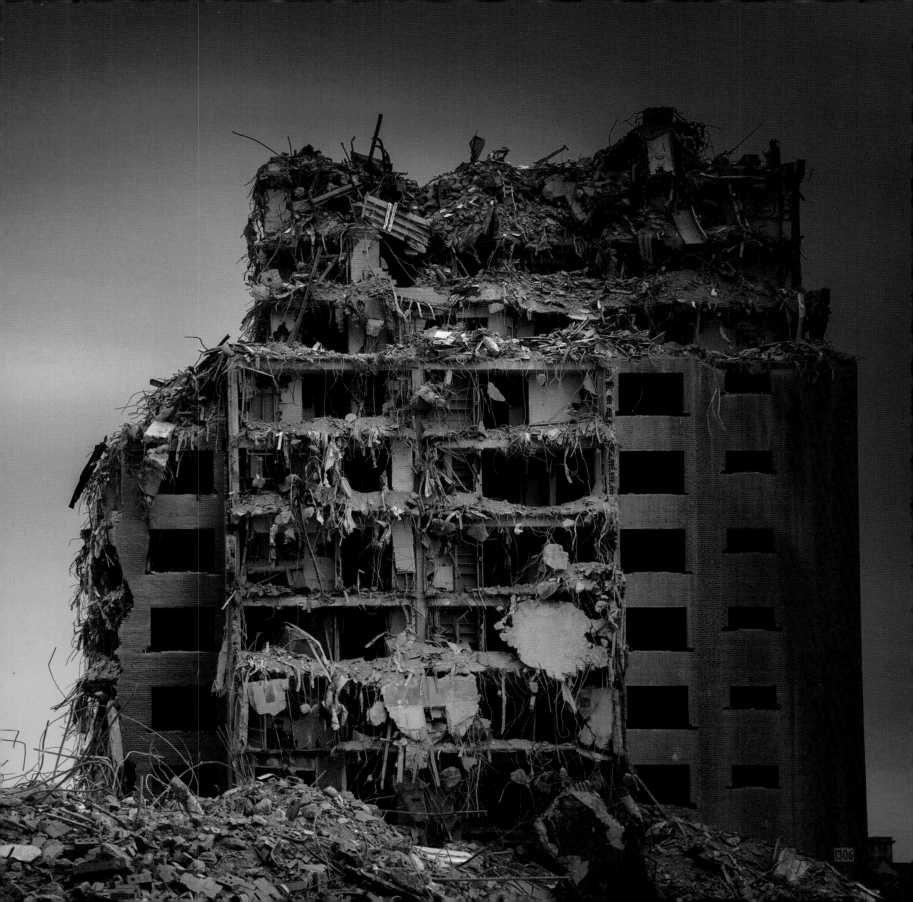

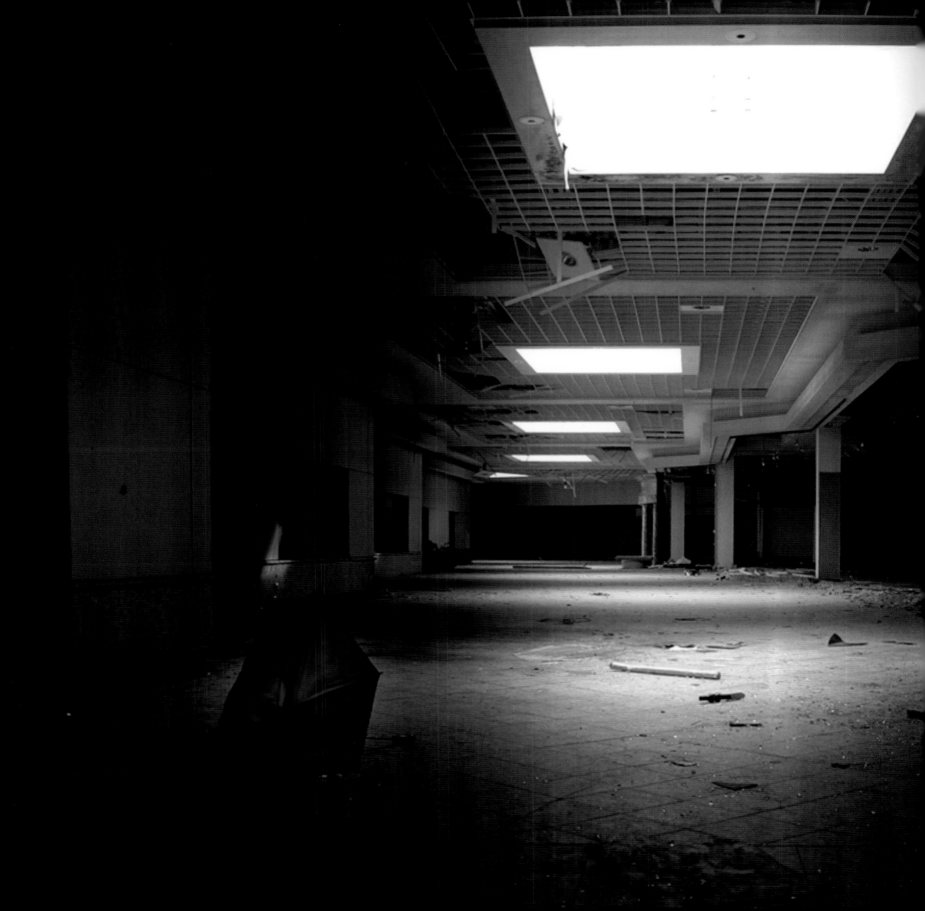

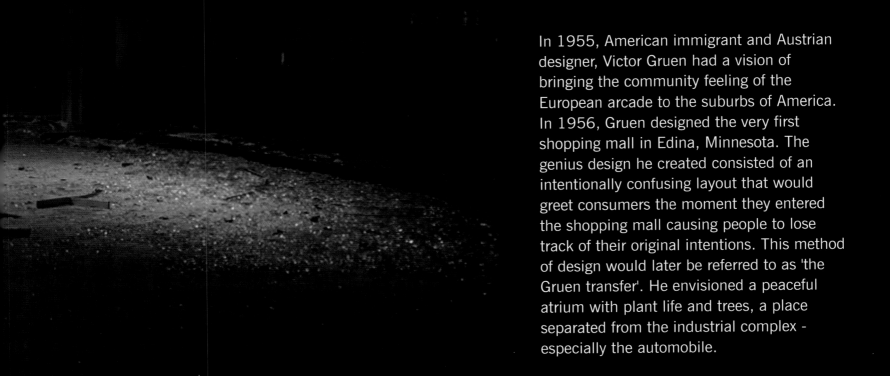

BLACK FRIDAY
MALL

In 1955, American immigrant and Austrian designer, Victor Gruen had a vision of bringing the community feeling of the European arcade to the suburbs of America. In 1956, Gruen designed the very first shopping mall in Edina, Minnesota. The genius design he created consisted of an intentionally confusing layout that would greet consumers the moment they entered the shopping mall causing people to lose track of their original intentions. This method of design would later be referred to as 'the Gruen transfer'. He envisioned a peaceful atrium with plant life and trees, a place separated from the industrial complex - especially the automobile.

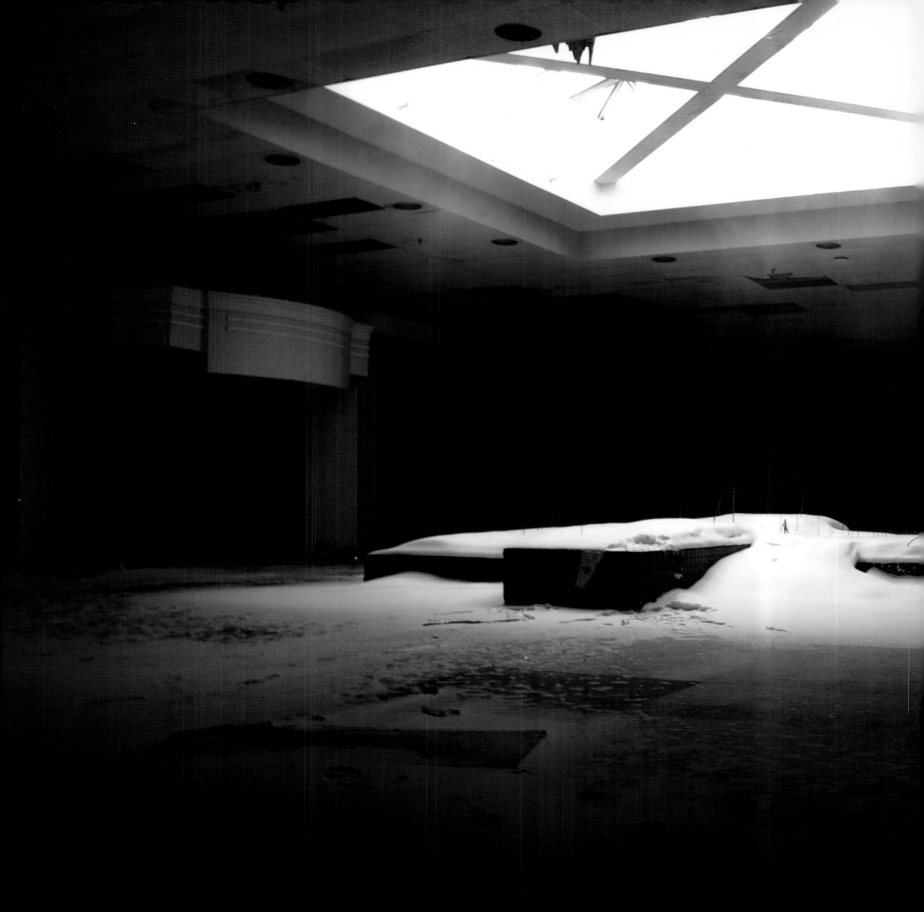

Victor Gruen despised the automobile. He hated the sound of cars and the pollution they created. His early writings even indicated he believed cars were anti-social to human development. Ironically, Gruen's creation only served to strengthen the suburban car culture that he despised.

Later in life, Gruen became disillusioned with malls and their unintended consequences. He revisited one of his old shopping centers and saw all the sprawling development around it and pronounced himself in "severe emotional shock." Shopping malls had been disfigured by "the ugliness and discomfort of the land-wasting seas of parking" around them. He said in an anguished speech in London in 1978, "My creation wasn't intended to create a gigantic shopping machine".

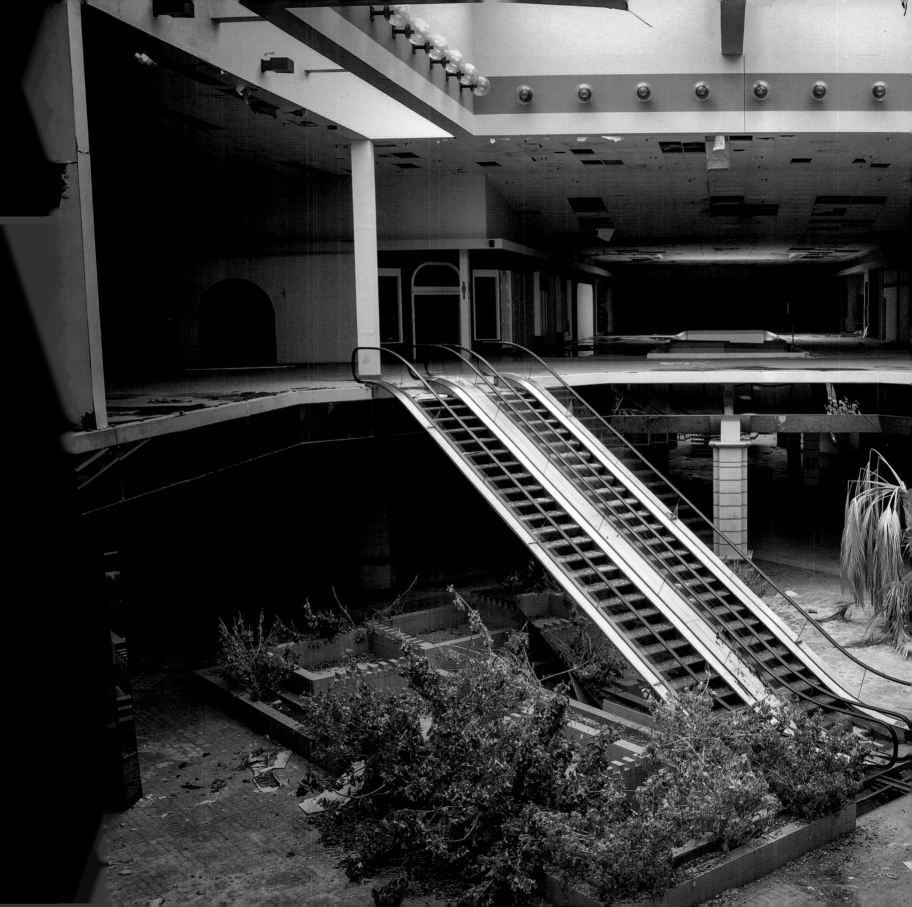

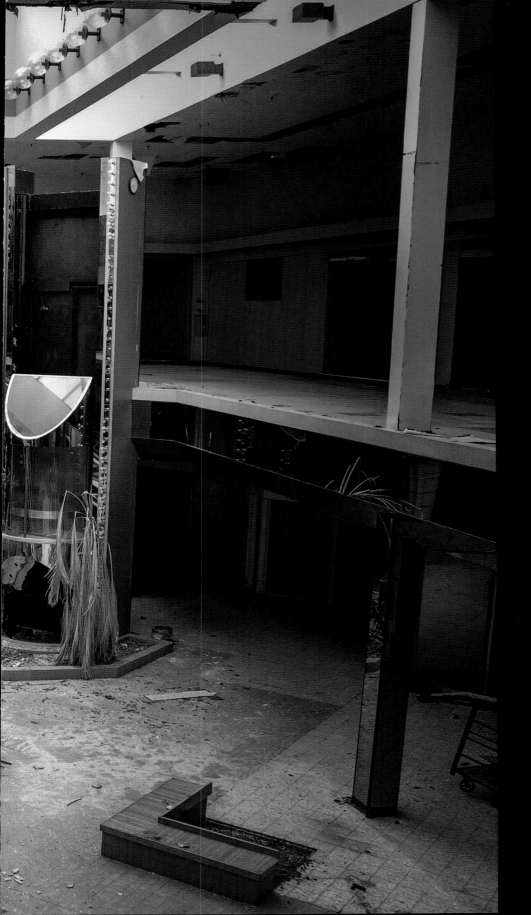

I am devastated...I invented the shopping mall to make America more like Vienna and now I ended up making Vienna more like America.

I hope all shopping malls end up neglected, abandoned, and forgotten. I refuse to pay alimony for those bastard developments." He returned to Vienna where he would become a recluse until his death on February 14, 1980.

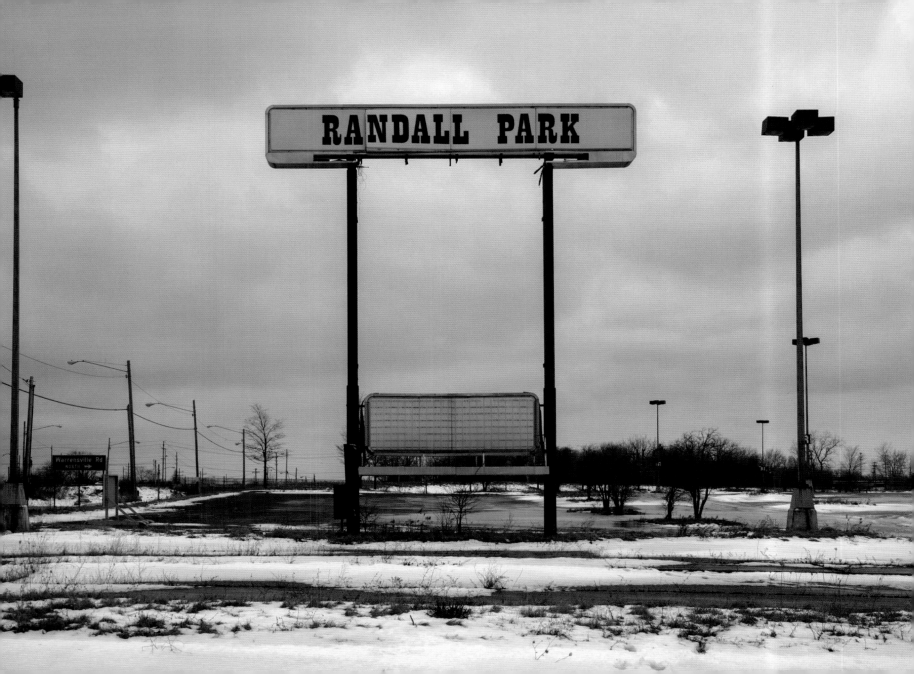

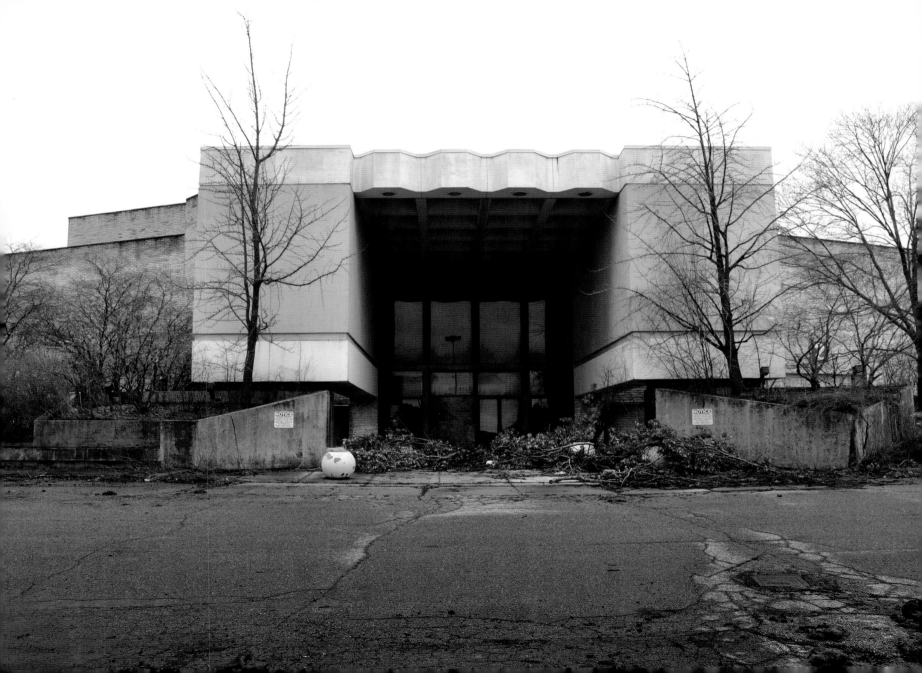

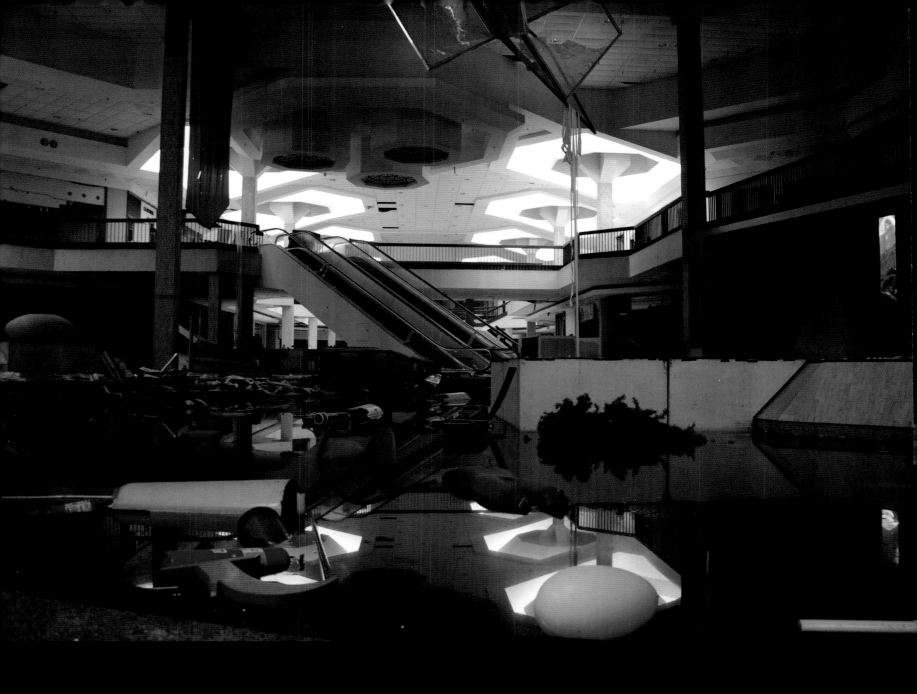

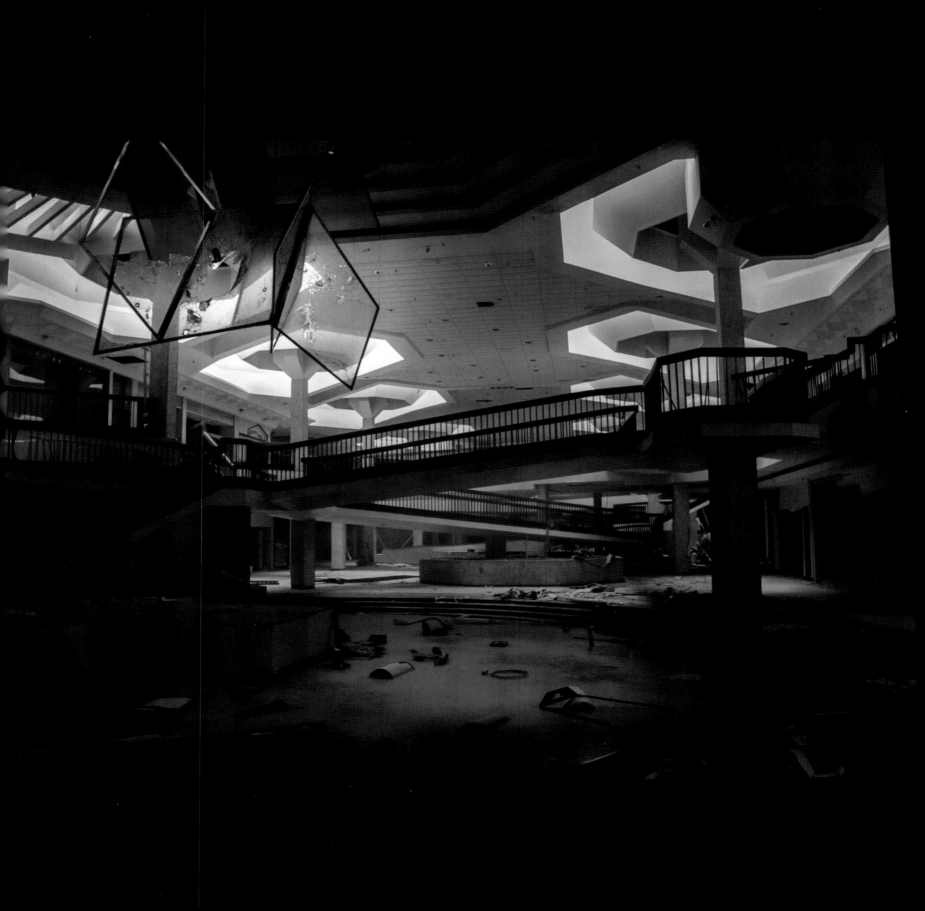

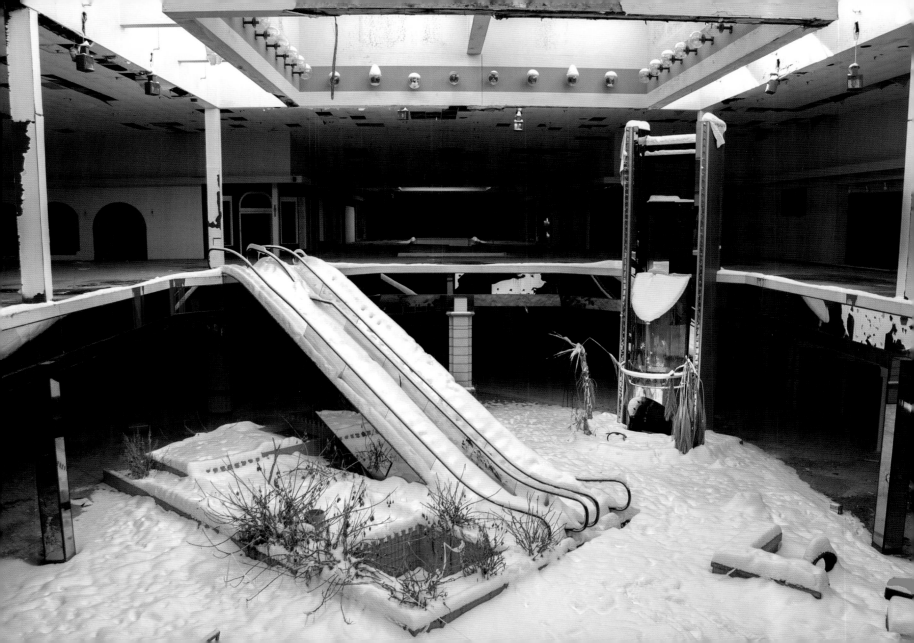

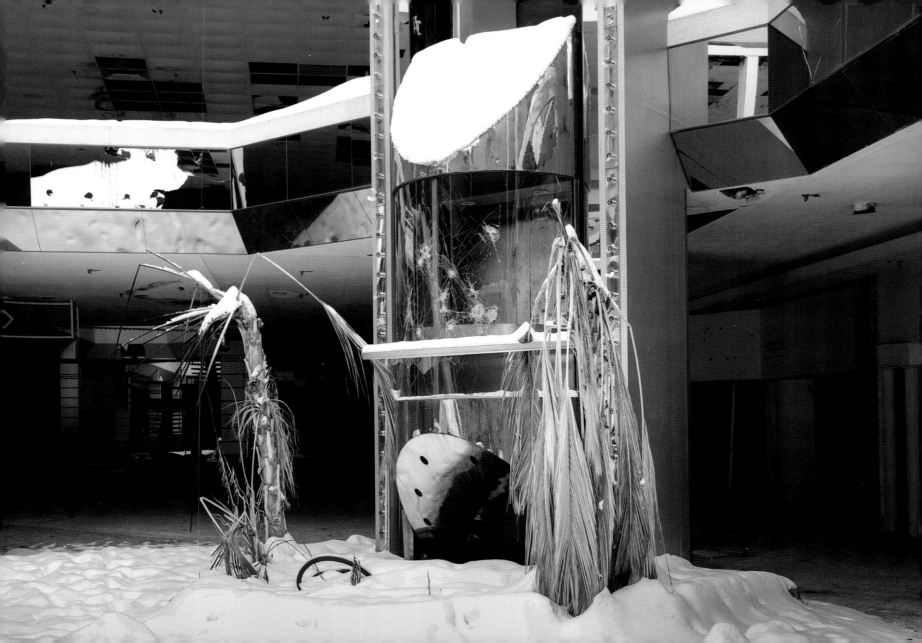

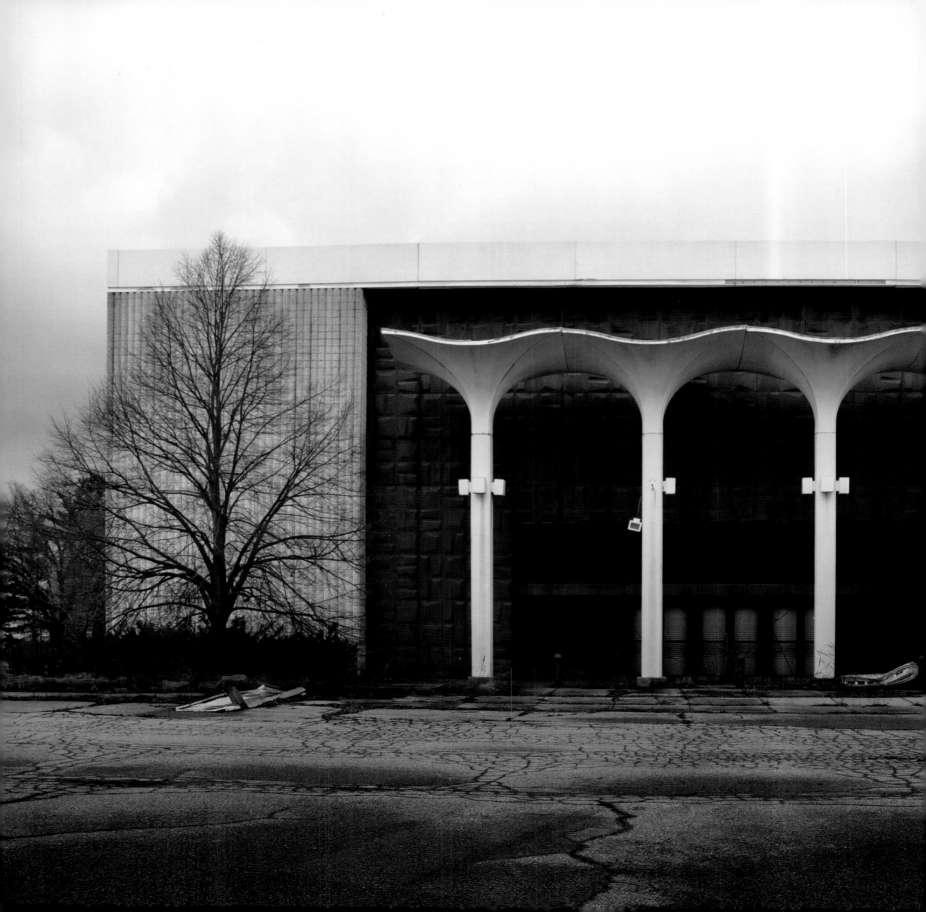

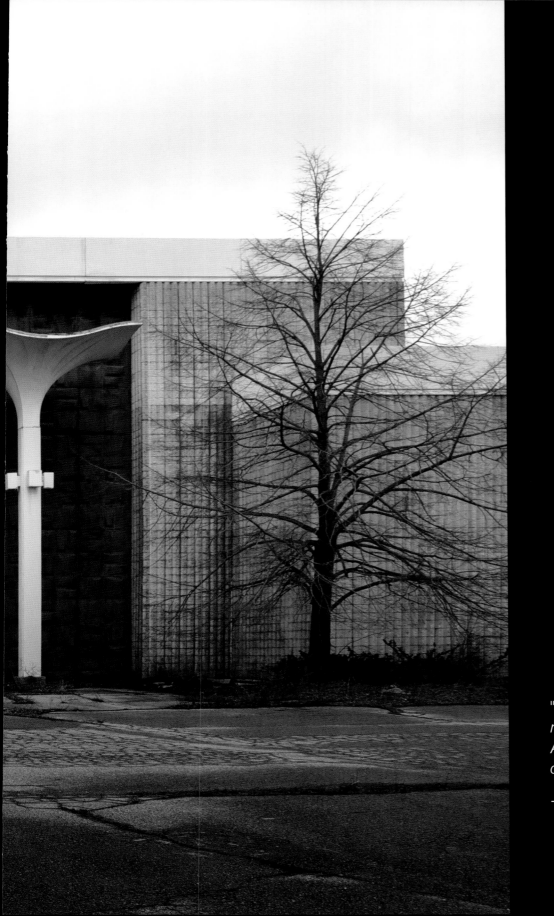

"*The wealthiest 20 percent of all Americans now control 84 percent of all the wealth in America. The upper 1% controls over 40% of the wealth in the U.S.*"

- Seph Lawless (CNN)

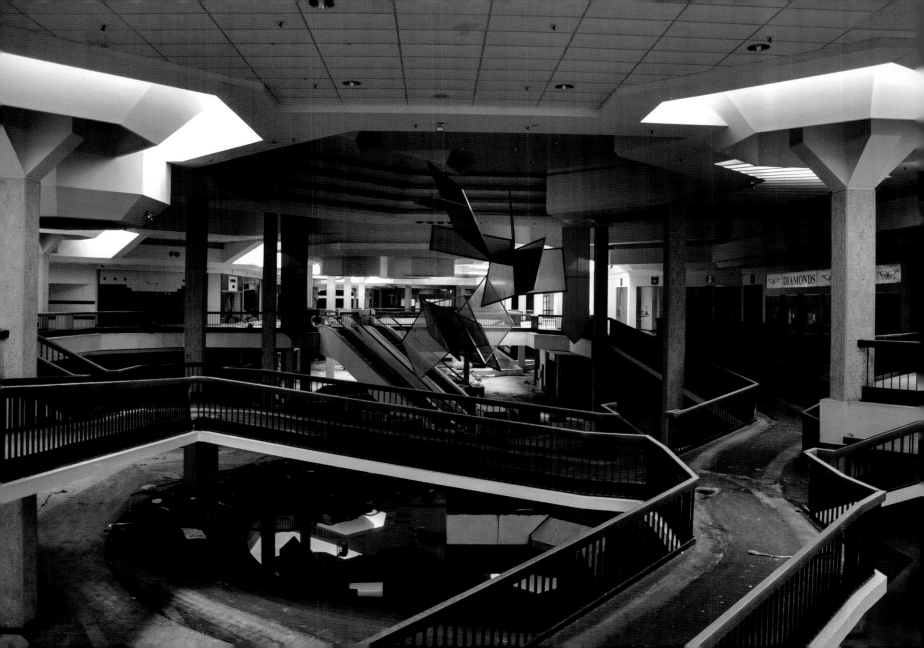

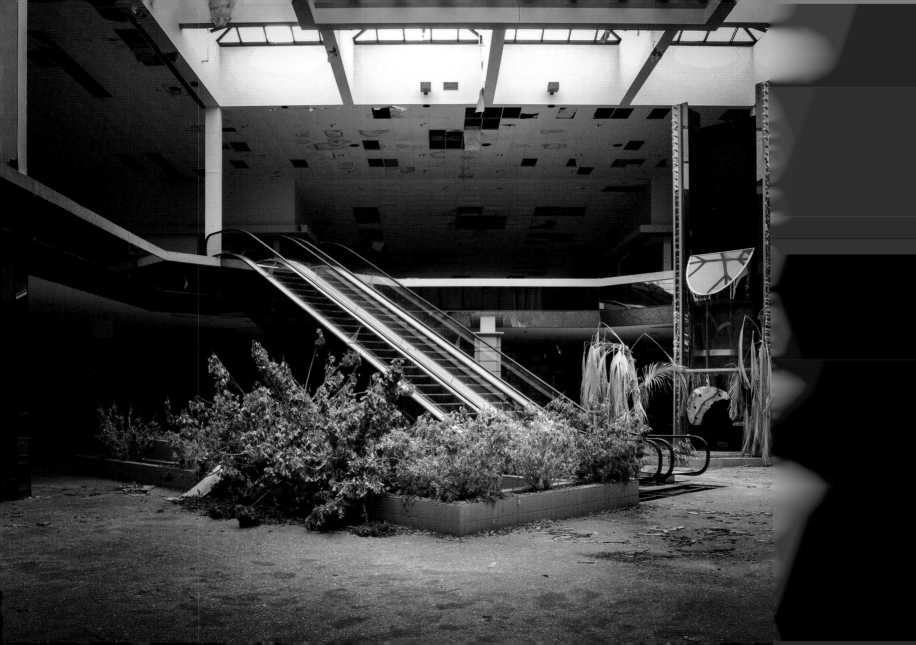

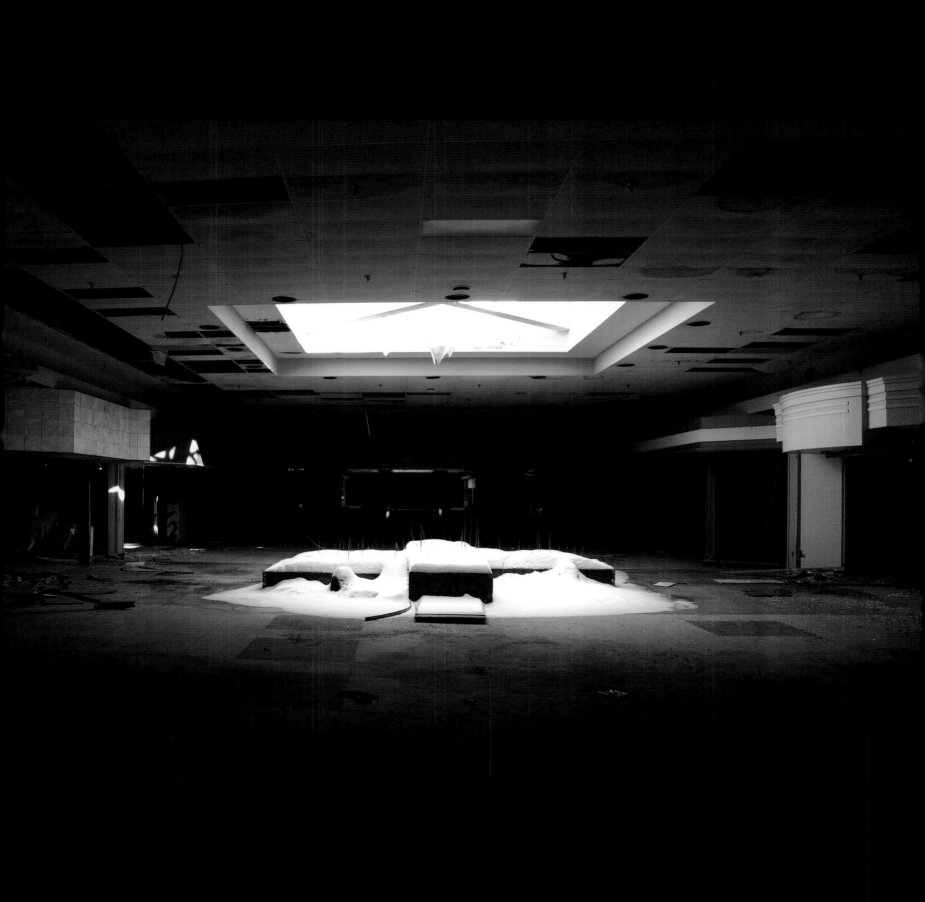

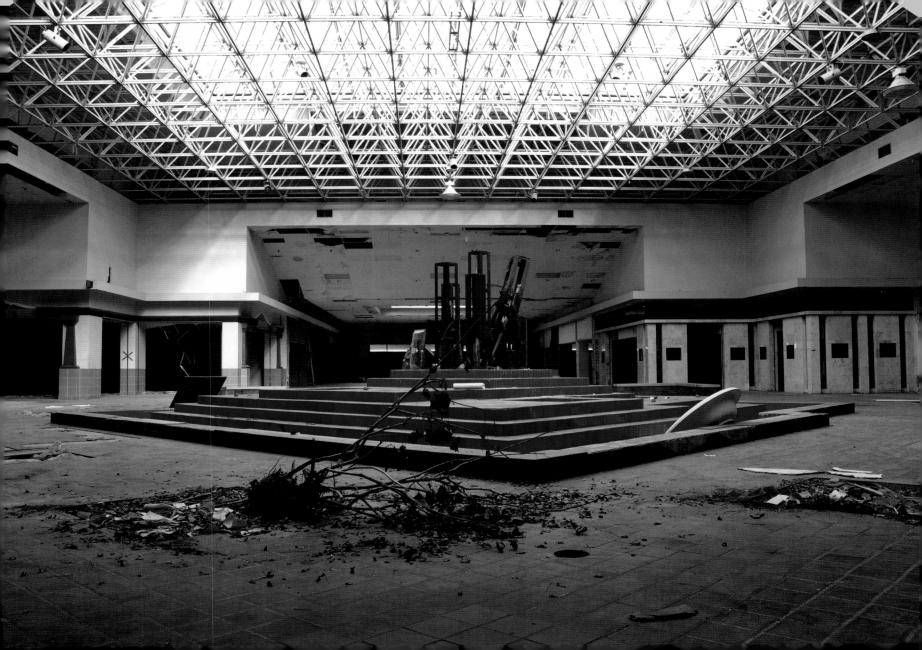

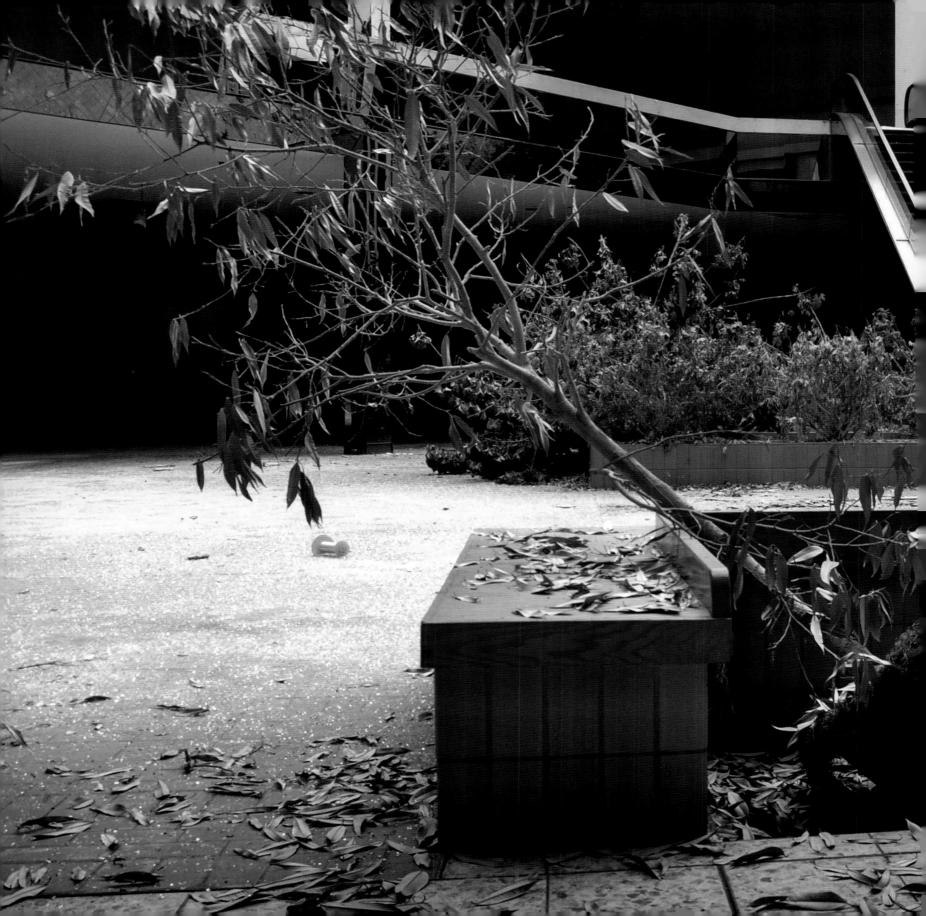

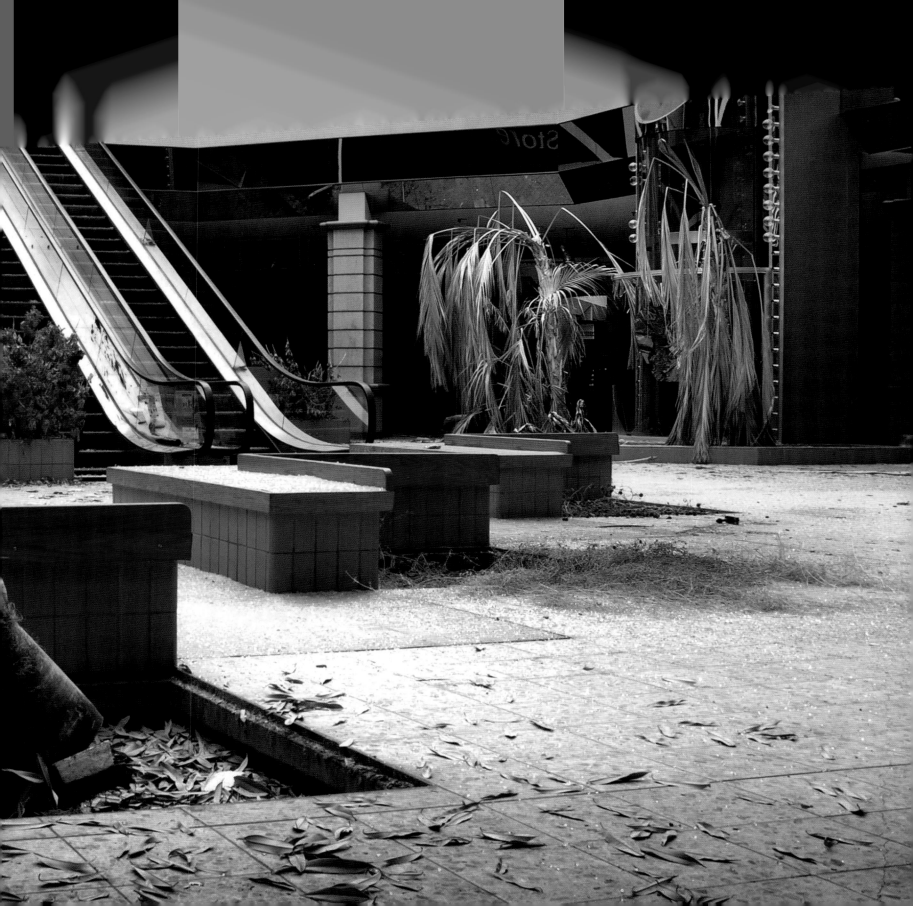

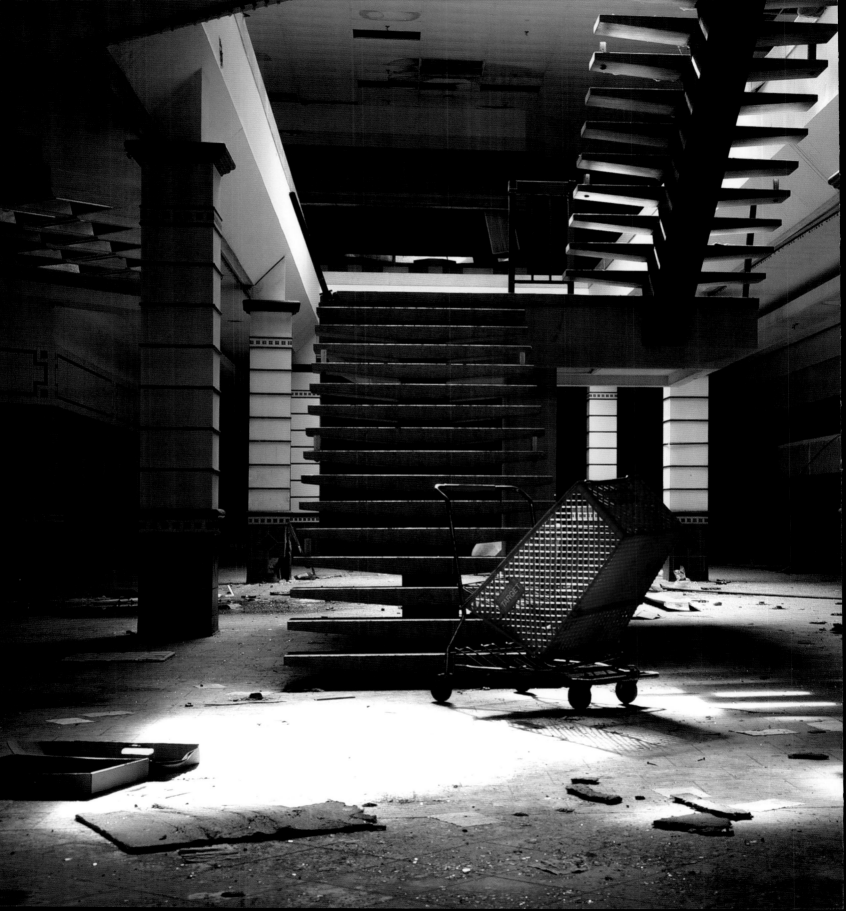

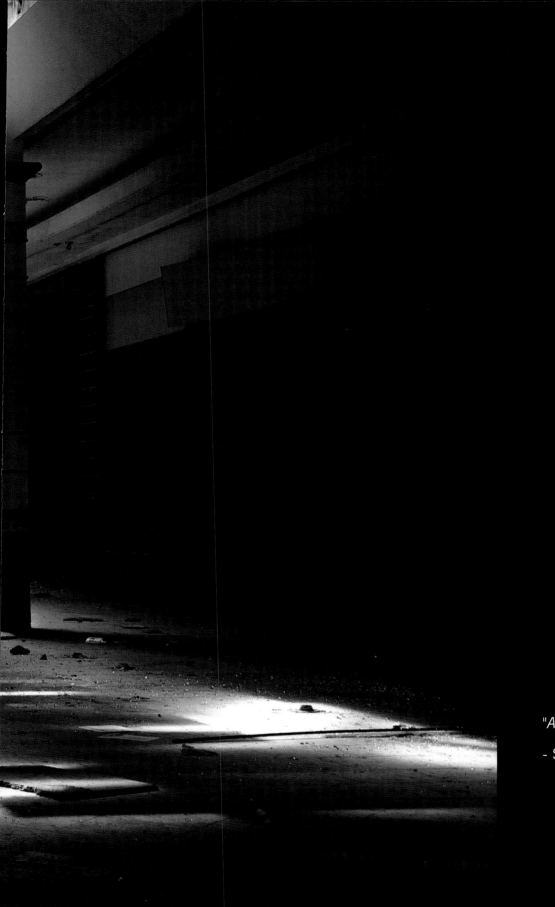

"*America is a gia*

- Seph Lawless

THE MOST TOXIC PLACE IN AMERICA

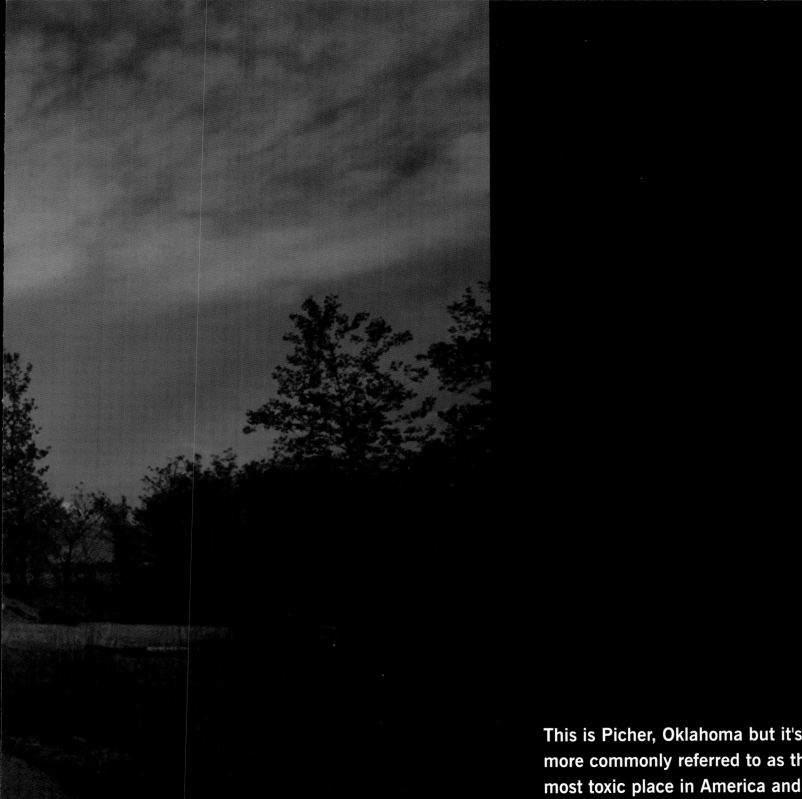

This is Picher, Oklahoma but it's
more commonly referred to as the
most toxic place in America and

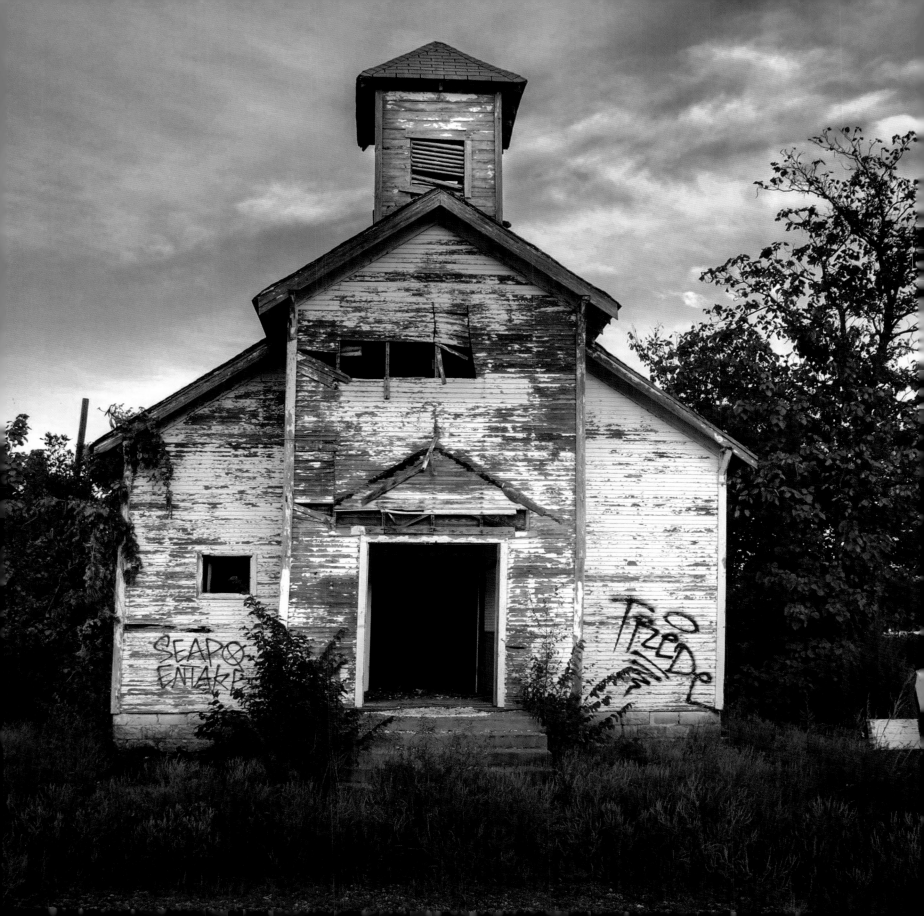

Picher officially stopped functioning as a city in 2009 after the U.S. Government labeled the city a superfund site after years of unrestricted mining resulted in environmental factors that caused high levels of lead in at least 34% of the children living there. That government study was conducted in 1996 and was prompted by a high school teacher that noticed several of her students having learning disabilities.

At one time this was a major national center of lead and zinc mining for the United States. To put that into perspective this area produced 20 Billion dollars worth of ore over the first half of the century, in fact over half of the lead and zinc metal used in WWI was was produced right here in Picher, Oklahoma.

Years later the same thing that once built this magnificent city would ultimately be the same thing that would destroy it and now it's a shell of its former self. An apocalyptic real-life ghost town that is an eerie reminder of what can happen when mankind doesn't respect Mother Nature and our environment.

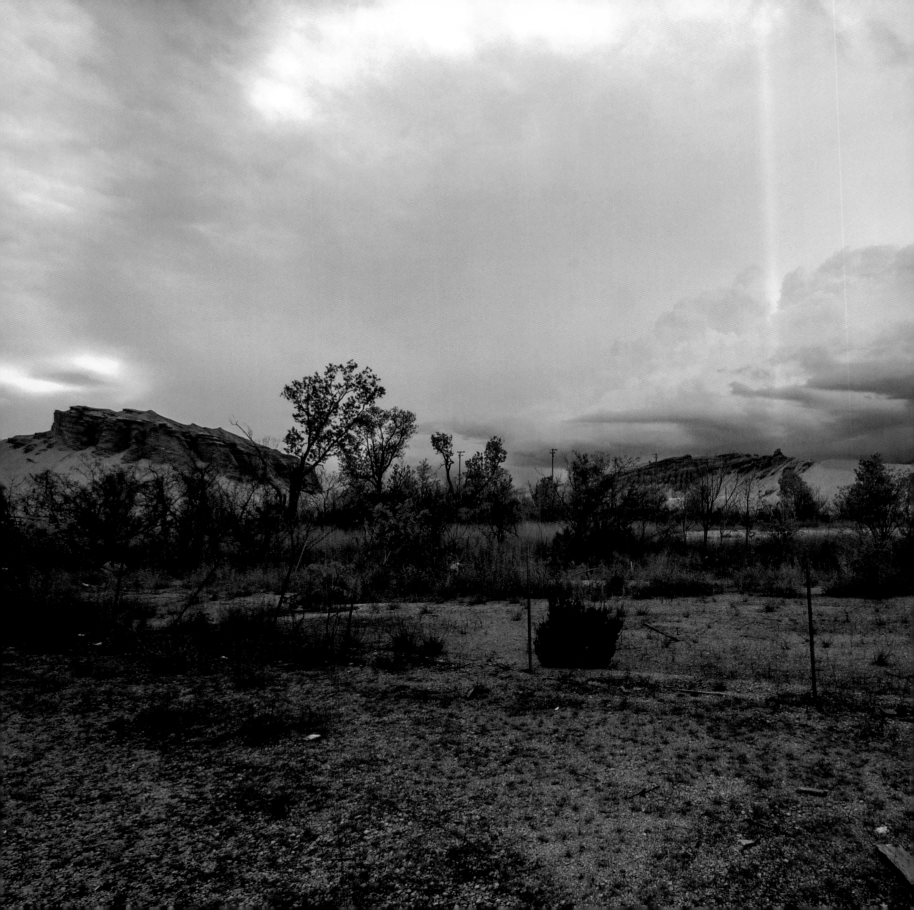

LAND WE RUINED AND MADE TOXIC

The years of mining in this area led to the discovery of the cave-in risks, sinkholes can happen at any given moment. Structures, even vehicles on the surface of this area, have been deemed in imminent danger of caving in.

That wasn't the only problem here. There is also groundwater contamination, and other health effects associated with the chat piles that resemble a cryptic moutain range that completely engulf the entire town that constantly looms over Picher. Itself hiding amongst the shadows of these formidable and toxic glaciers.

It wasn't long before the government and the Environment Protection Agency enforced a mandatory evacuation of the entire town. Residents were forced to leave their homes abruptly and by June 29, 2009, all of the residents had been given federal checks to enable them to relocate from Picher permanently. The city itself is considered to be too toxic to be habitable. On the last day all the final residents met at the high school auditorium to say goodbye to each other. At that time there was only six remaining residents.

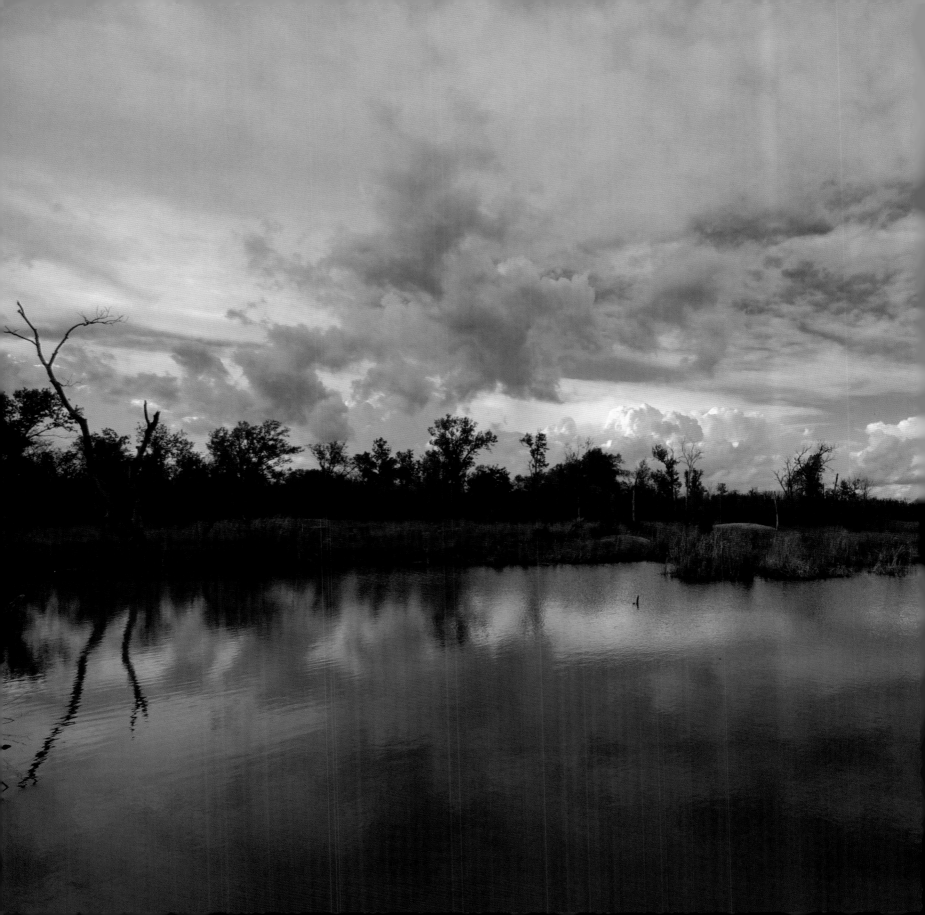

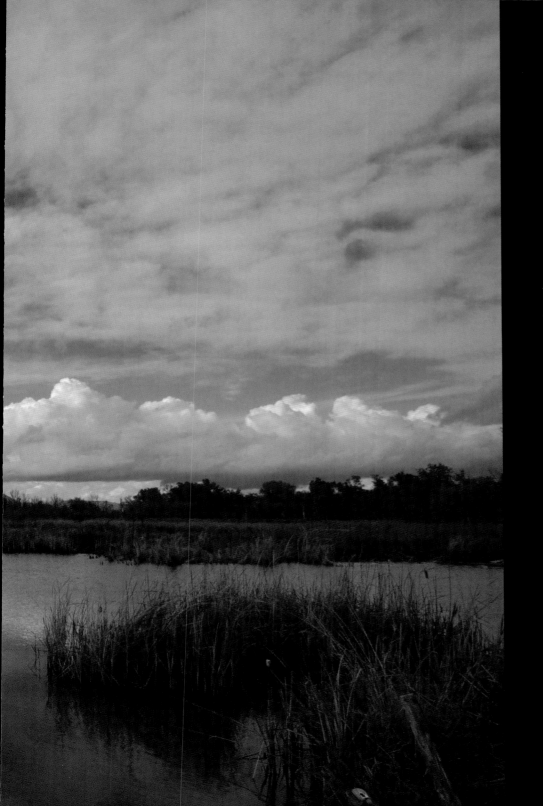

The very last man to leave was the towns
only business, a pharmacist named Gary
Linderman, who refused to leave the city
after everyone else did. He continued to
supply medicine for the surrounding cities
until he died of a mysterious illness. I spo
to Gary several times by phone and had
planned a visit to meet him for an intervie
but sadly he died just days before I arrive
there.

I walked through this apocalyptic ghost to
and I didn't see a single soul for miles. I
passed the abandoned homes where fami
once called home eerily hiding in the
shadows of the mountains of the gigantic
piles of chat that overlook the entire city.
became very angry that greed and capital
triumphed here over the respect for the
environment and the health of the people

Today, there is even talk that some state
government officials want to deal with thi
toxic town by simply returning the land as
back to the Native Americans in an effort
avoid having to pay for the clean up.

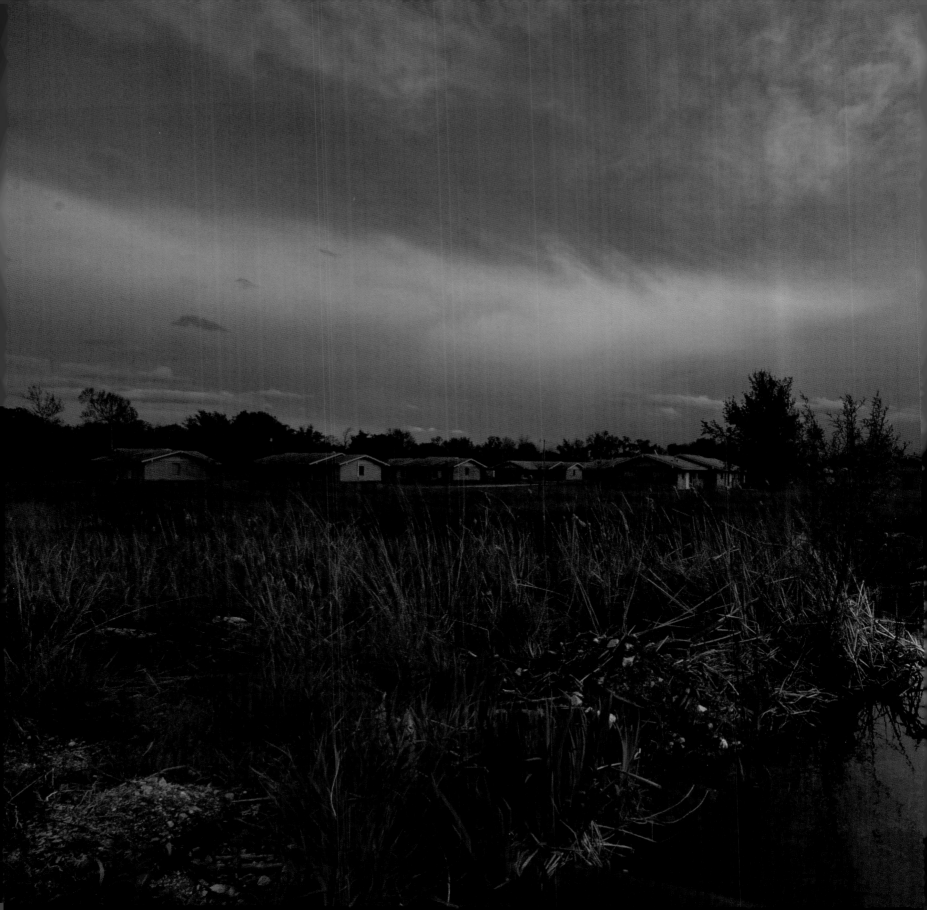

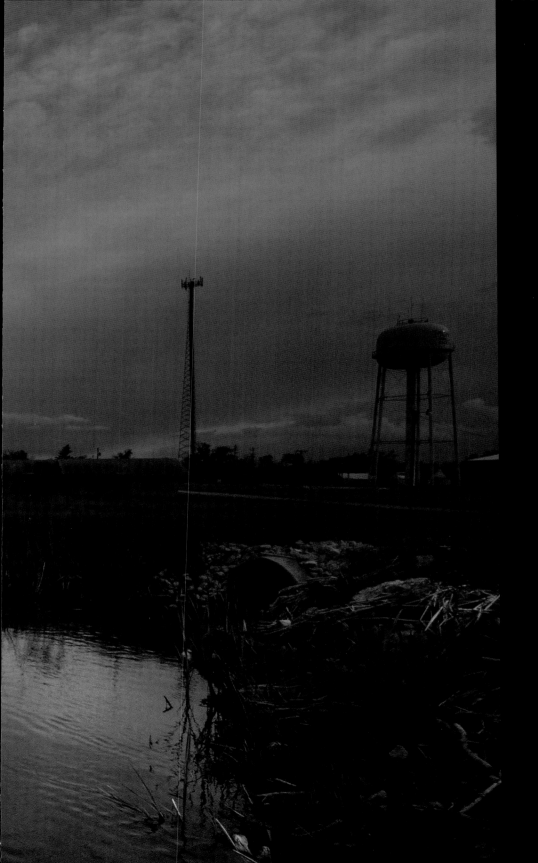

Irony does exist in American history and I can't think of anything more arrogant than for the white man to steal Native American Indian land then to cut open the land, take all the bad stuff out, put it on top for them then tell the Native Americans go ahead take the land we ruined and made toxic.

If that did happen it would be the second time in America history that the United States would commit genocide against the Native American people by allowing them move into a land that has toxic environmental conditions that would result the risk of lifelong neurological problems a even death of the Native American People.

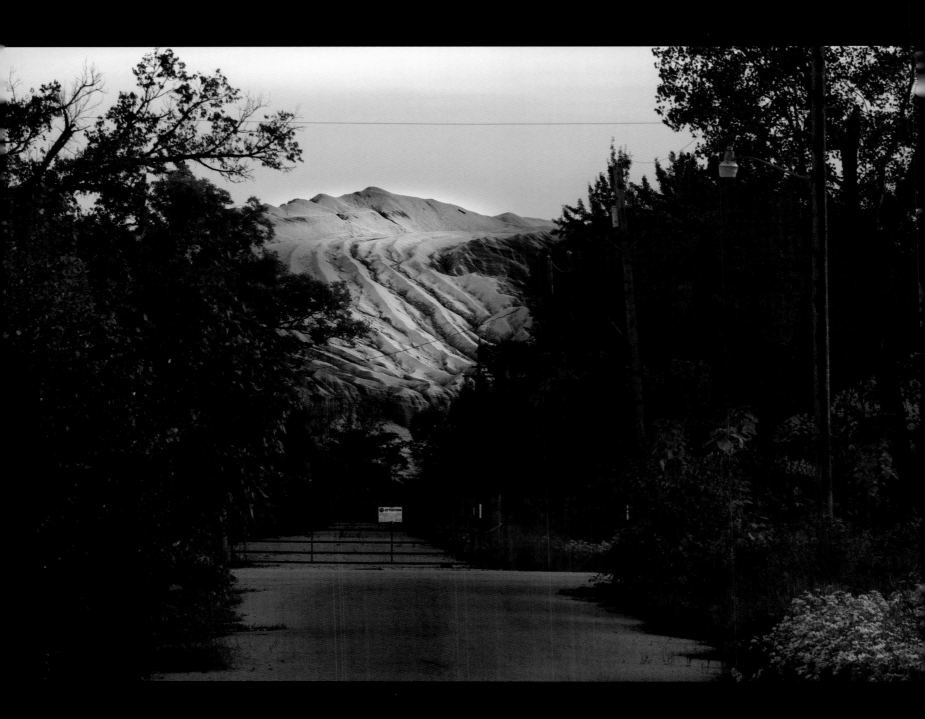

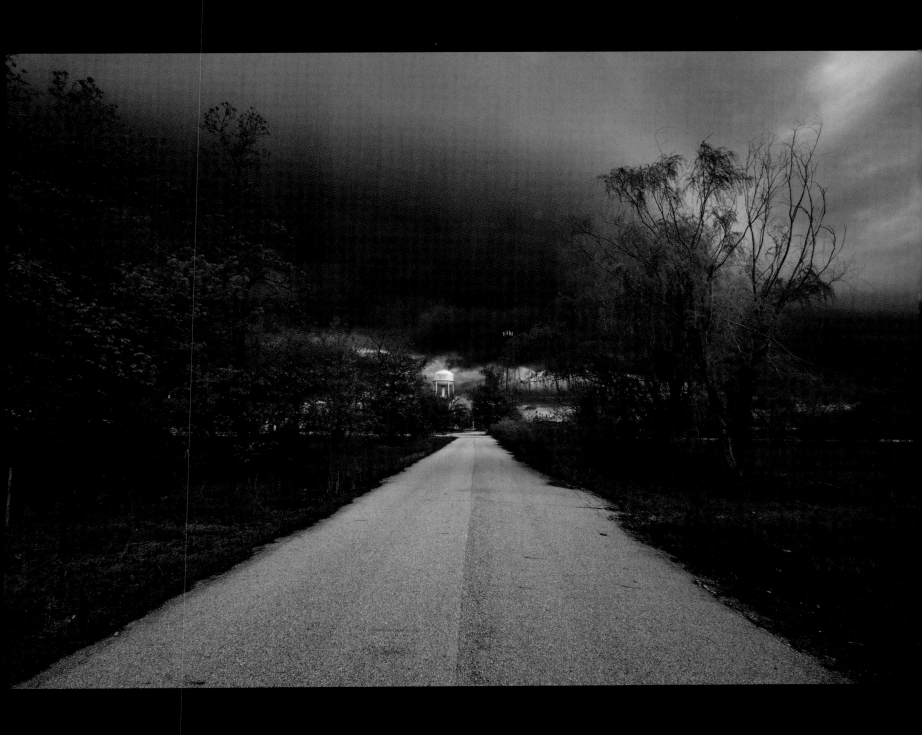

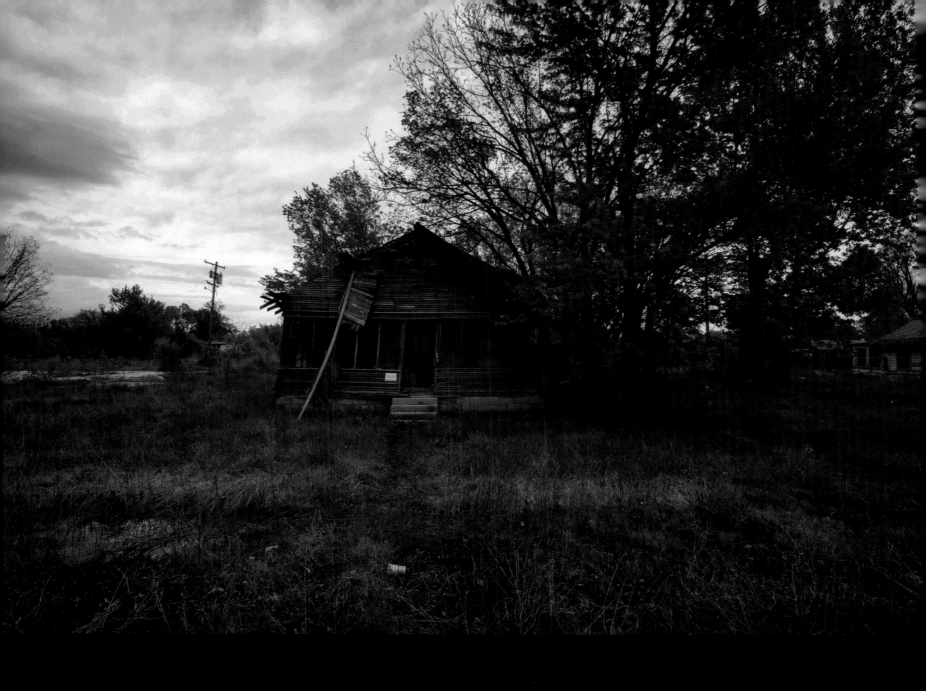

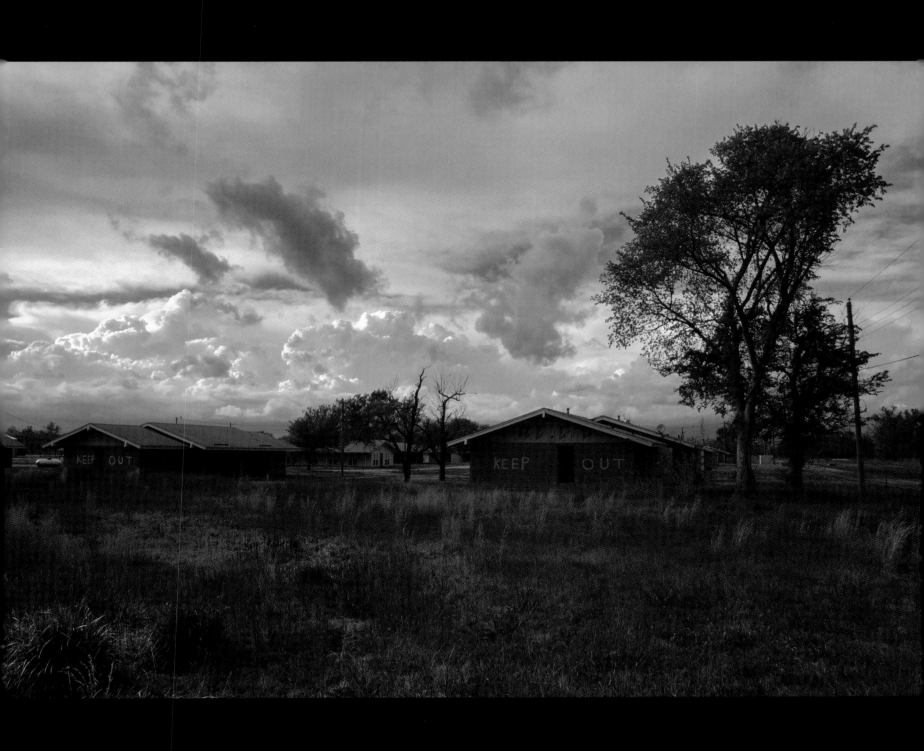

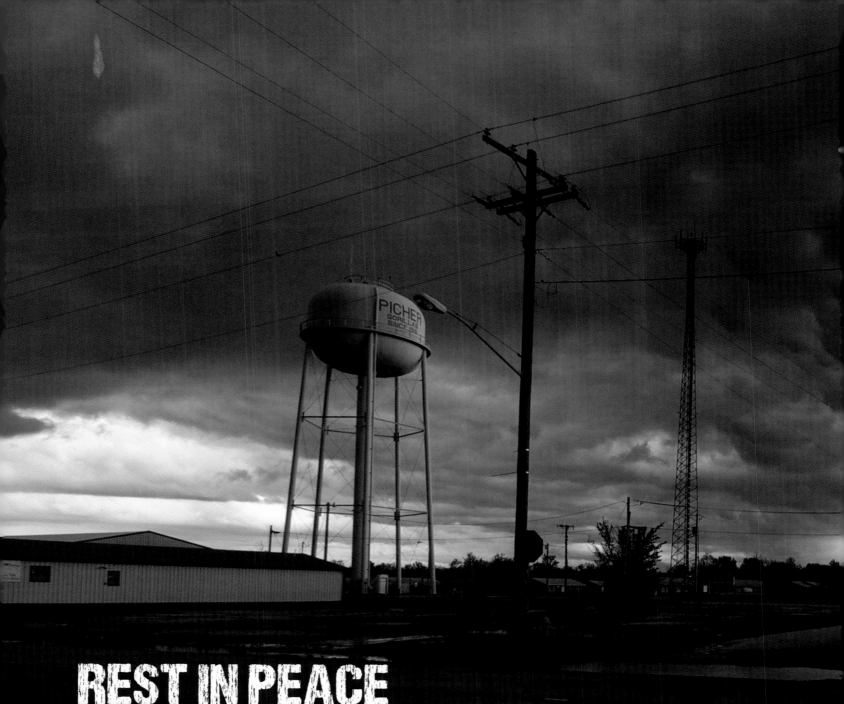

REST IN PEACE
PICHER

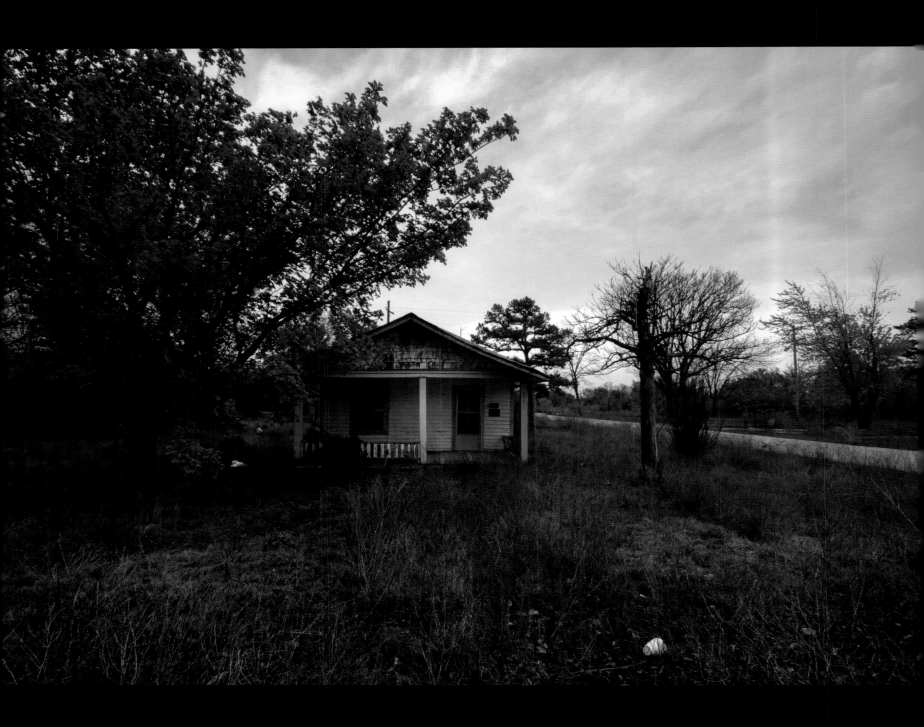

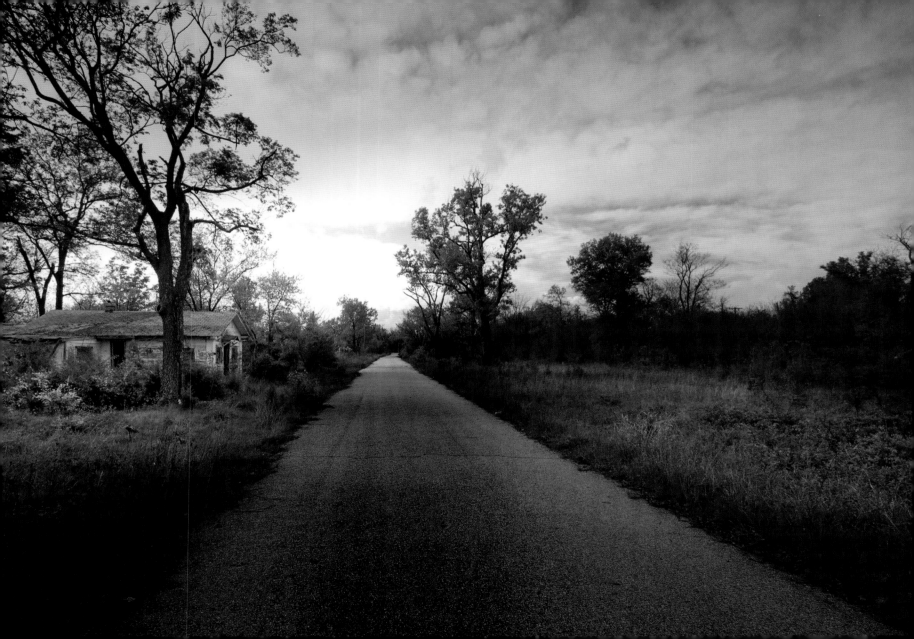

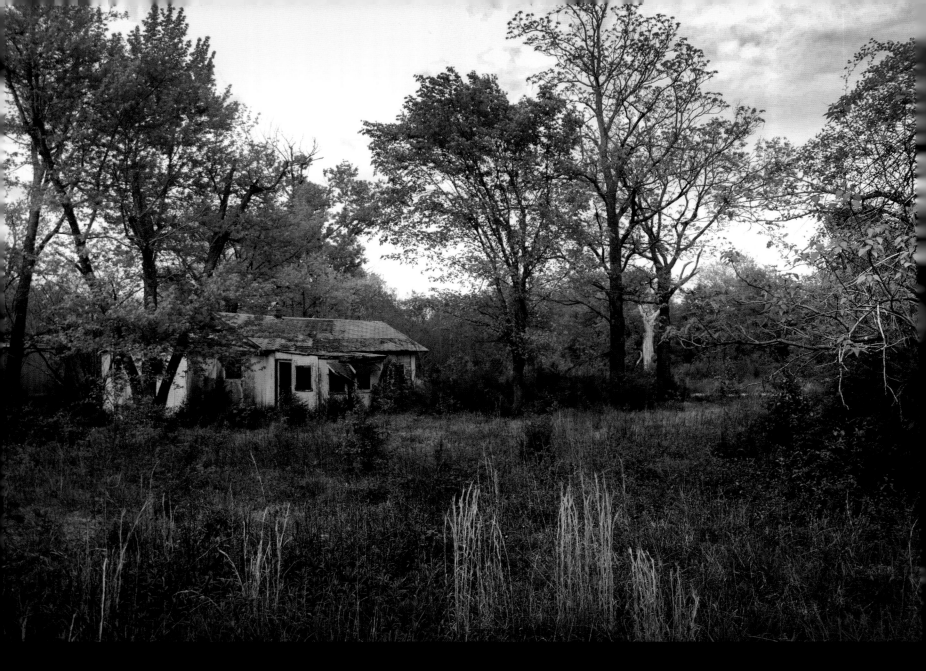

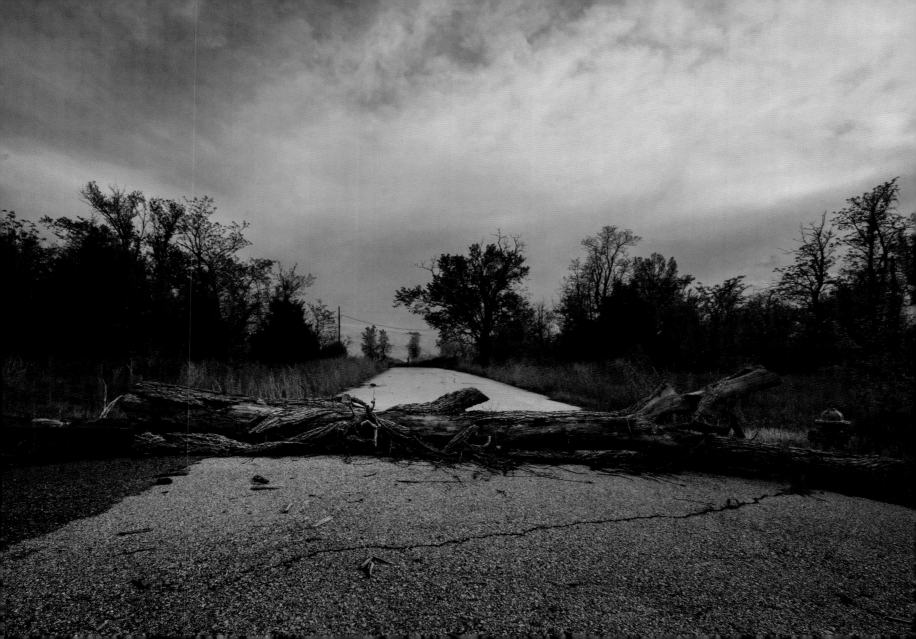

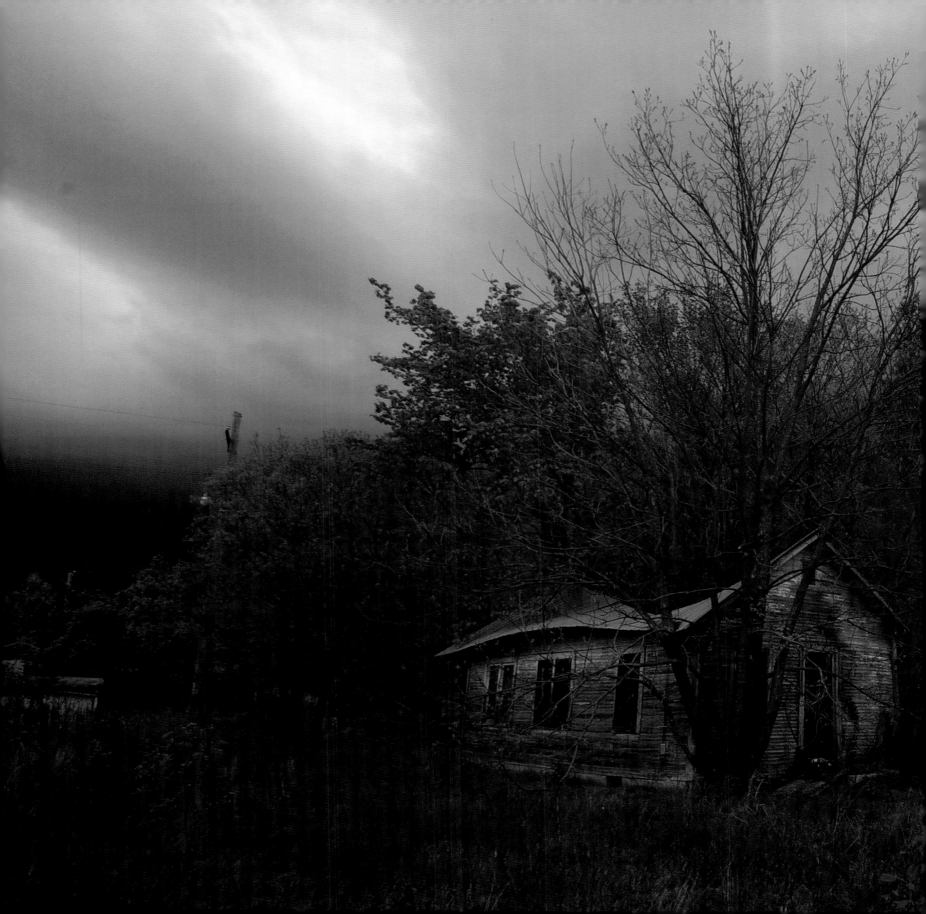

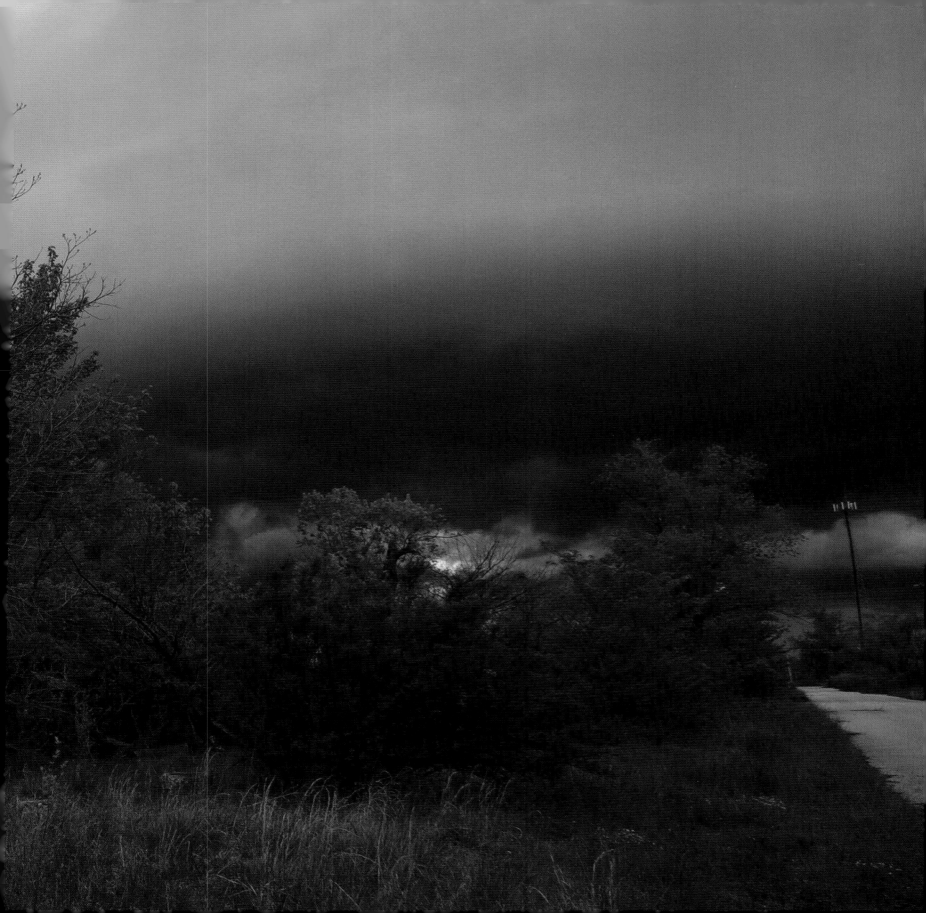

Just like many of the asylums of the time, it became abhorrently overcrowded soon after opening. Designed to house some 250 patients even though 713 patients were registered living there by 1880 and things only got worse. By 1938, there were 1,891 registered residents and by 1949 the asylum was home to over 2,800 people. One of its most famous patients being Charles Manson.

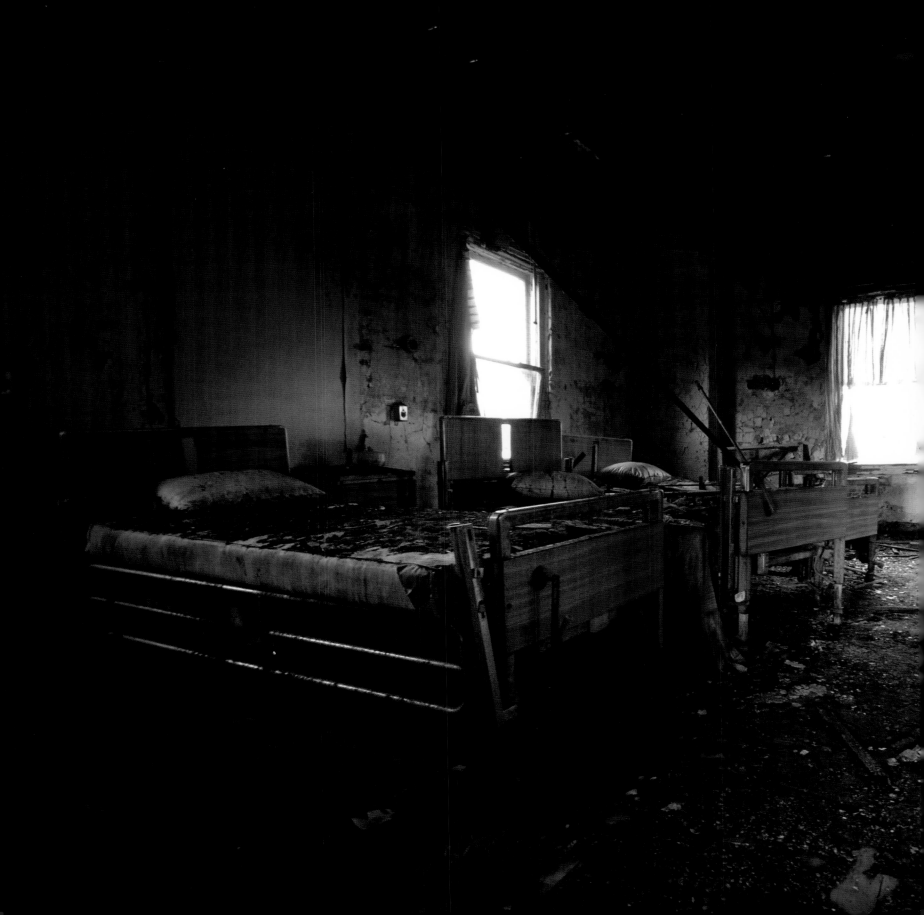

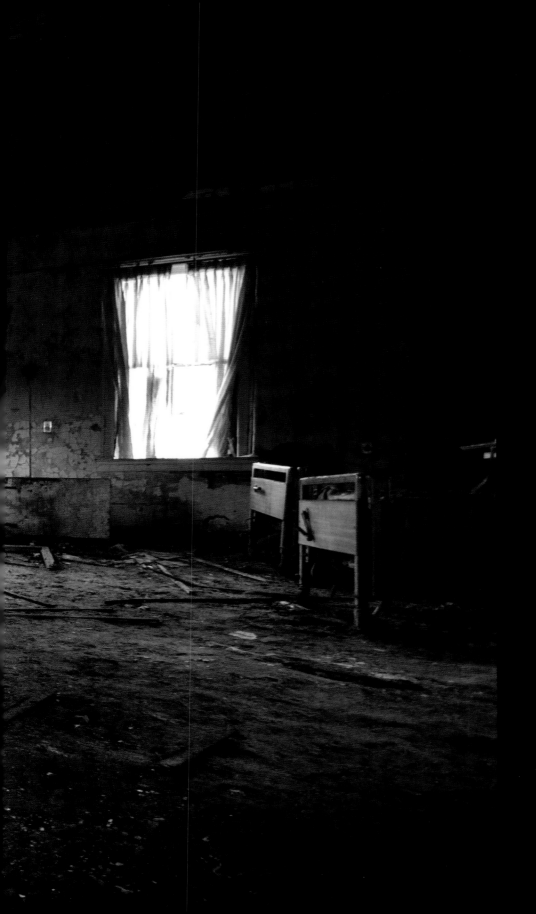

The staff had been terribly overworked but the administration wasn't innocent either. Several documented acts of torture by the wardens read like a horror movie. Rudimentary full frontal lobotomies were regularly performed using ice picks.

Patients were placed in solitary confinement for weeks upon weeks and vicious inmates were left to terrorize other patients.

Tens of thousands died over the years. Many from unnatural causes only to be buried in the mass graves which can be seen from the broken windows that overlook the hospital's cemetery.

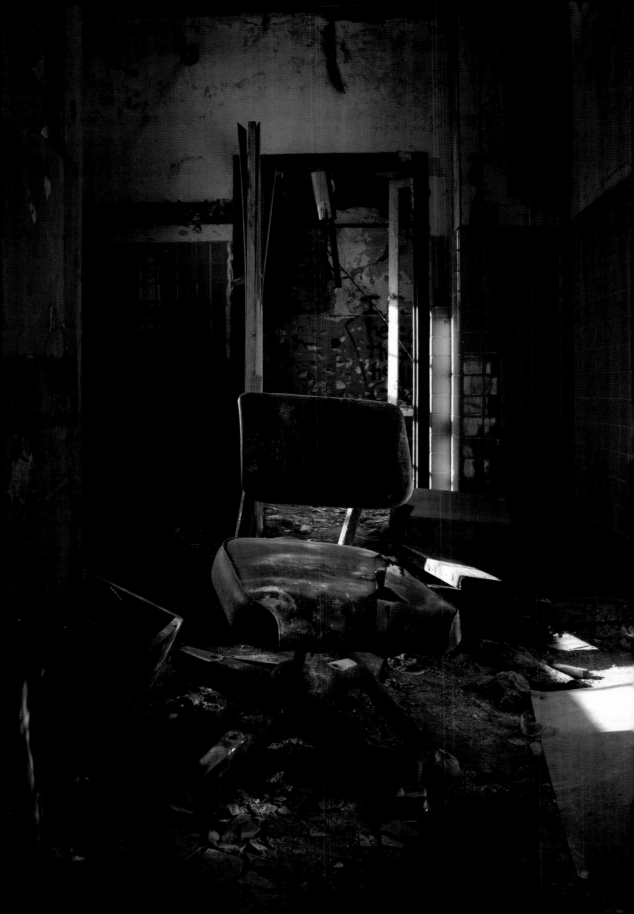

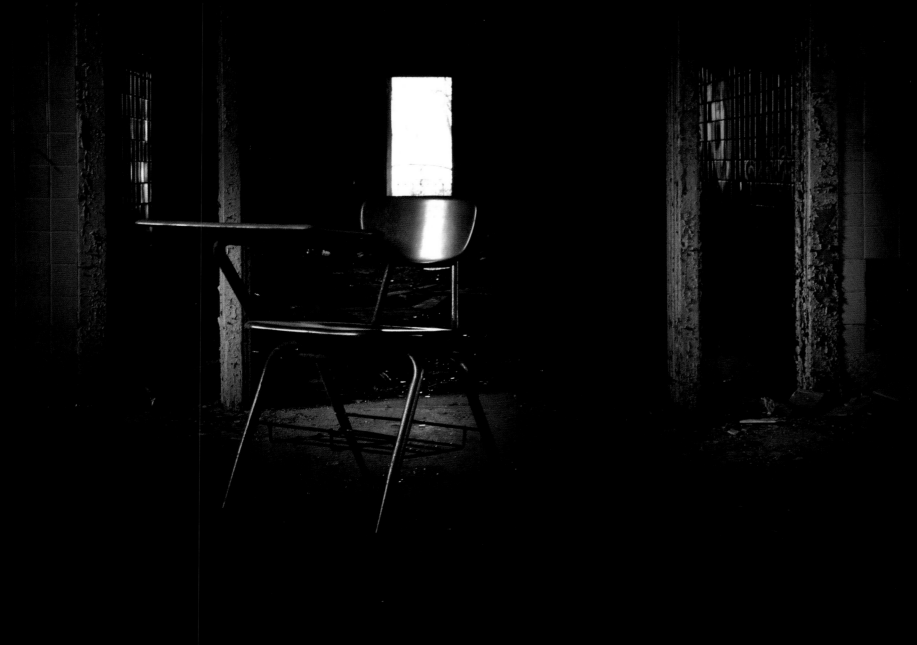

"I used to visit nursing homes when I was younger. Not because I knew anyone there. I only did it so I could walk outside and appreciate my life a little better. The fact that I was walking, even breathing on my own was enough to make me feel incredibly grateful, but it was the fact that I still had my mind and wits about me that was really exciting, almost overwhelming."

- Seph Lawless

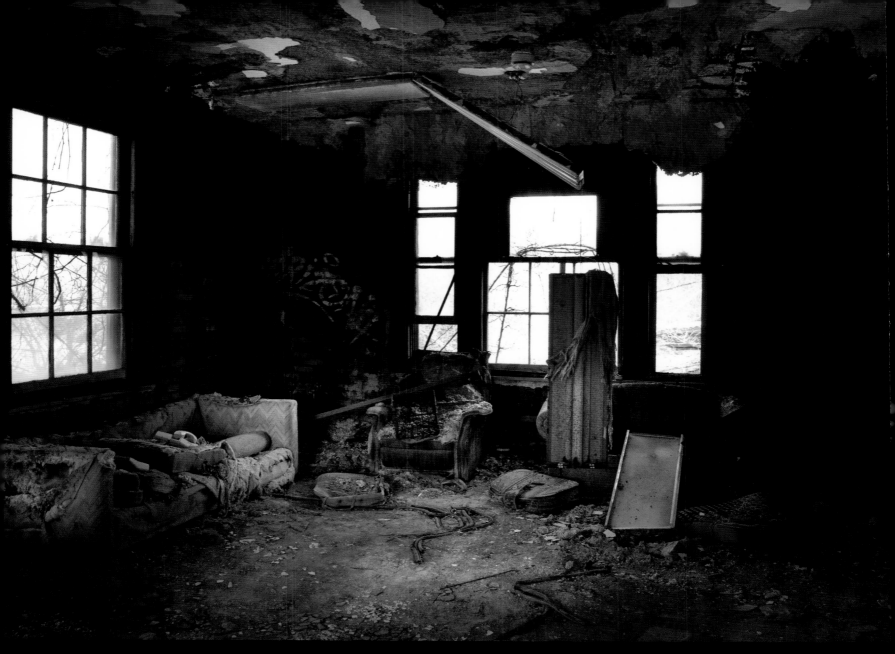

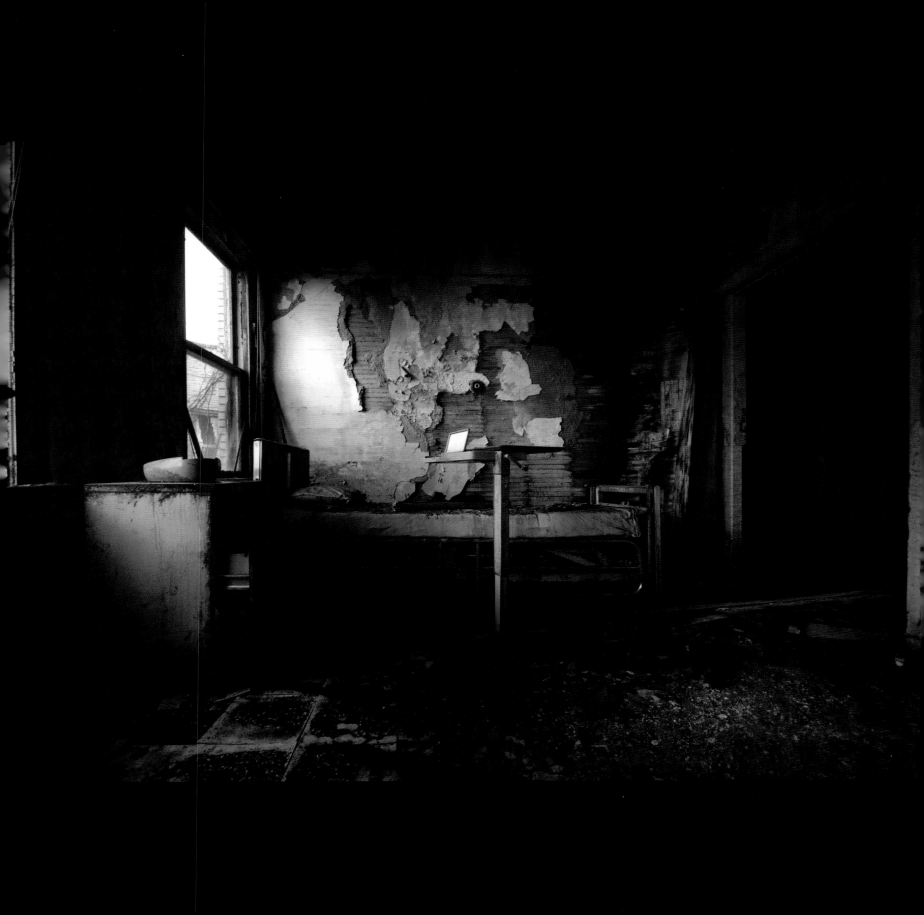

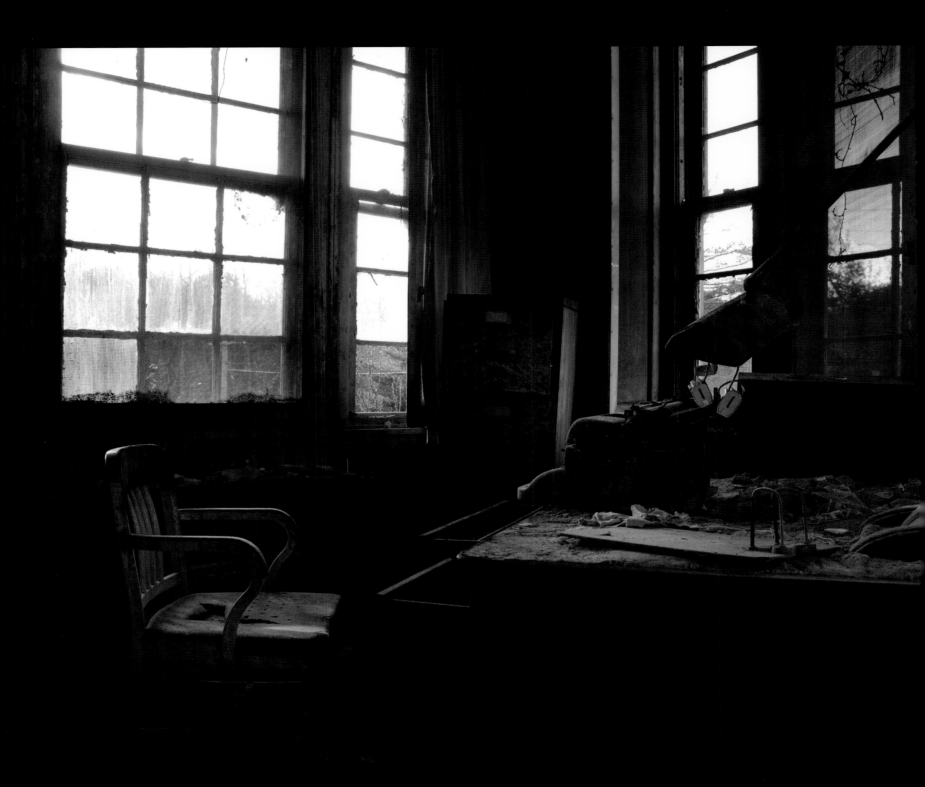

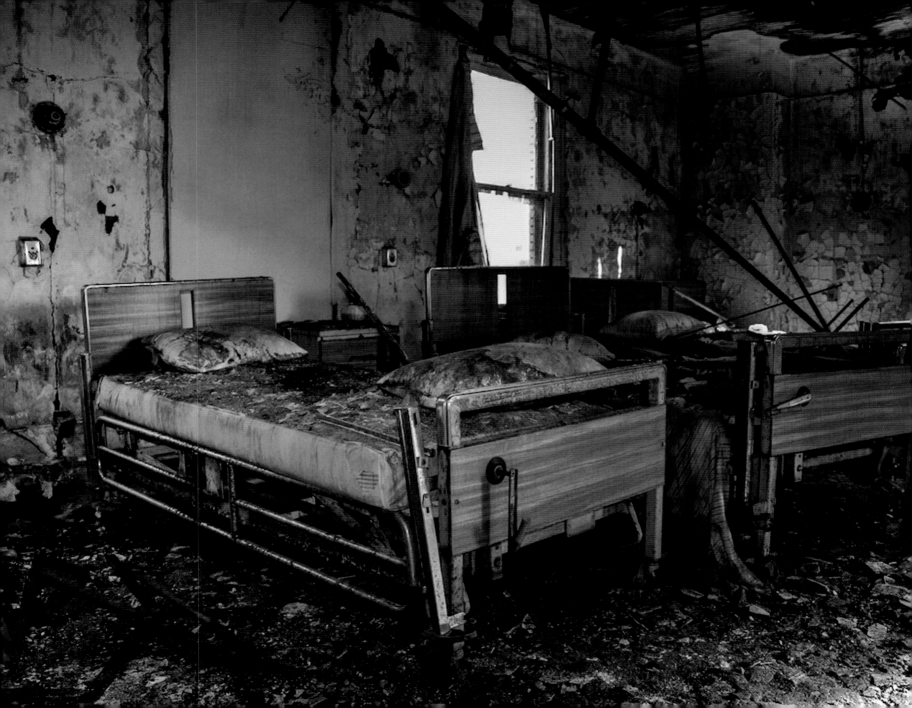

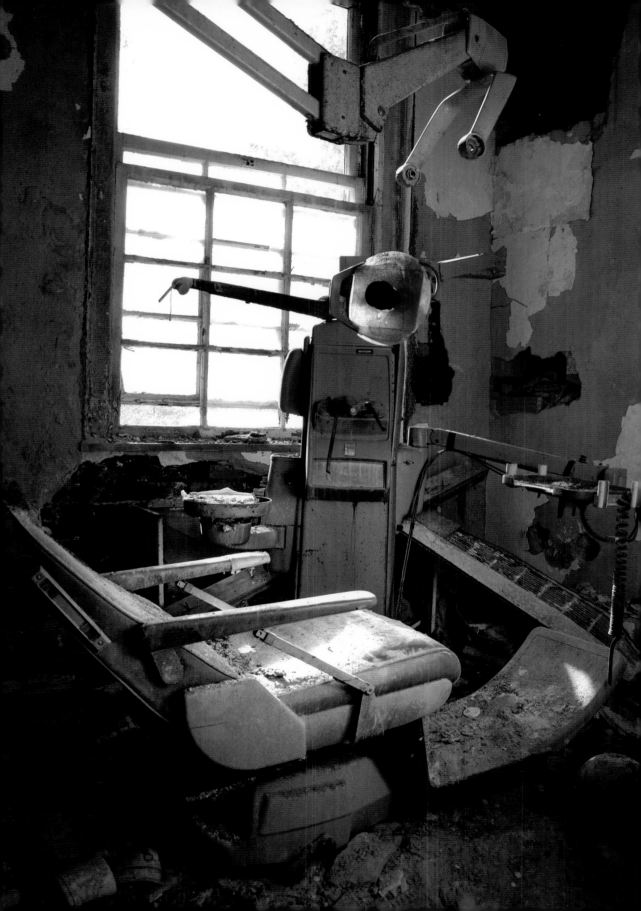

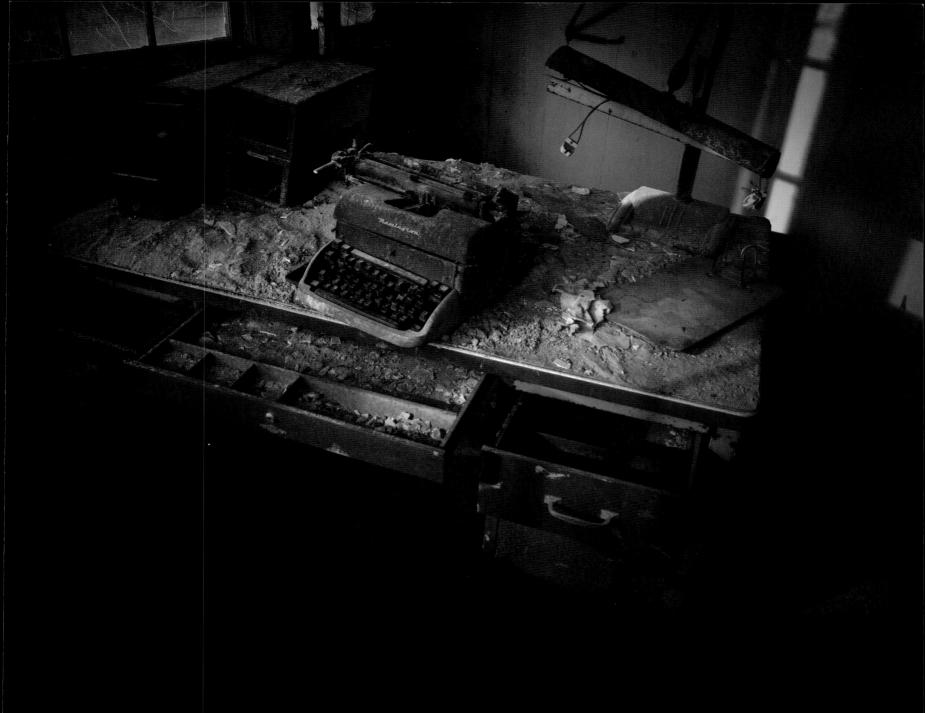

"*Most Americans never read a book after they graduate high school, so I came out with a photo book.*"

- Seph Lawless (ABC NEWS)

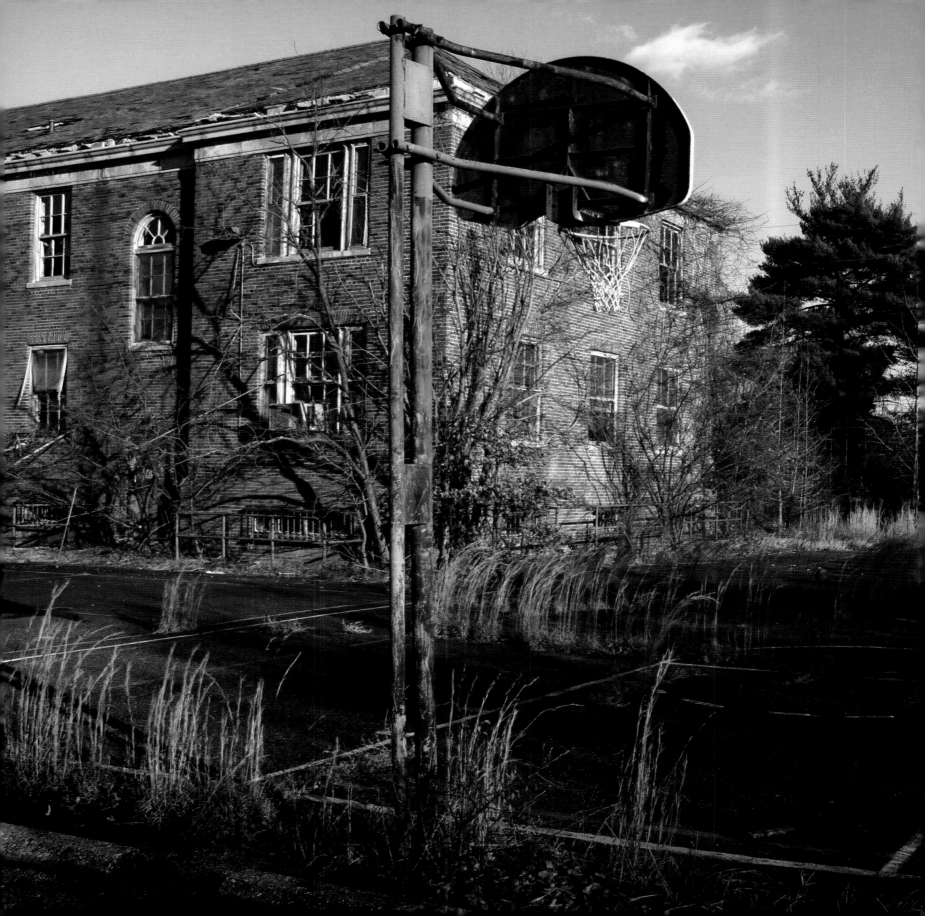

AN AMERICAN HORROR
STORY

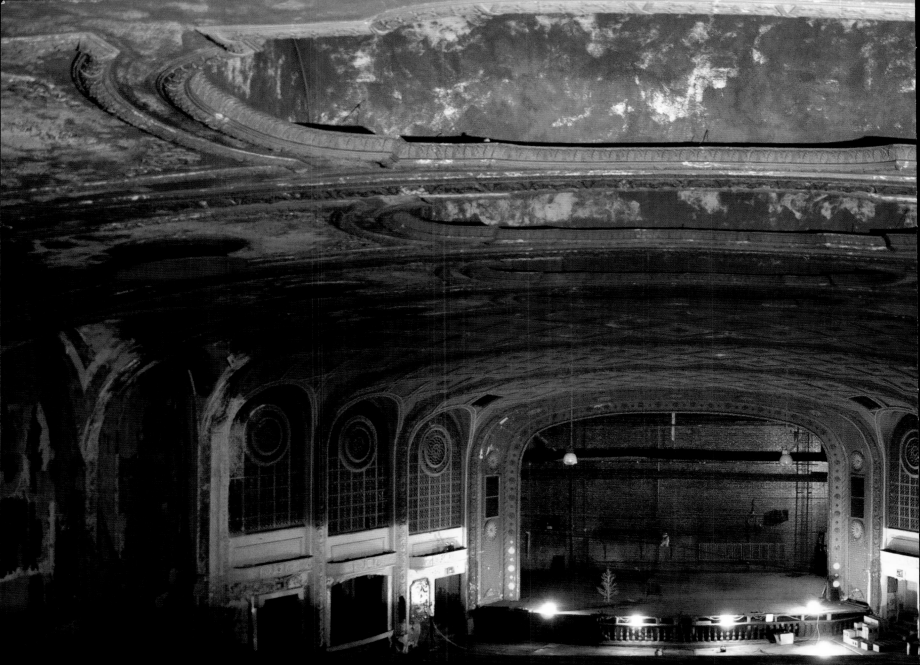

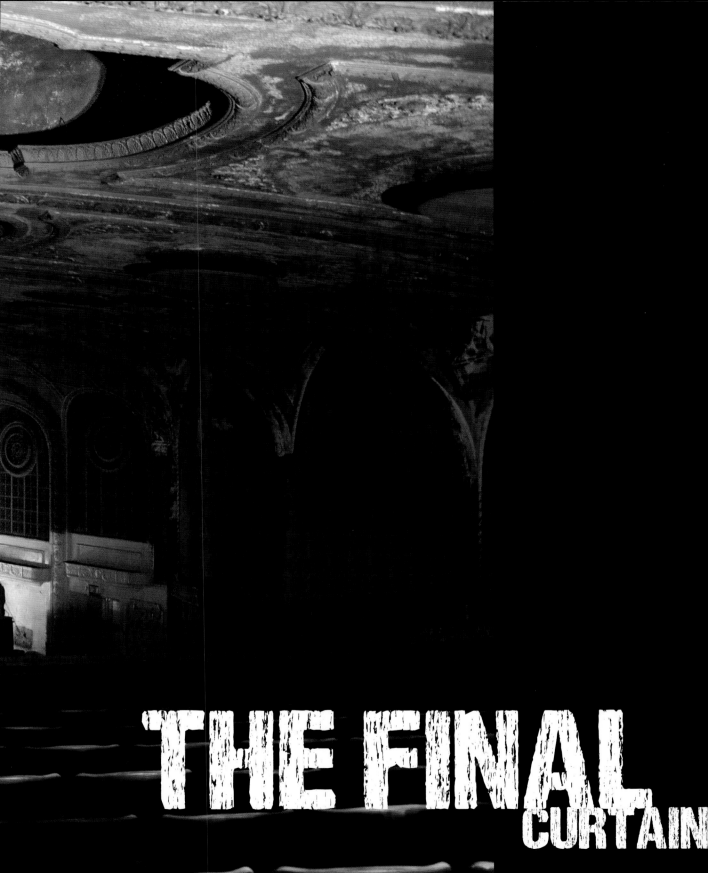

THE FINAL
CURTAIN

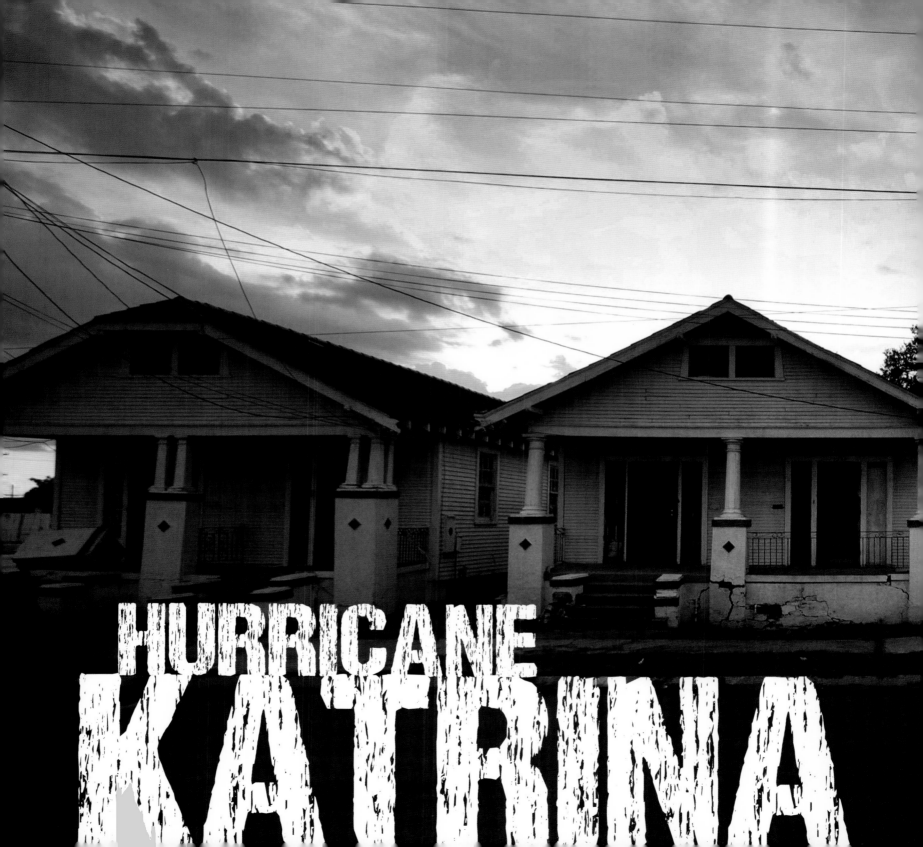

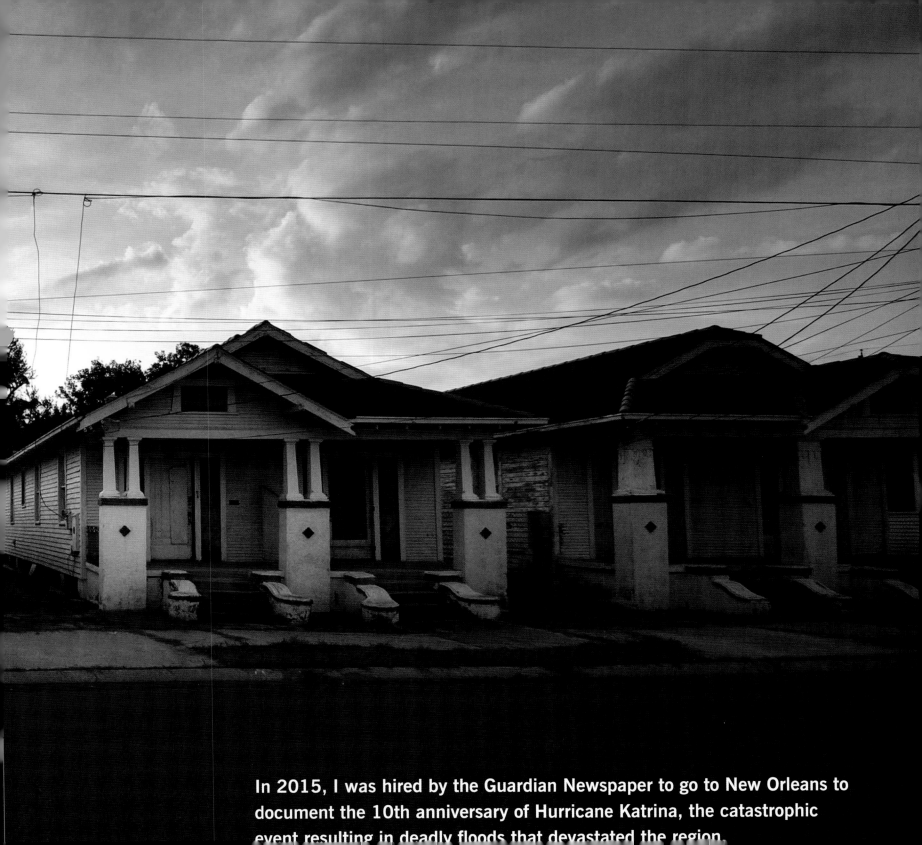

In 2015, I was hired by the Guardian Newspaper to go to New Orleans to document the 10th anniversary of Hurricane Katrina, the catastrophic event resulting in deadly floods that devastated the region.

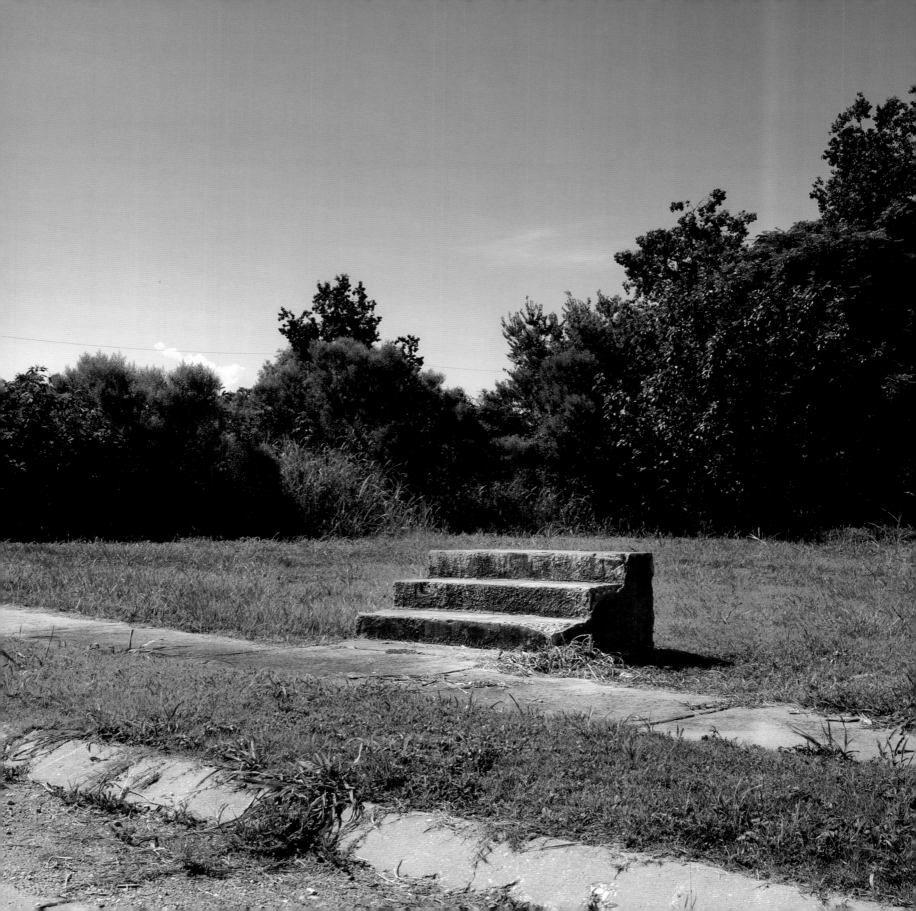

It wasn't just the insurmountable level of destruction and loss of life that made this event such a tragic global story. America's lack of preparedness to deal with the tragedy, at both the state and federal level, tarnished the United States' reputation, appearing frail and vulnerable.

Surprisingly, even after a decade, much of New Orleans was still in ruins.

I met several people during my time in New Orleans. People who survived the flood recounted that fateful day for me, sharing their horror stories along with their memories. One women shared with me the haunting tale of initially facing the floodwaters with her husband, who eventually was able to swim to a neighbor's house to retrieve their small boat. They were able to get inside and immediately tried finding others as dead bodies filled the flooded waters around them. Overwhelmed with grief and the inability to help, the woman went into a state of shock. At the end of the interview, she told me she still has reoccurring nightmares from that day.

Another man shared with me a story of being forced by the National Guard troops into a large sporting arena called the Superdome, which was utilized as a makeshift FEMA shelter by the U.S. government. The man recounted the horrors that took place inside the Superdome, horrors that deeply affected him. He shared with me the fact that survivors couldn't leave and were kept inside the stadium by armed guards. Food was scarce and women and children were fed first, leaving most of the men hungry and increasingly violent. The smell of urine and faeces overwhelmed the large venue. Some people even committed suicide by jumping from high levels of stadium seating to the ground floor.

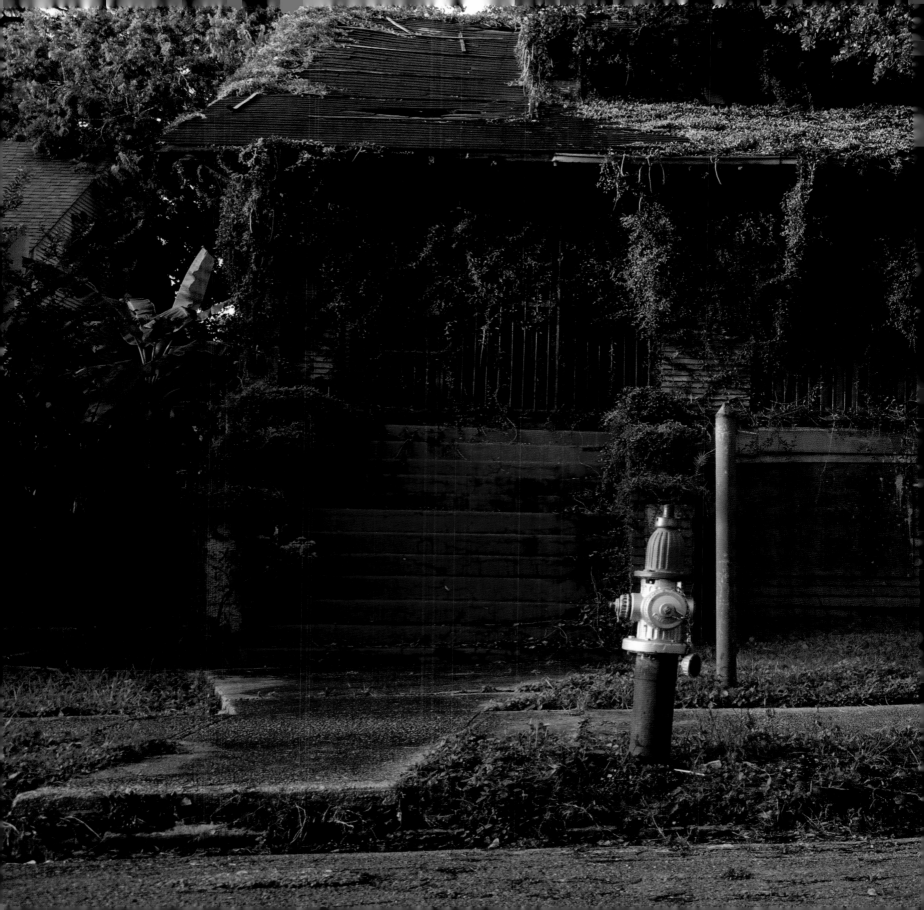

The people I was meeting all had a few things in common. They were poor, they were African American, and they were largely neglected by most Americans. New Orleans, like some other major metropolitan cities in the United Sates, has a long history of segregation that has affected the region dramatically.

The rift between white and black in New Orleans got even worse after Hurricane Katrina.

The lower ninth ward used to be home to the largest number of African American homeowners in the city and was one of the areas most affected by the flood. As I walked around the lower ninth ward of New Orleans, there was a deep, luminous void that you couldn't escape, even if you wanted to. Empty fields lay where houses used to stand. Concrete steps, seemingly out of place, rose out of grassy fields, steps that once led into someone's house, a house that was abruptly washed away into the sea. One street was lined with house after abandoned house, spray painted with symbols on the doors by early FEMA rescuers, indicating how many dead bodies they'd found inside. The imagery was so overwhelming at times that I broke down as I documented this morbid and poignant chapter of America's past.

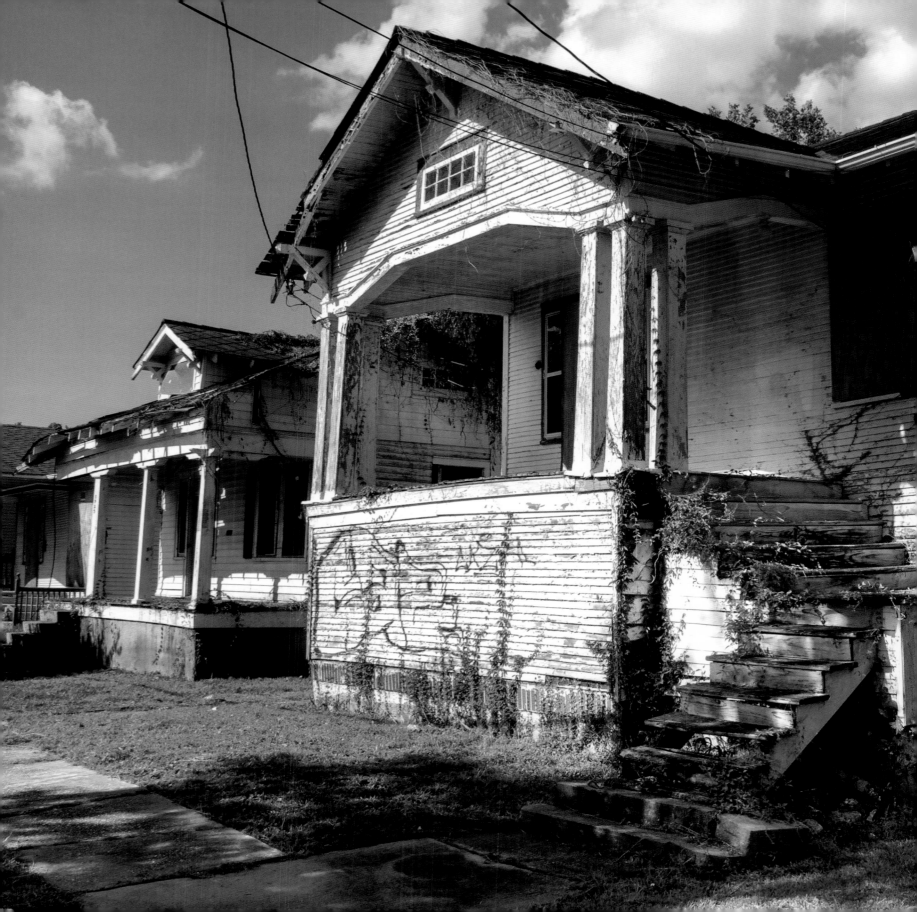

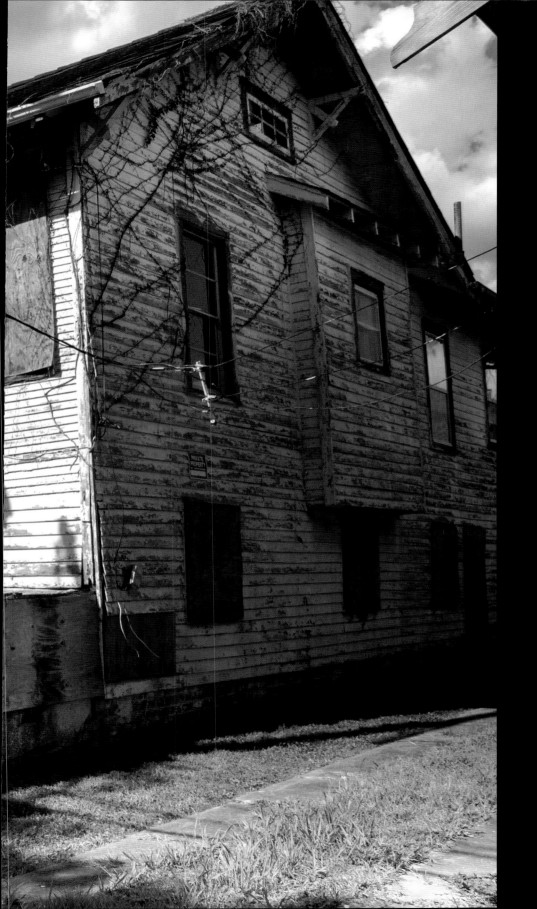

"*Some things are better left unsaid...tha*
why I started taking photographs."

- Seph Lawless (BBC NEWS)

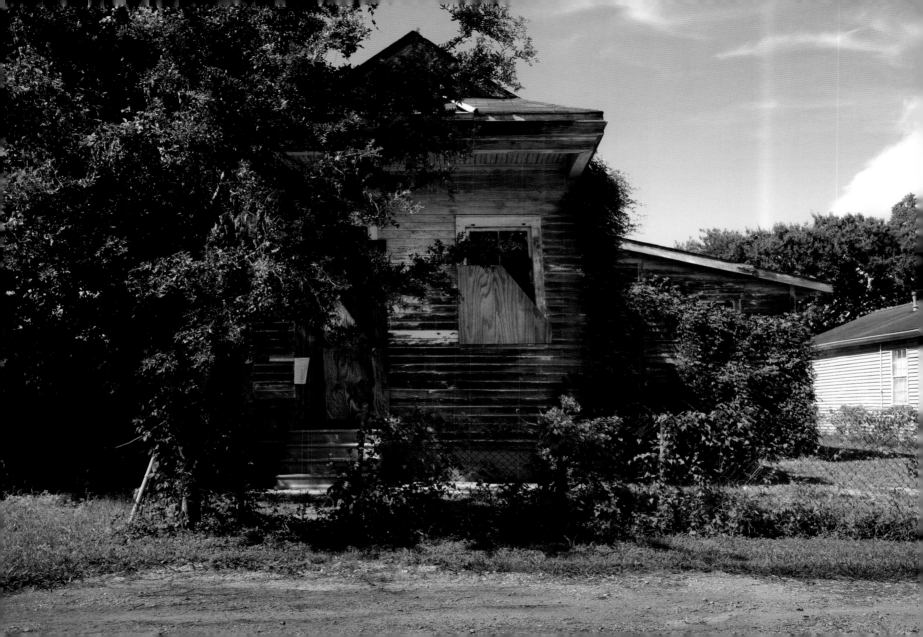

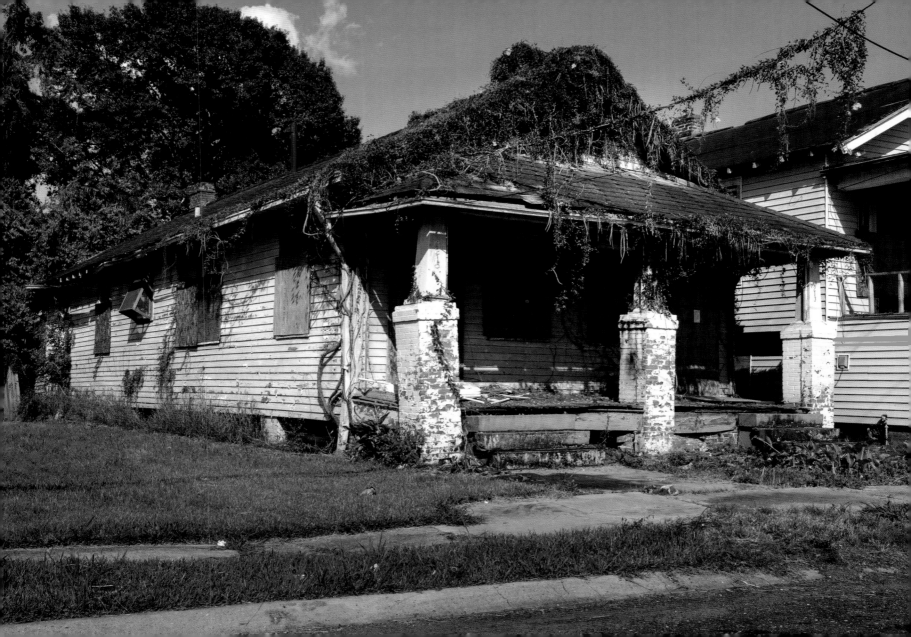

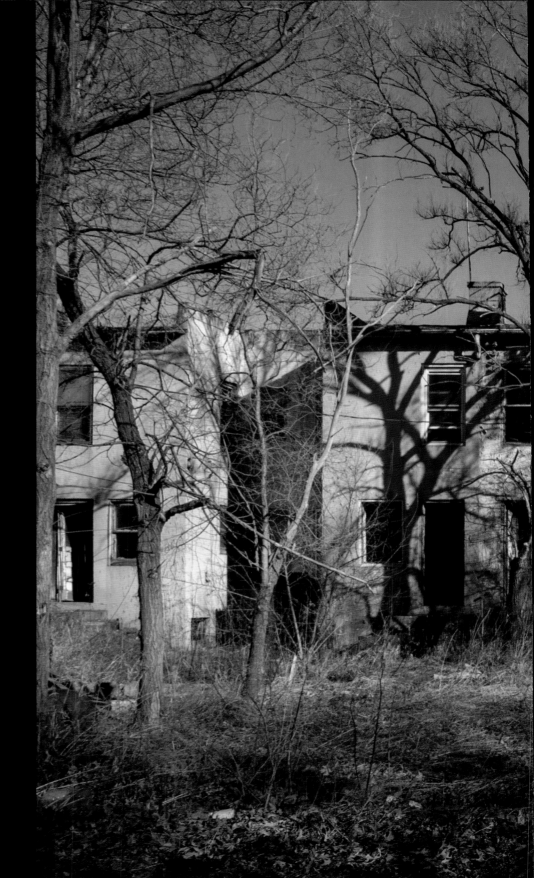

he has been spending in
depressing spaces the past few
king a toll on him. "I was so
lly drained I became very
country, I became bitter,"
d. "I said something to the
n not proud to be an American.
show how (messed) up my
ly is." He backpedaled and
at he loves his country but isn't
d of what it does. He's also
arians on social media for
most Americans don't read a
ollege. He even got a divided
a post about how beautiful
uring his trip here. "Whoever
as nothing in Kansas wasn't
enough," Lawless said about
s. "People just say there is
e, and it's flat, it's such a
t's such a beautiful place."

a Eagle Newspaper

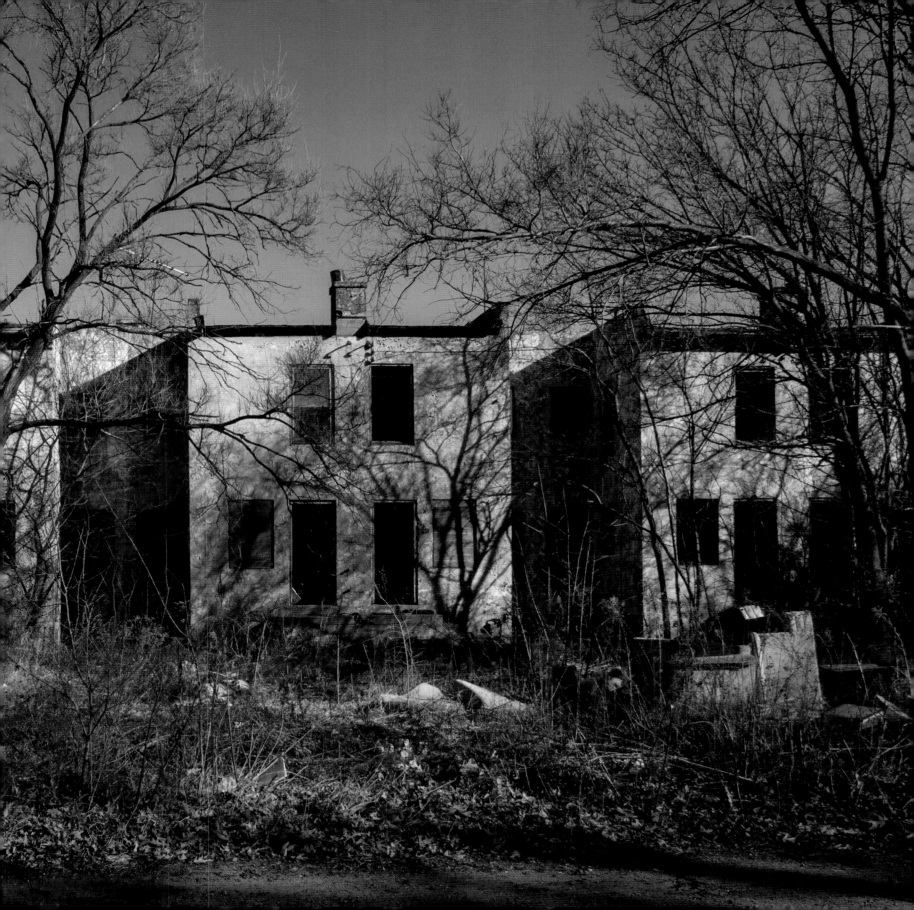

The death of a nation manifests itself in several ways that range from the death of an industry to the death of joy. No other place exemplifies this better than the hauntingly beautiful abandoned theme parks scattered across the United States. The giant roller coasters resembling large, skeletal dinosaurs remain, and as I explore these apocalyptic ruins I'm constantly reminded that everything expires. Everything becomes extinct.

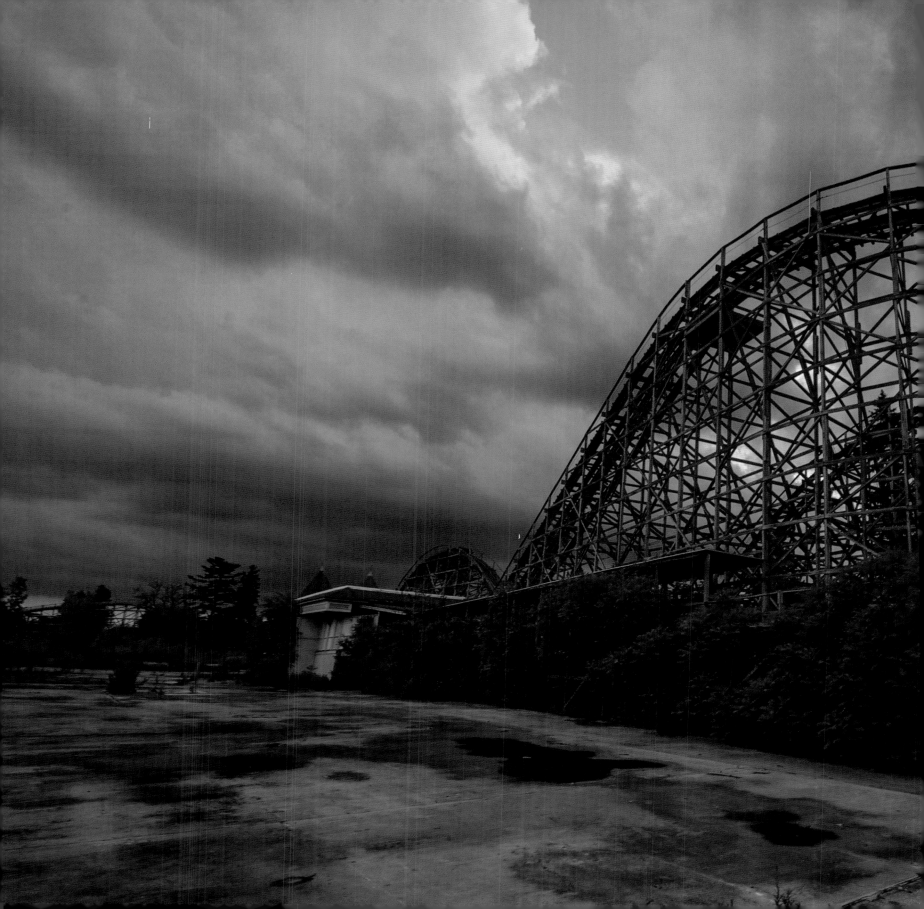

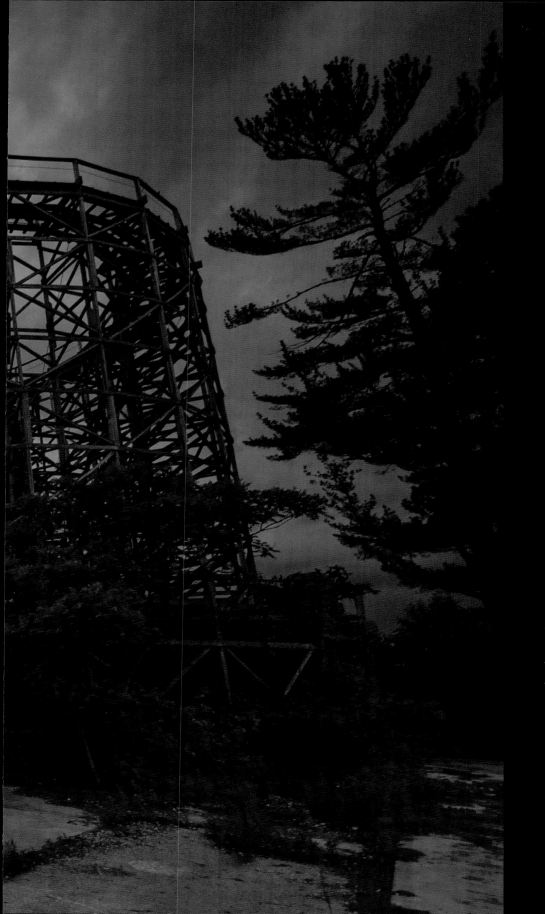

I remember it like it was yesterday. I remember going up that first incline on the roller coaster. I can still hear the clink, clink, clink of the chains pulling the cars upward. As soon as you reached the top, there would almost be a deafening silence, immediately followed by screams and laughter. In those few moments, it was pure bliss.

Years later, I'm here inside the broken remnants of this abandoned amusement park, and I gaze over to where the big roller coaster used to be. I remember riding all these rides and then, later at night, sitting on a blanket by the lake under the stars watching fireworks. I miss it all.

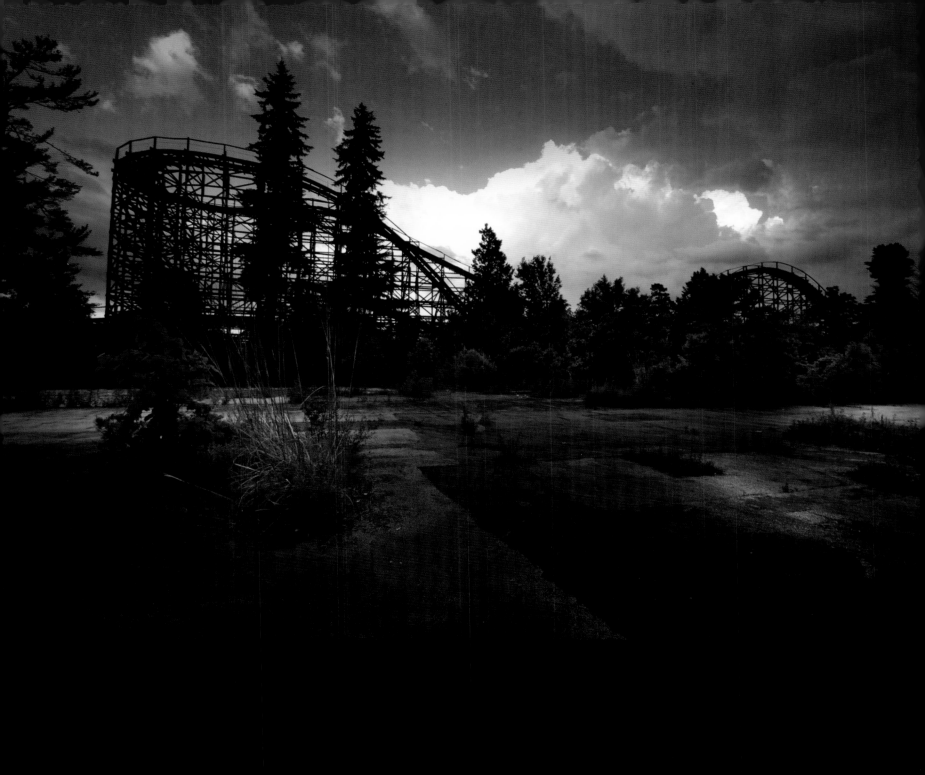

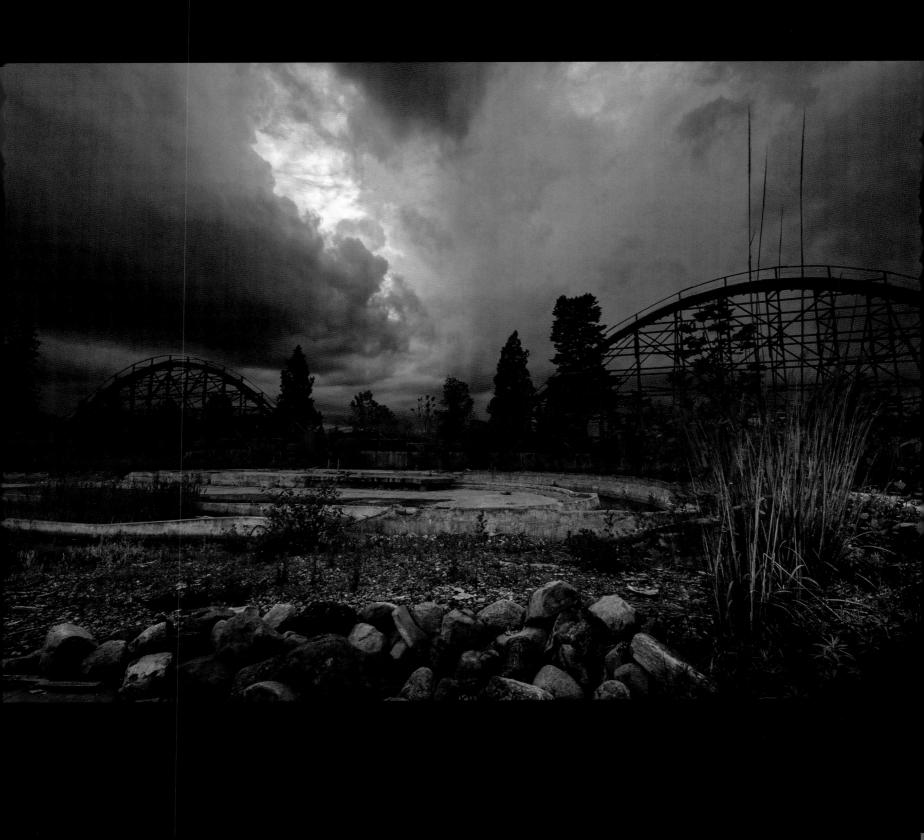

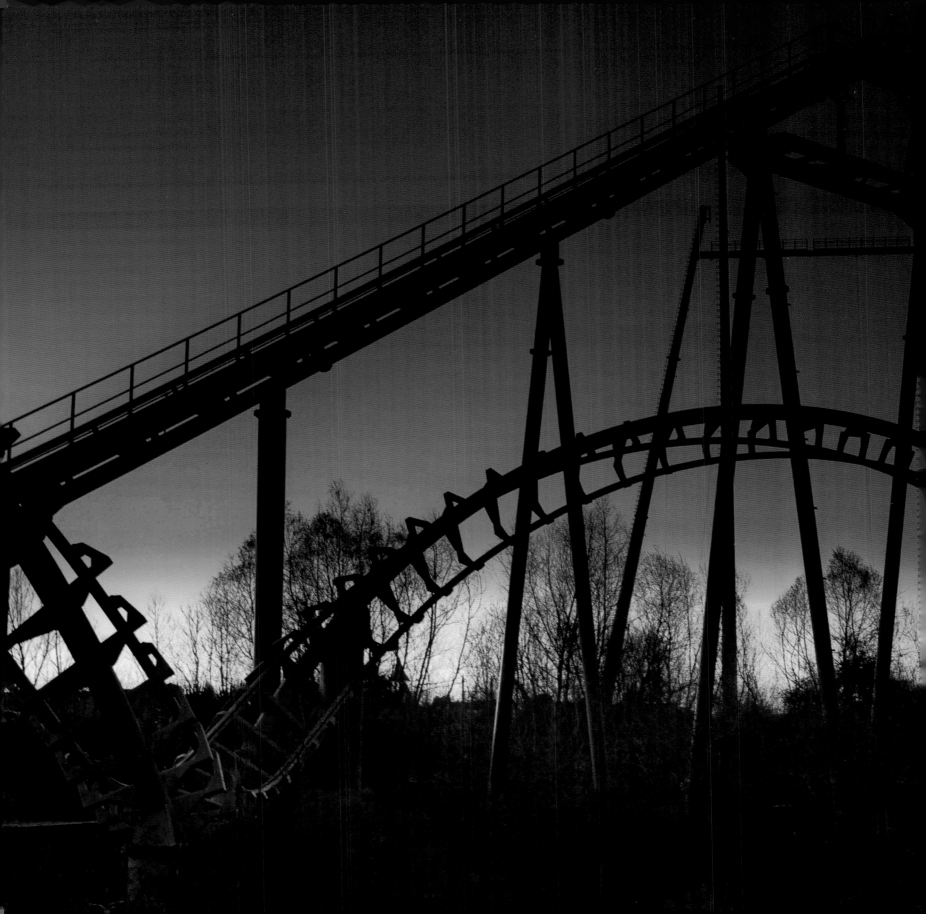

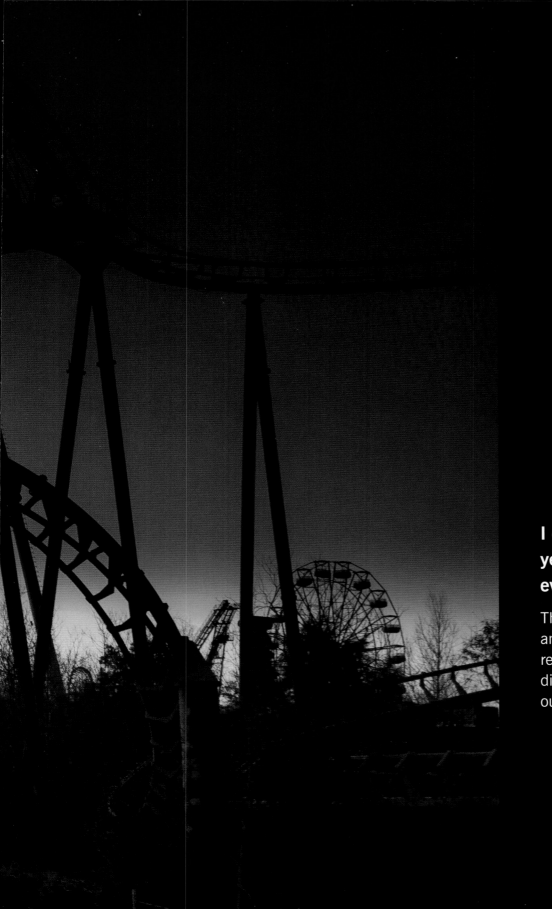

I can't remember what I did yesterday, but I can remember everything I did here.

The last ride left at this abandoned amusement park looks more like the skeleta remains of a once-thriving and powerful dinosaur. Extinction is inevitable. Survival is our only option.

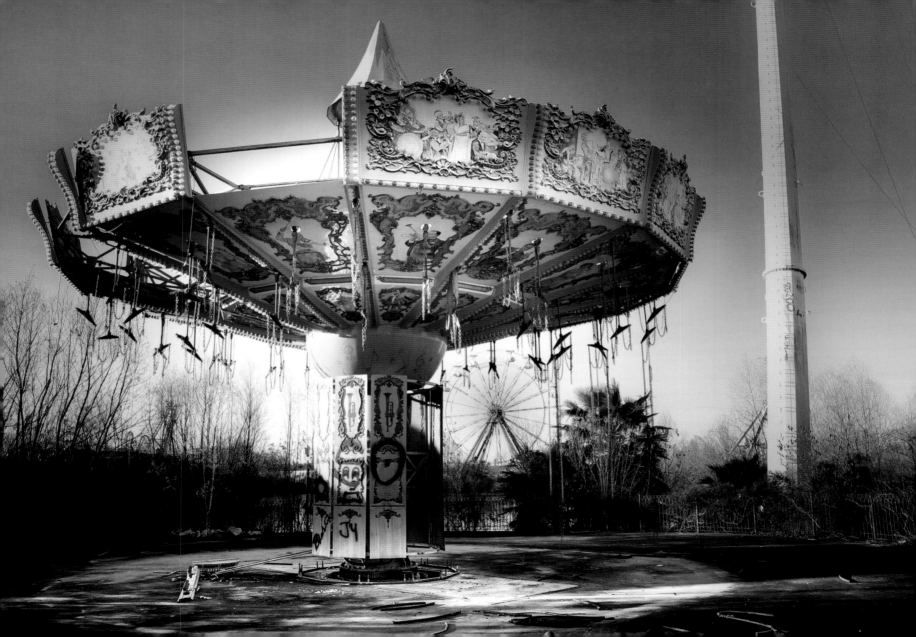

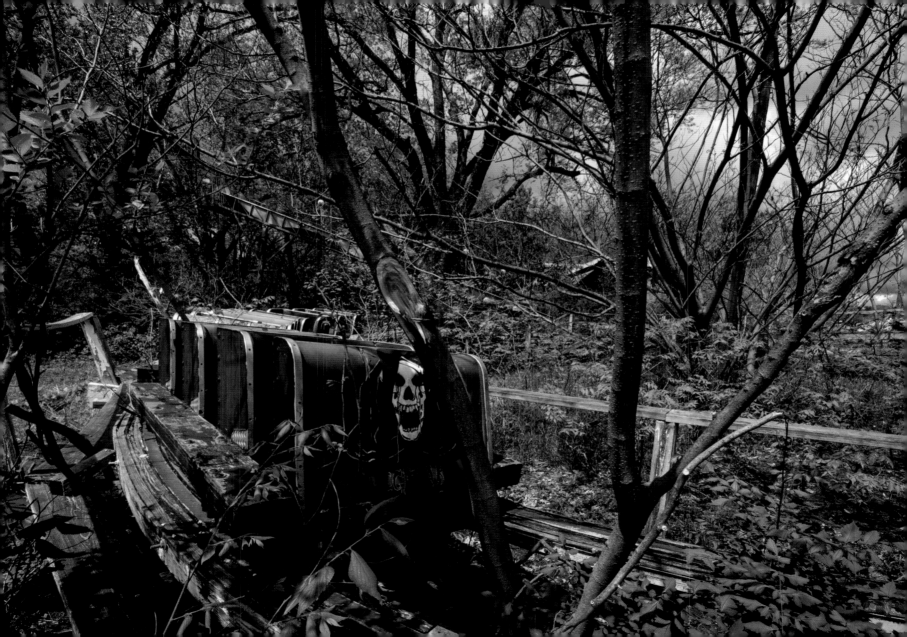

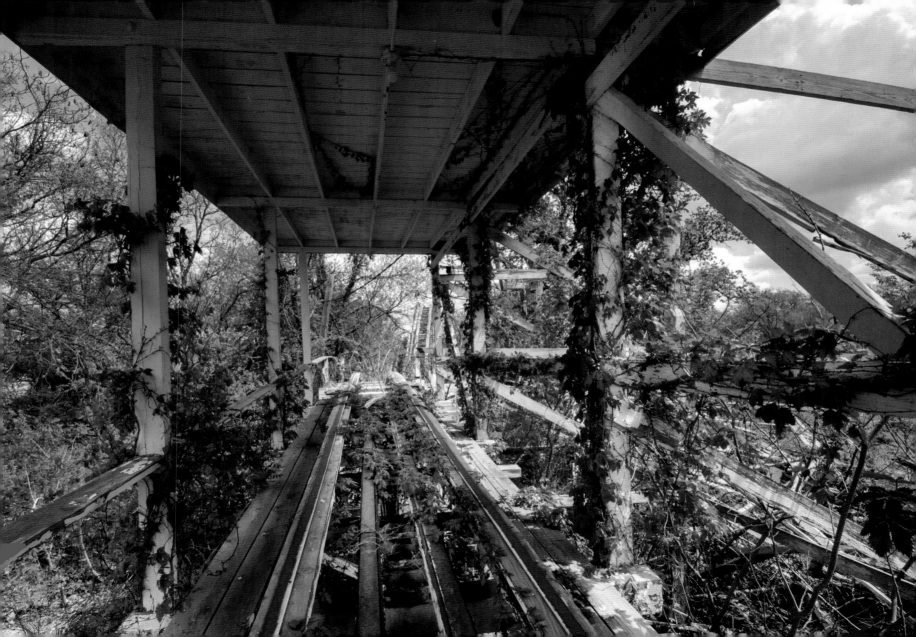

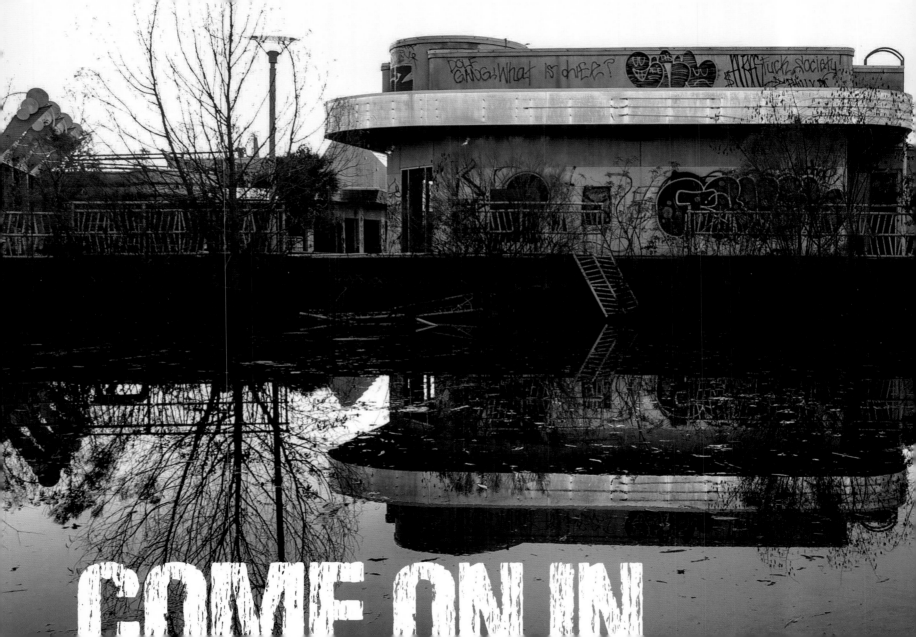

COME ON IN

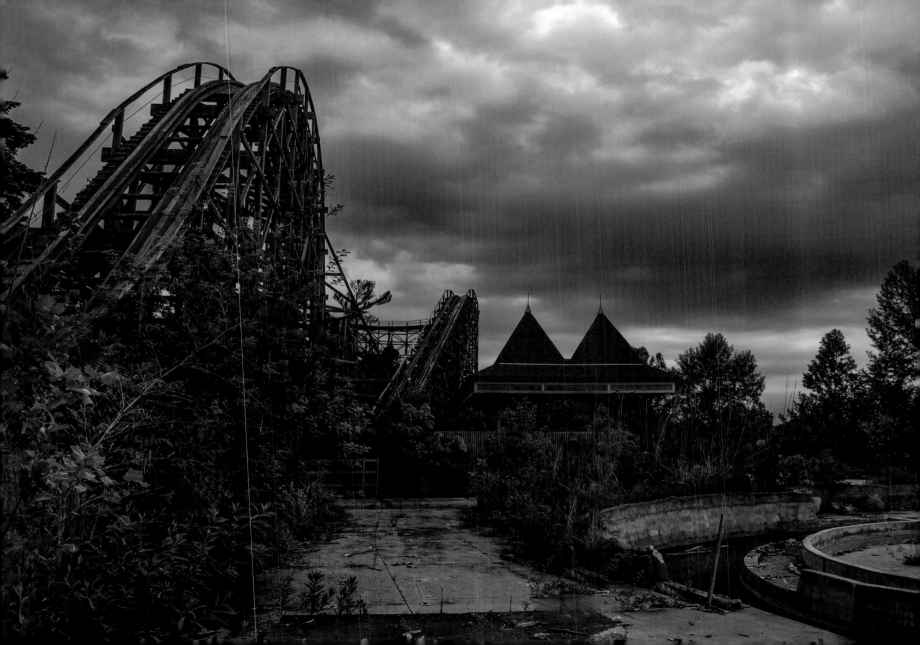

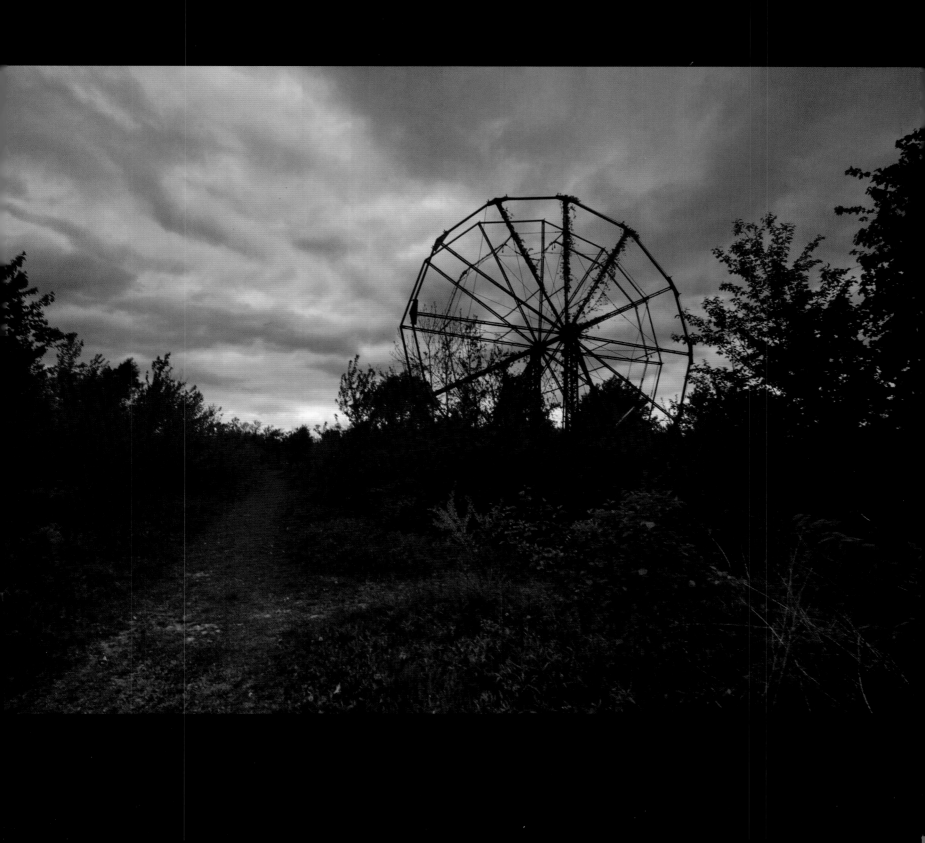

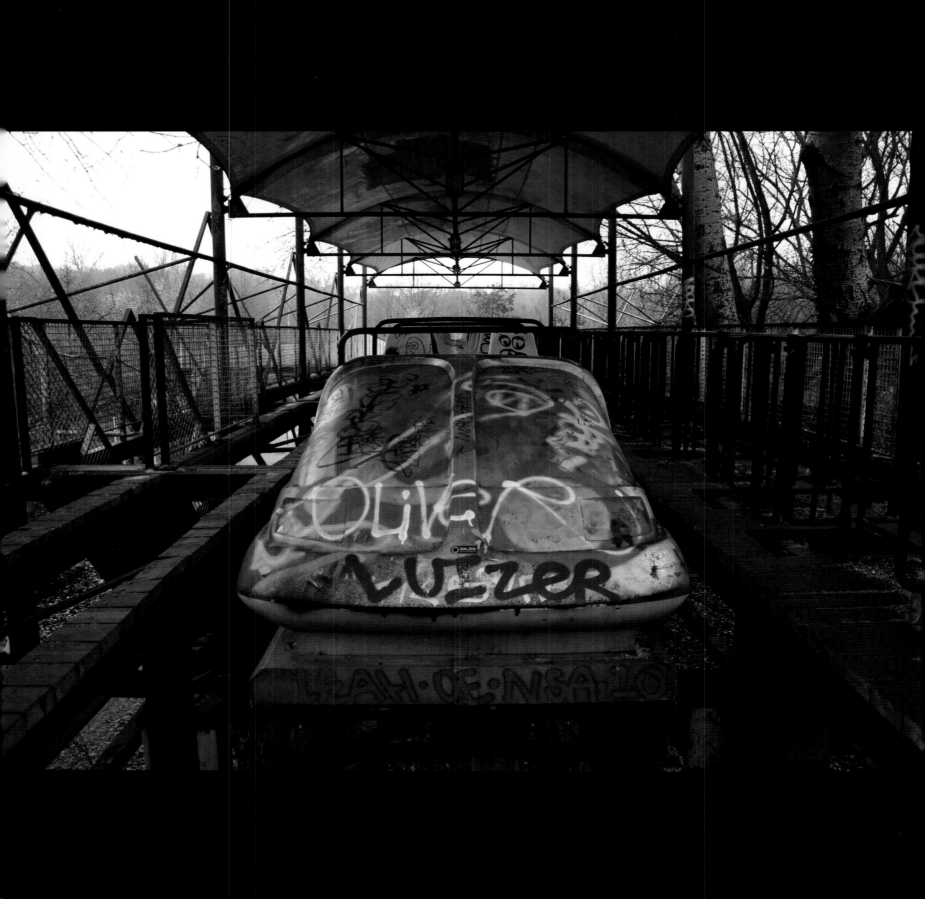

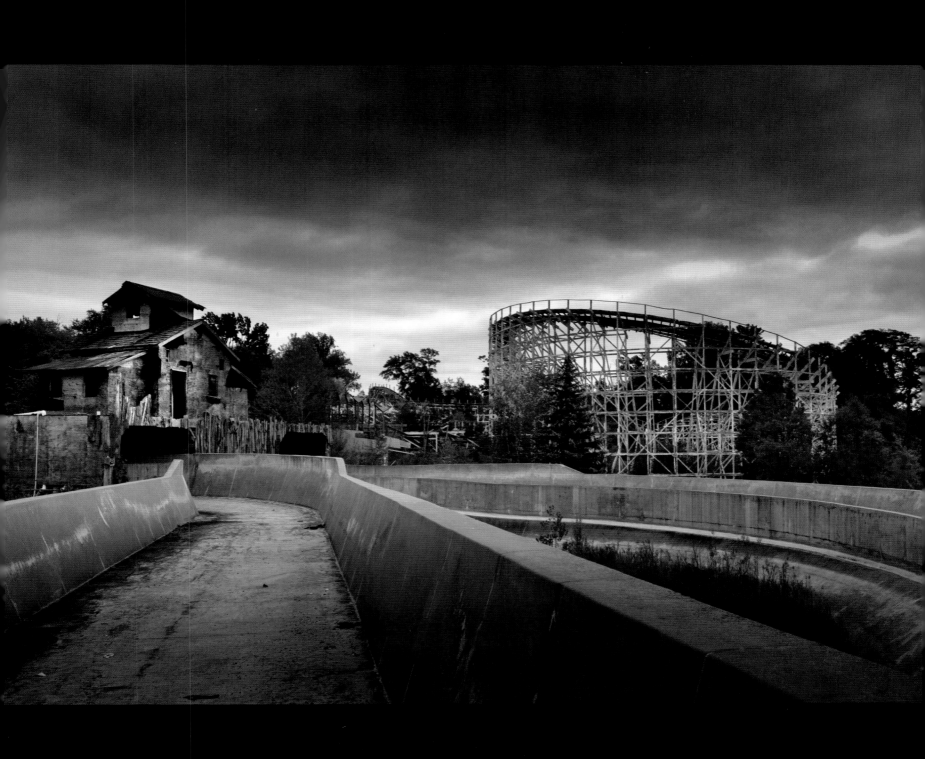

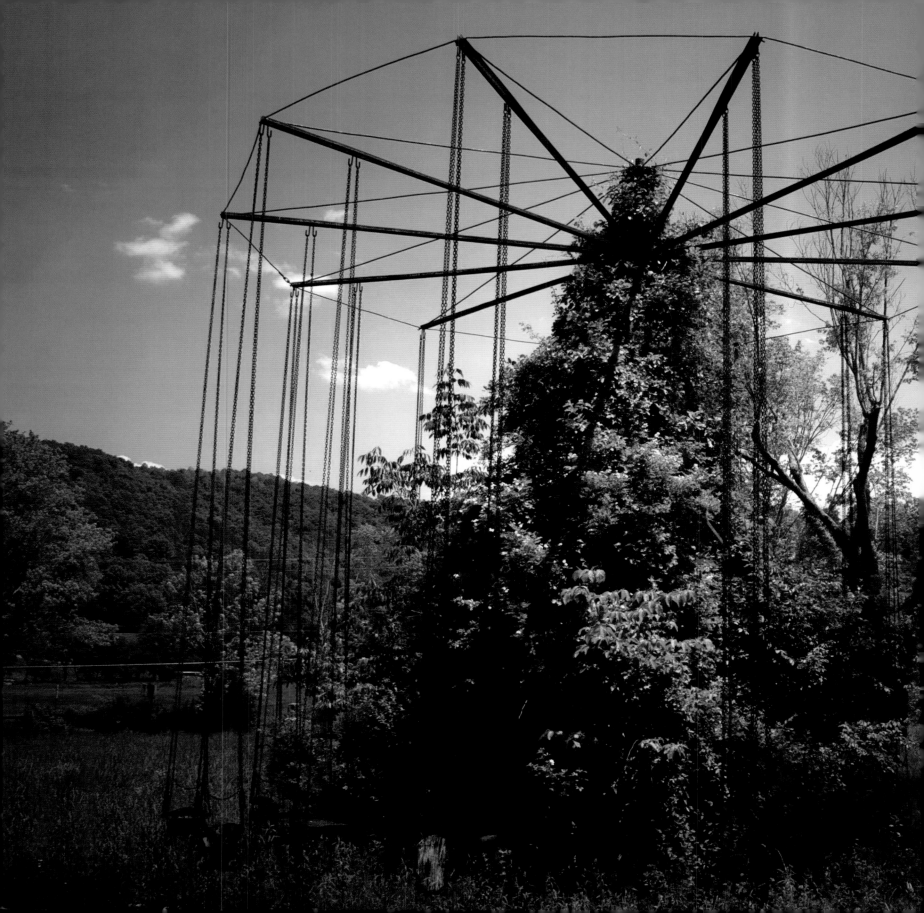

WELCOME
TO NATURE

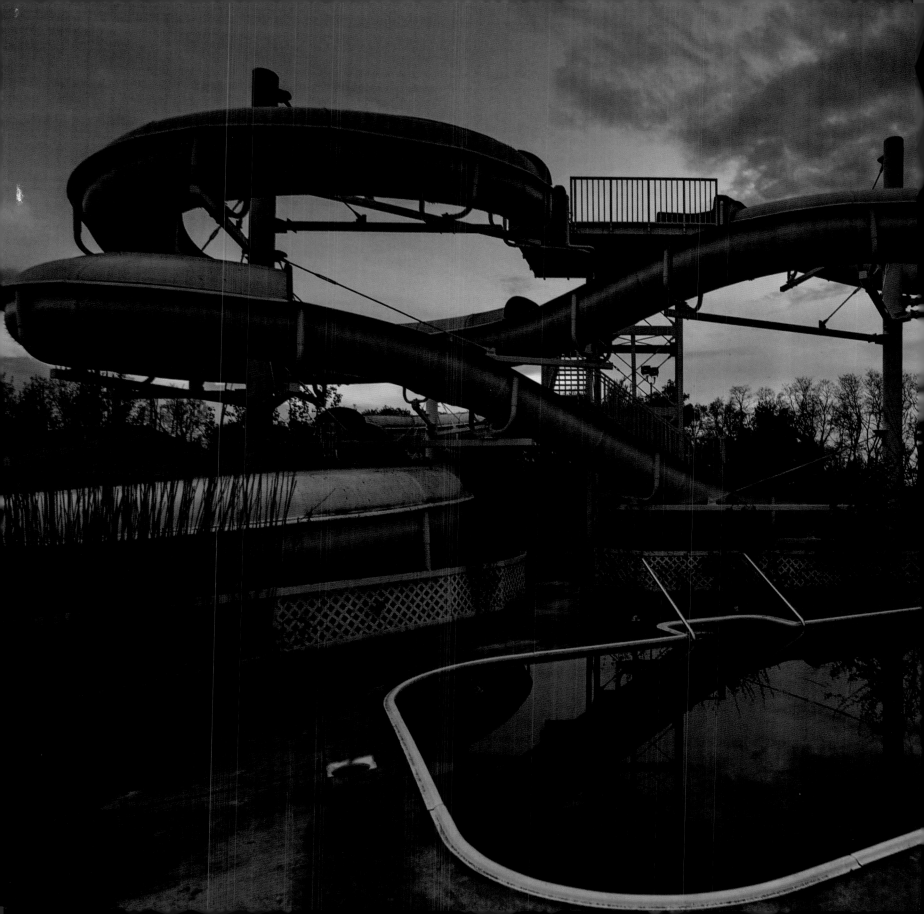

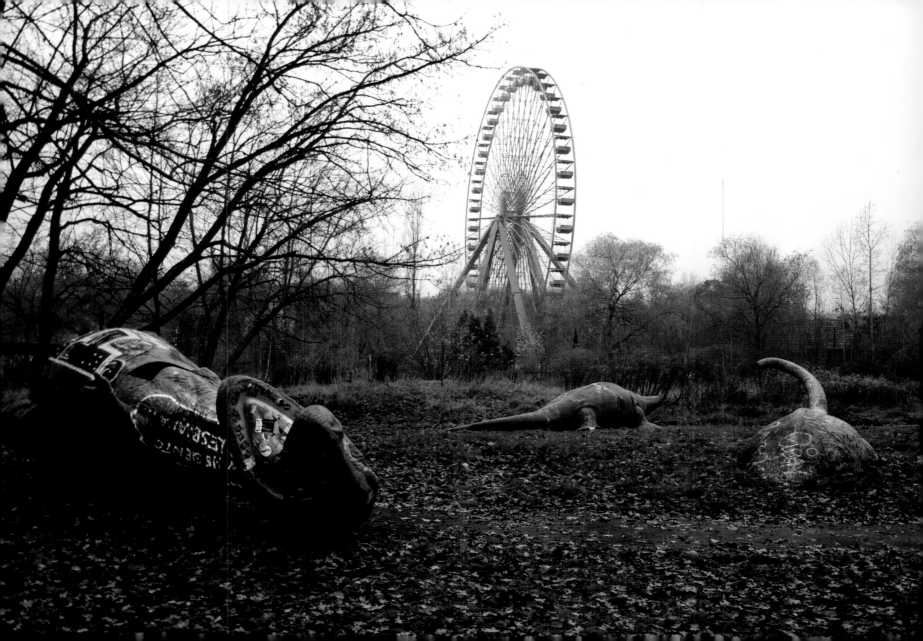

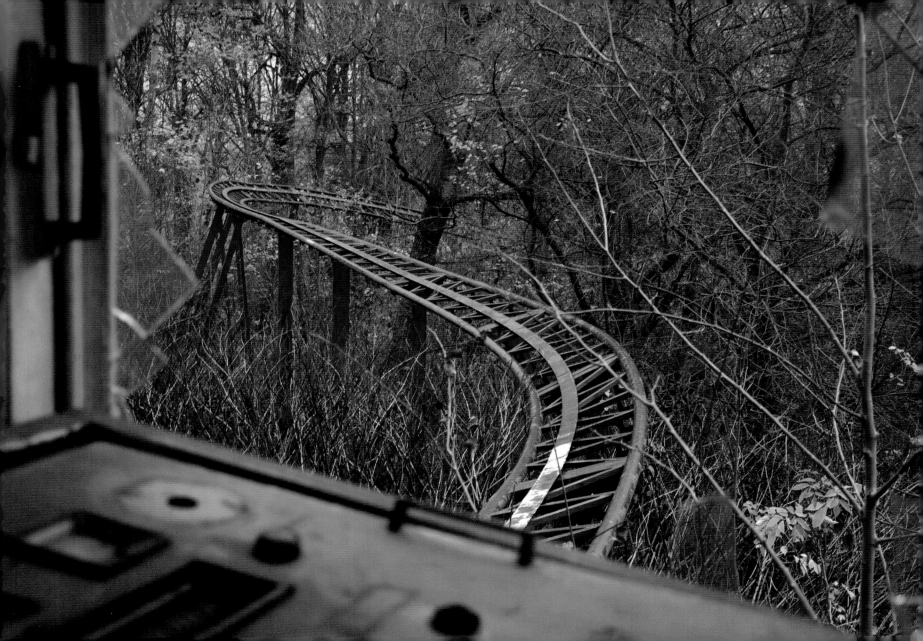

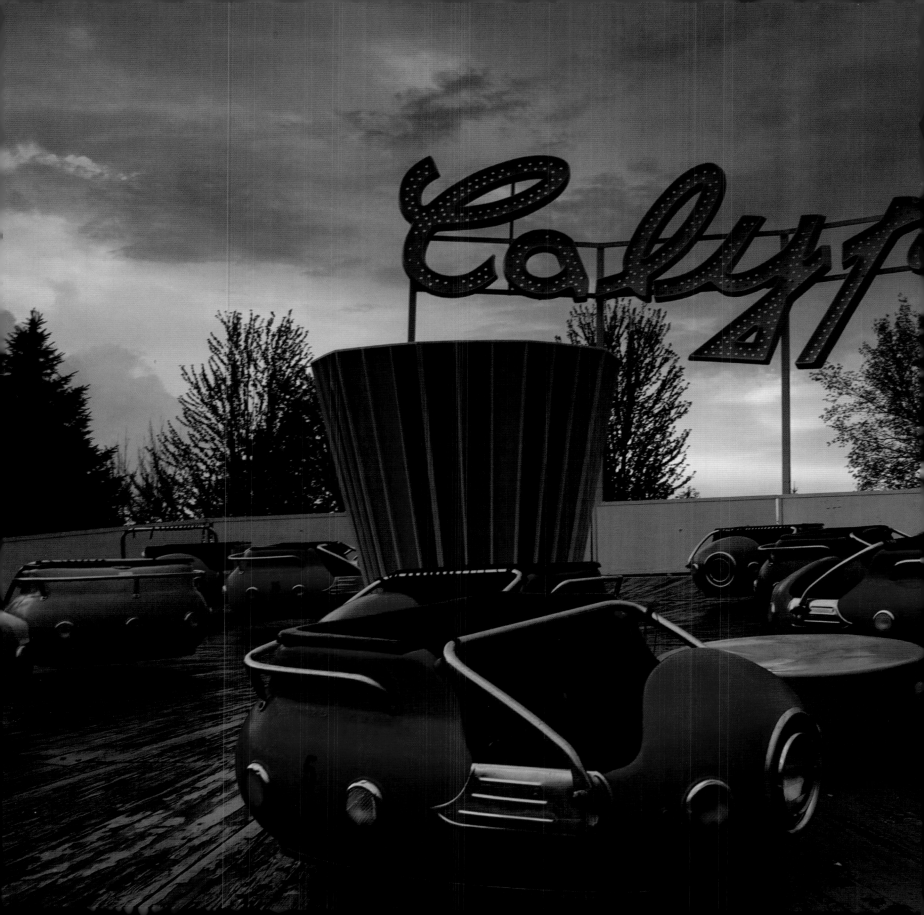

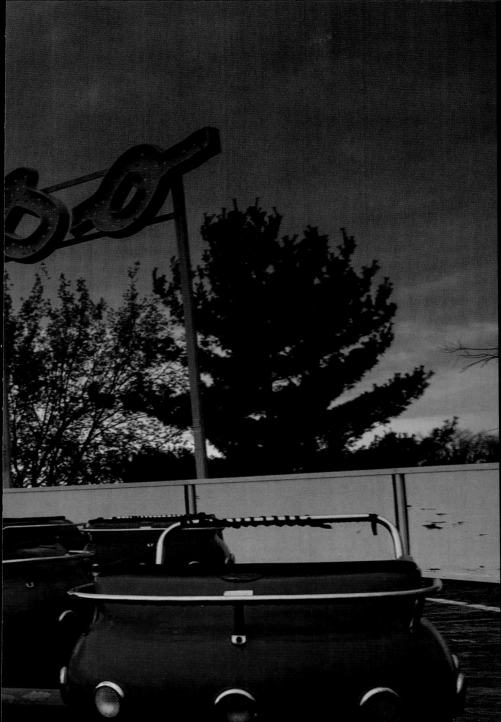

My father worked at a once-thriving American automobile manufacturing factory in Detroit, Michigan, and eventually transferred to Cleveland, Ohio, where he would raise a family and fulfill the American Dream.

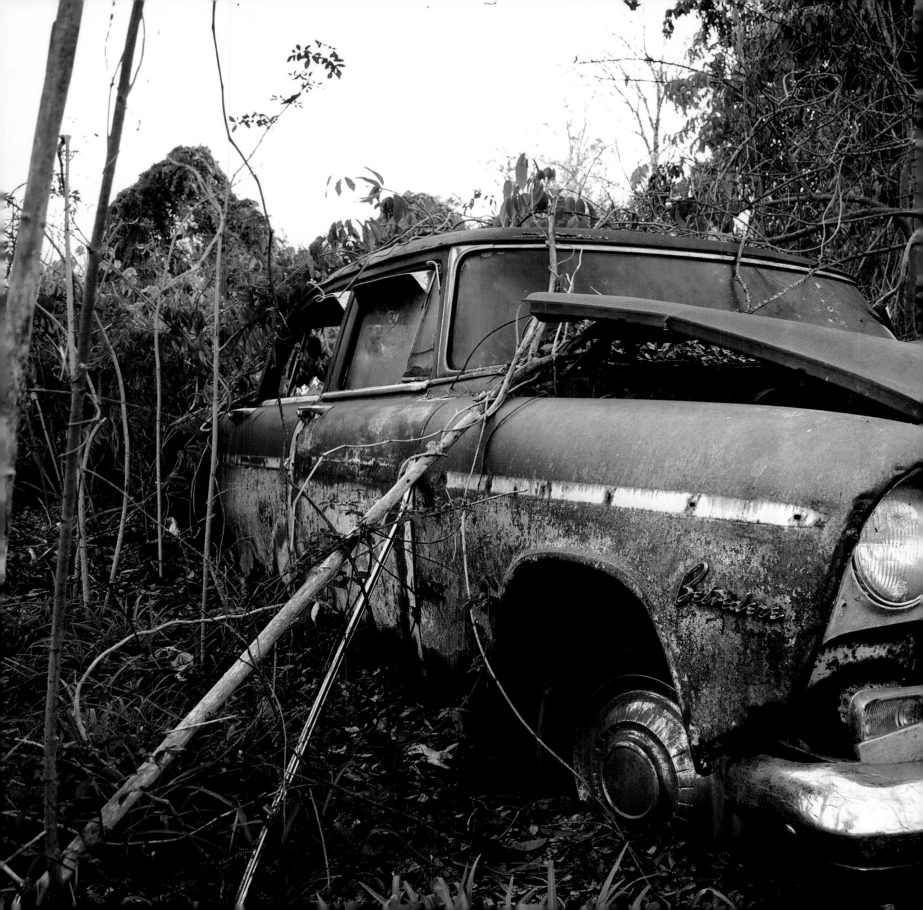

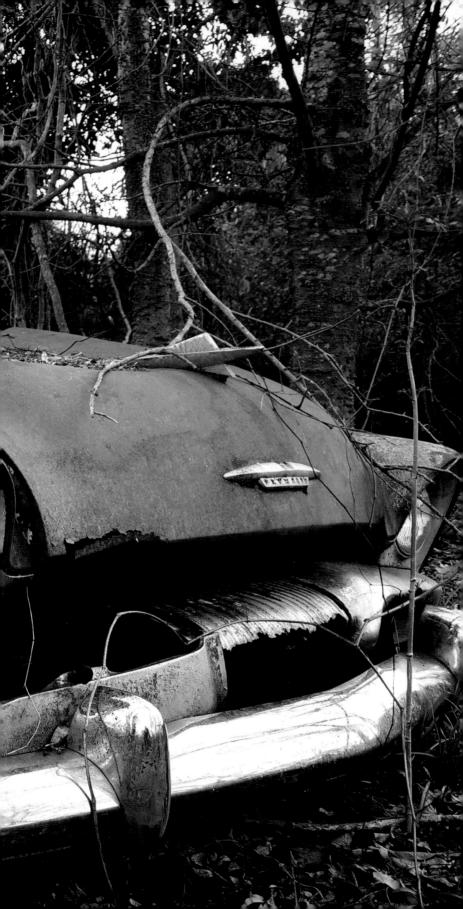

SPREADING LIKE A DISEASE

At the time, it seemed trivial to me, and it wasn't until years later that I understood it all. I was standing on the roof of a crumbling automobile manufacturing plant overlooking the city of Detroit, and I was just beginning to witness the greatest economic machine in the world start to crumble. I was terrified.

The city of Detroit was entering uncharted territory - a dark place that no major U.S. city has ever gone - but that would change. This was all merely a prelude to something far greater than anyone ever could have imagined. The complete failure and collapse of the United States of America and its people.

While standing on that crumbling rooftop, I began to think to myself, Whatever happened to the American Dream?...before I realized I was looking at it.

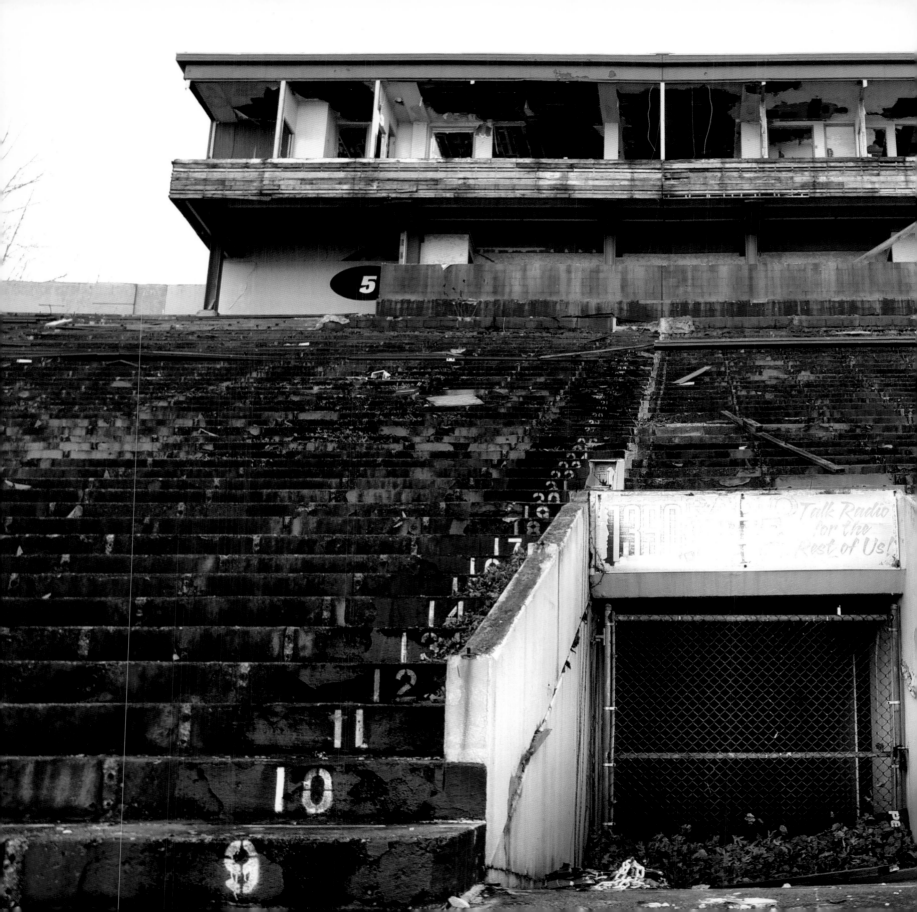

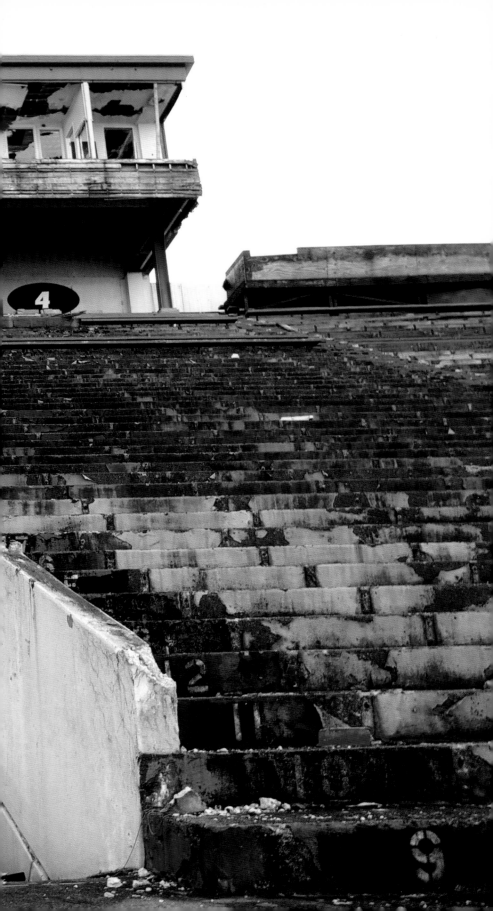

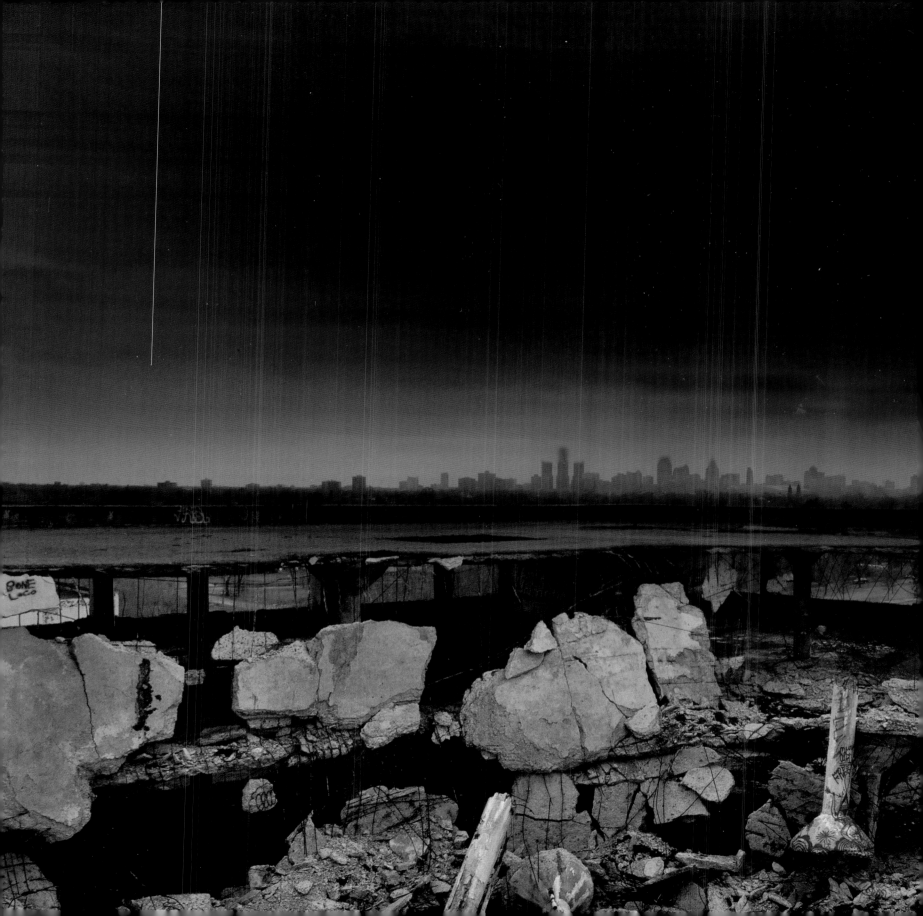

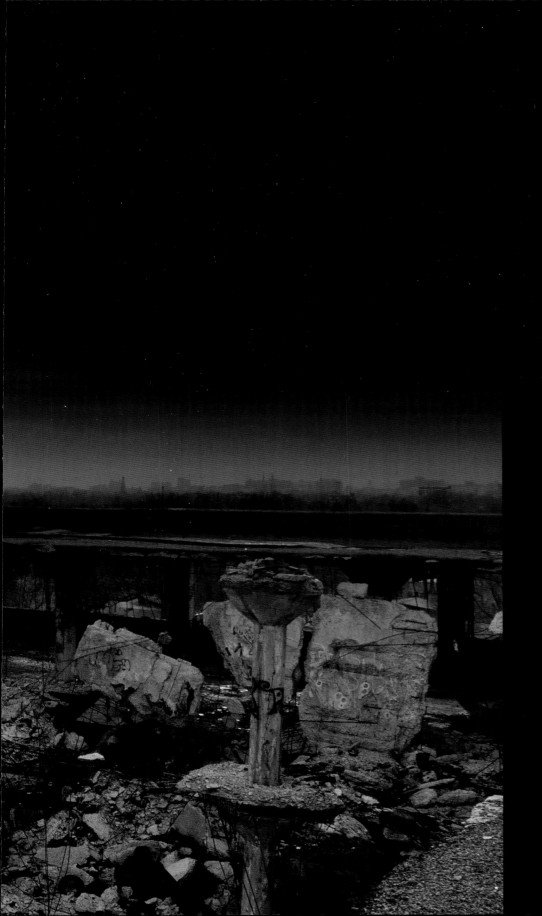

In early 2016, I witnessed Trump give a speech in Flint, Michigan:

"It used to be cars were made in Flint, and you couldn't drink the water in Mexico. Now cars are made in Mexico, and you can't drink the water in Flint, but we're going to turn this around," Trump said, referring to the Flint water crisis, where the water was tainted with lead after the city switched its water source from Lake Huron to the Flint River in 2014.

I immediately panned the room and saw just how powerfully those words connected with the men and woman in attendance that night.

I reached out to my liberal colleagues and even a member of Hillary Clinton's campaign and expressed what I saw transpiring throughout the region. My vocal concerns were ignored, and as a result, the Democrats suffered a crushing defeat in the U.S. Presidential election.

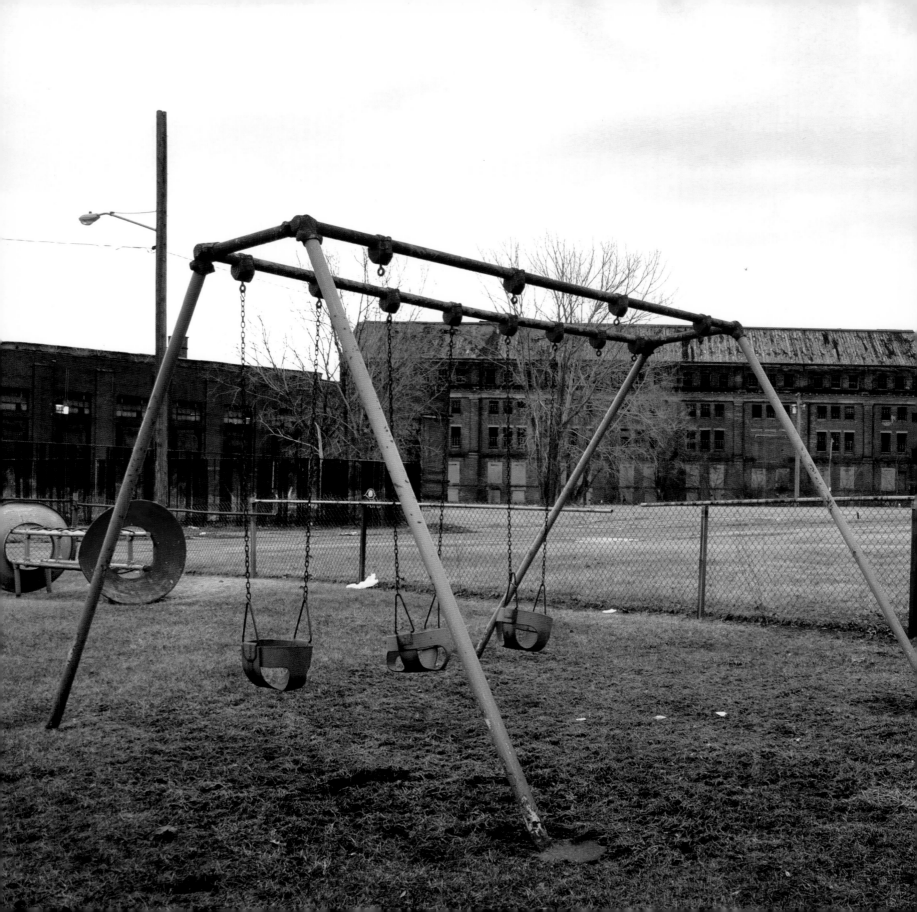

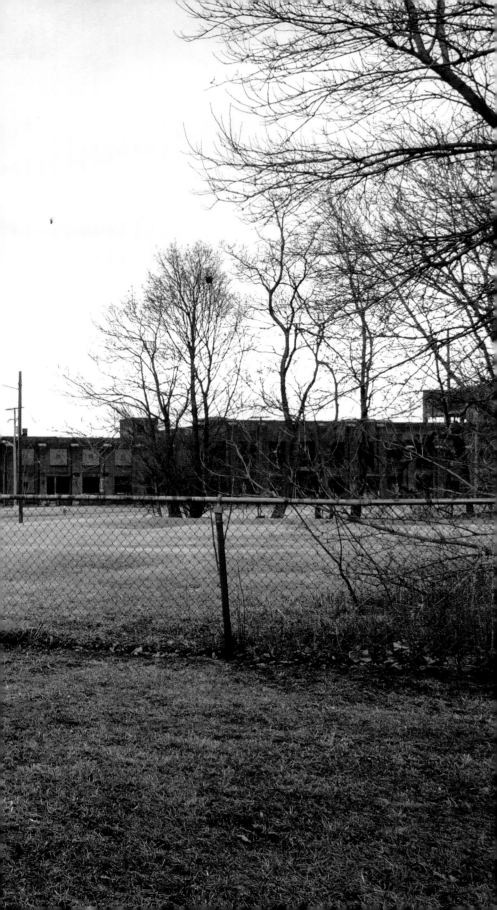

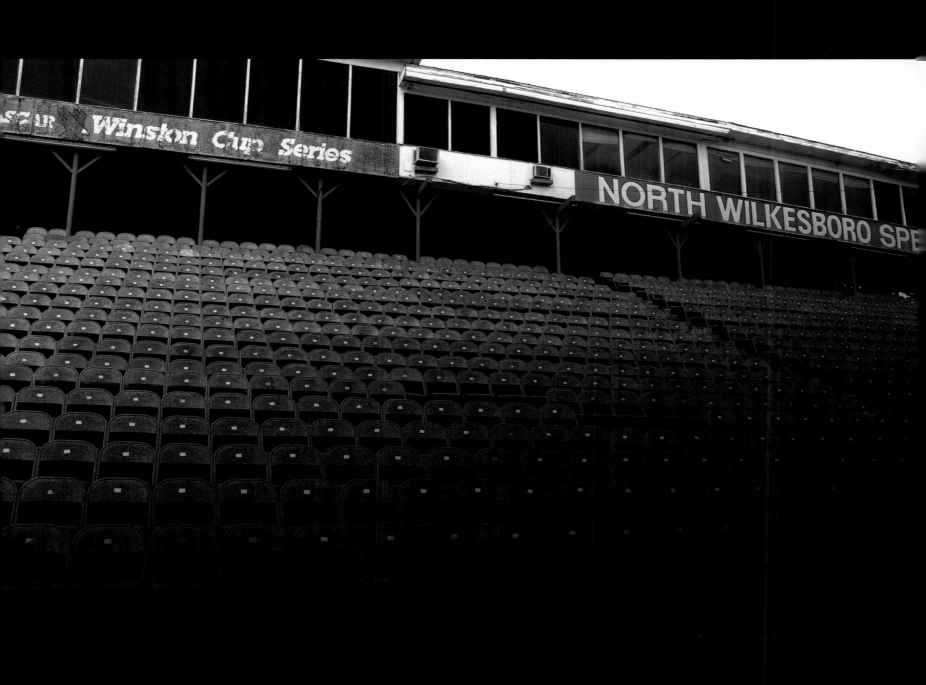

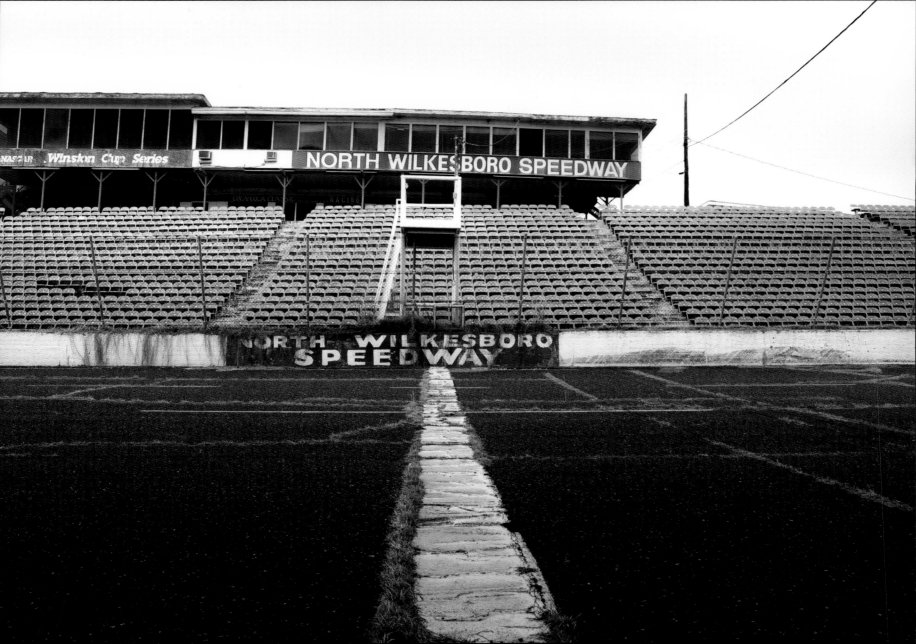

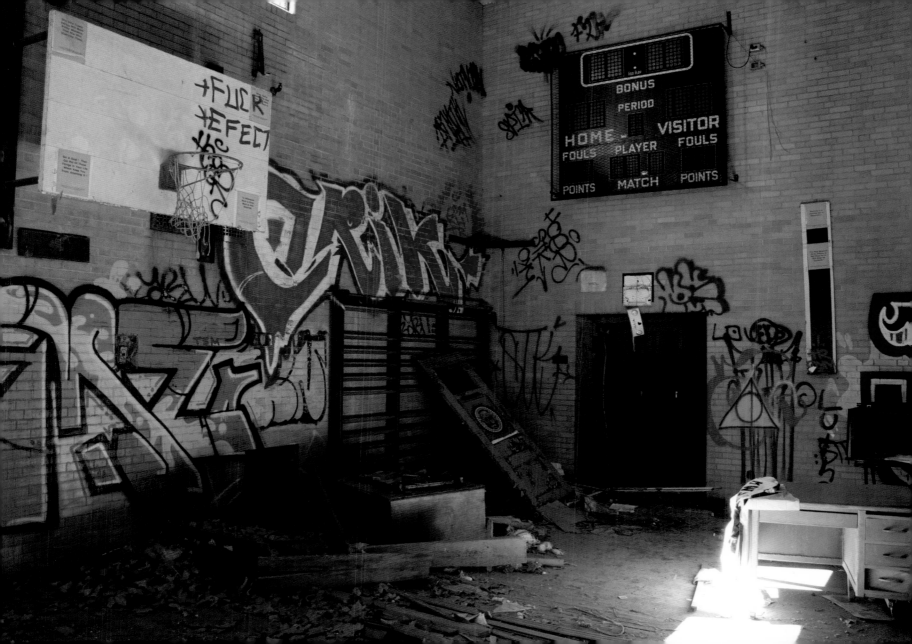

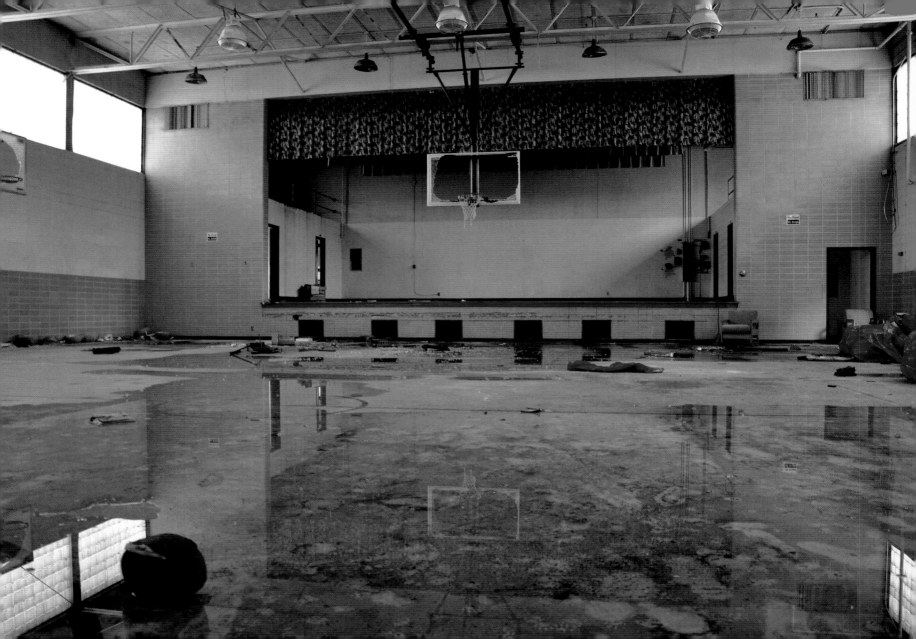

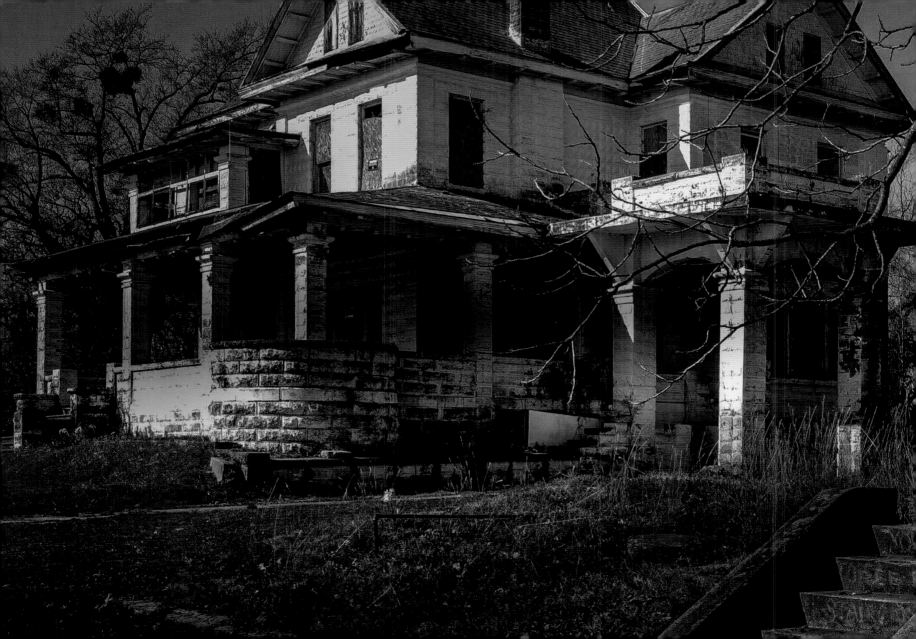

"*Four out of 5 U.S. adults struggle with joblessness, near-poverty or reliance on welfare for at least parts of their lives, a sign of deteriorating economic security and an elusive American dream.*"

- Seph Lawless (NPR Radio)

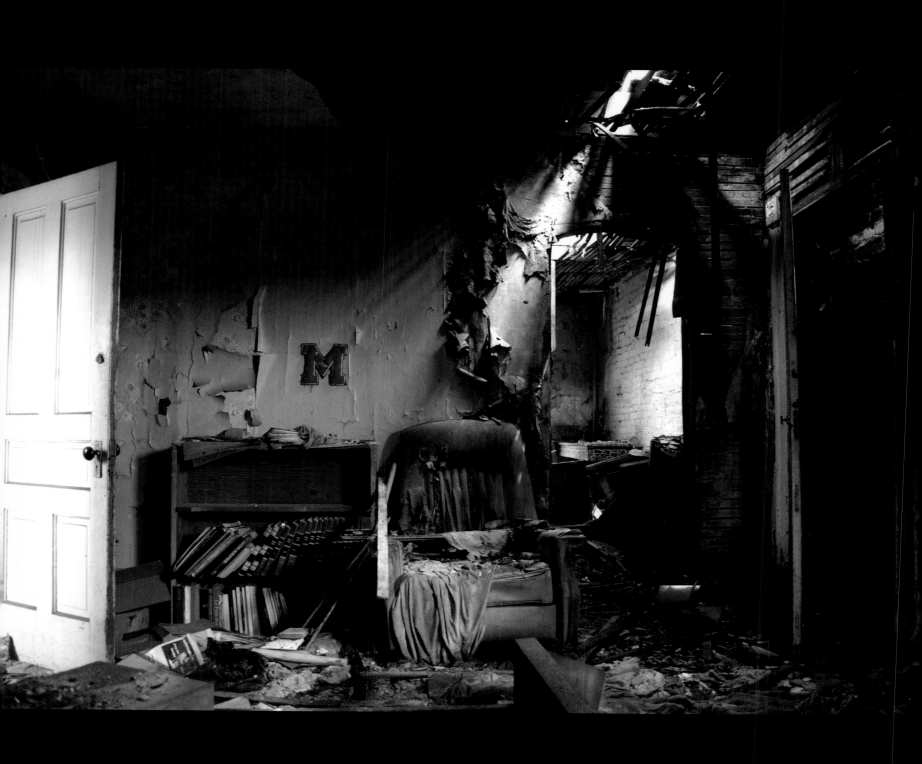

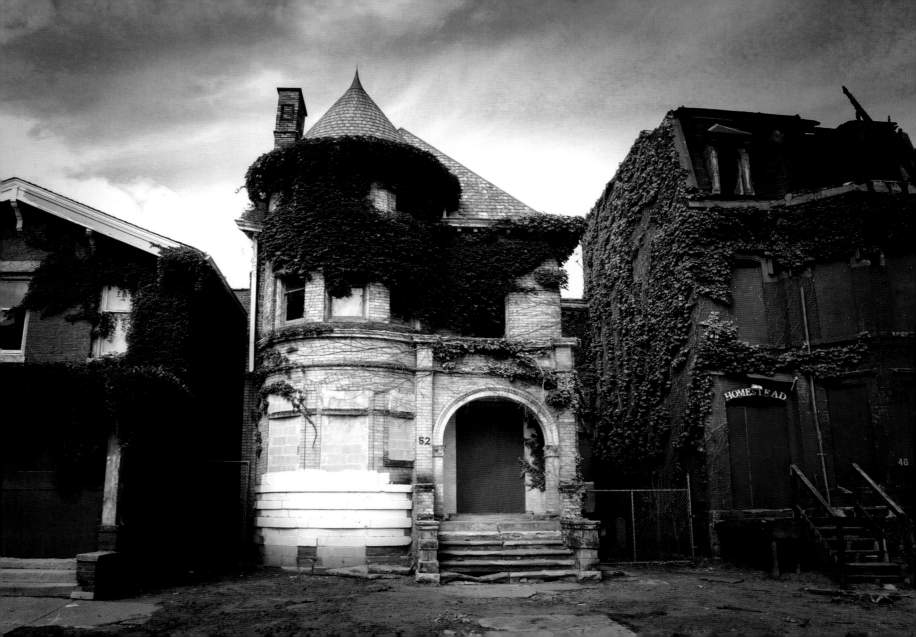

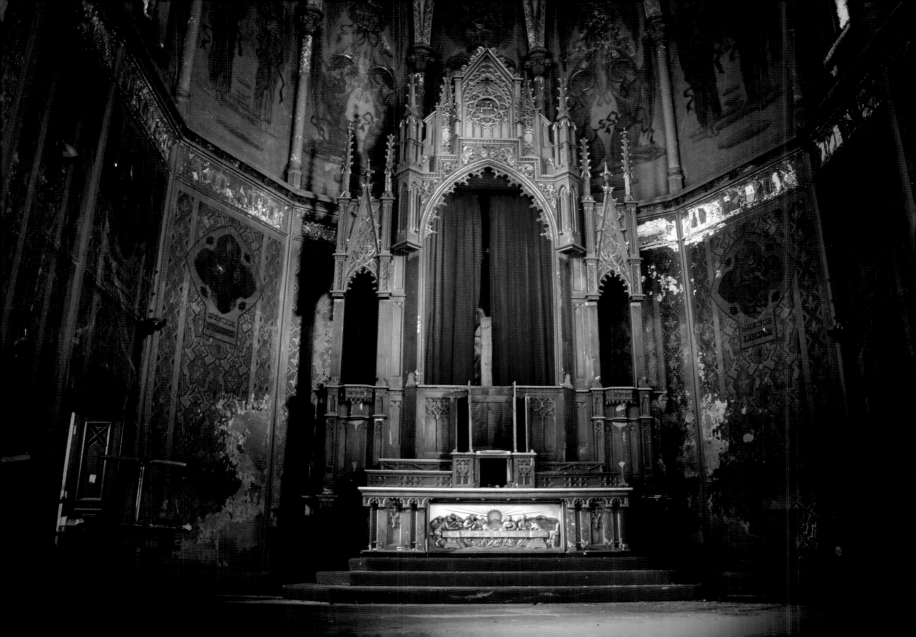

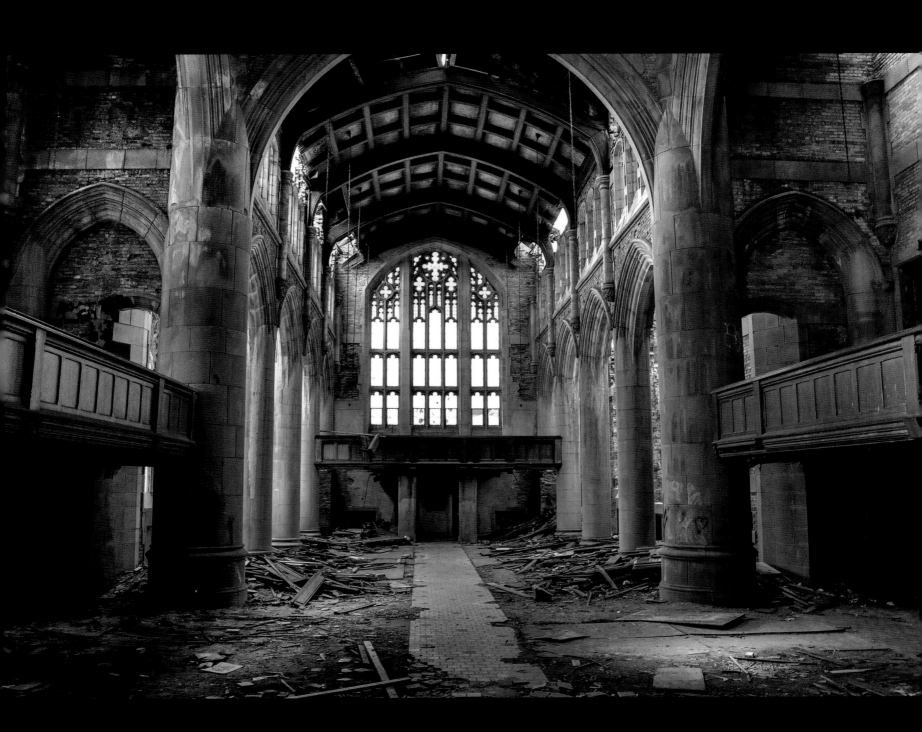

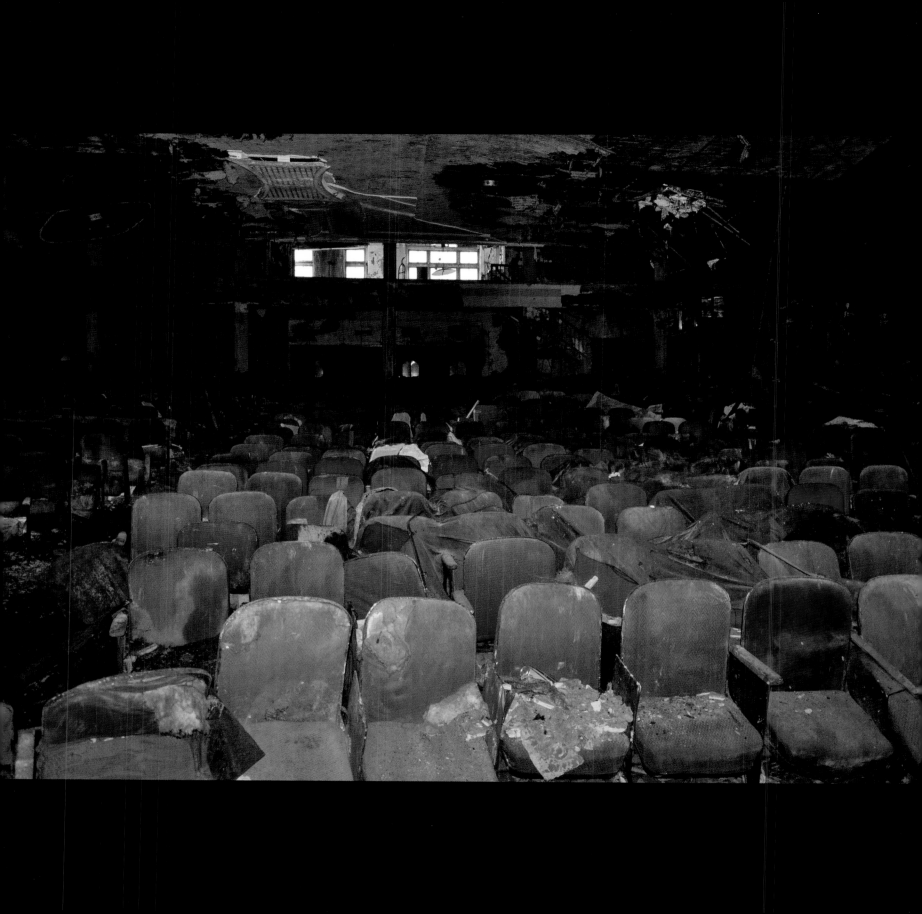

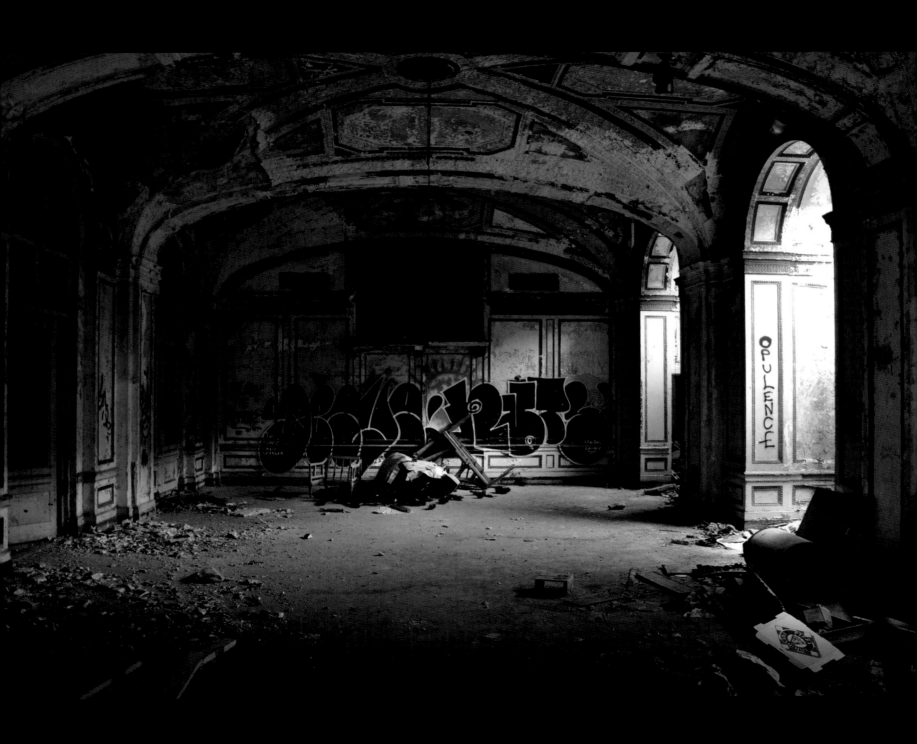

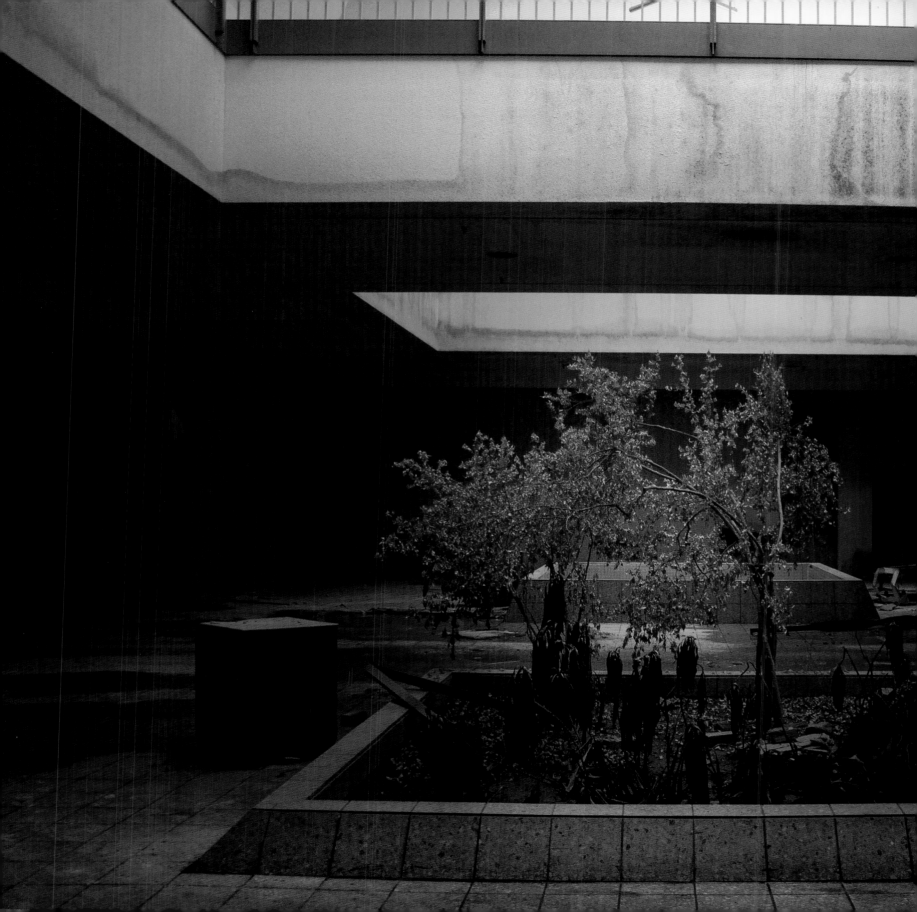

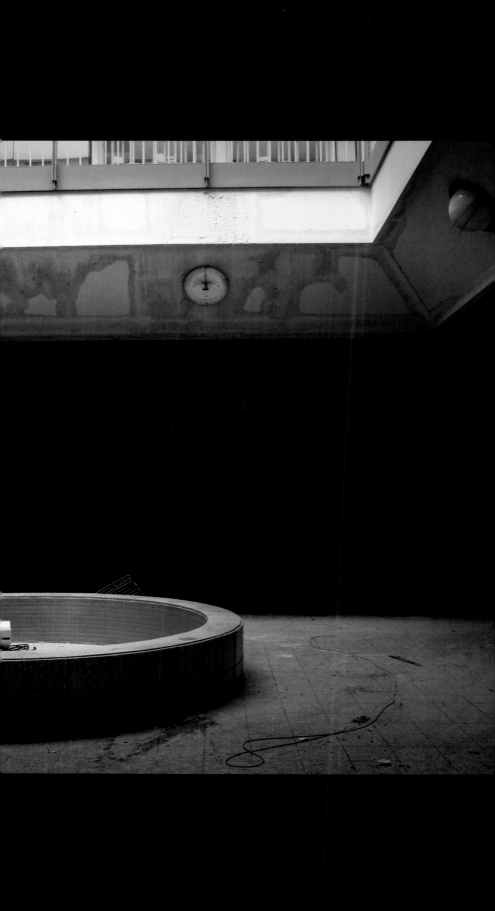

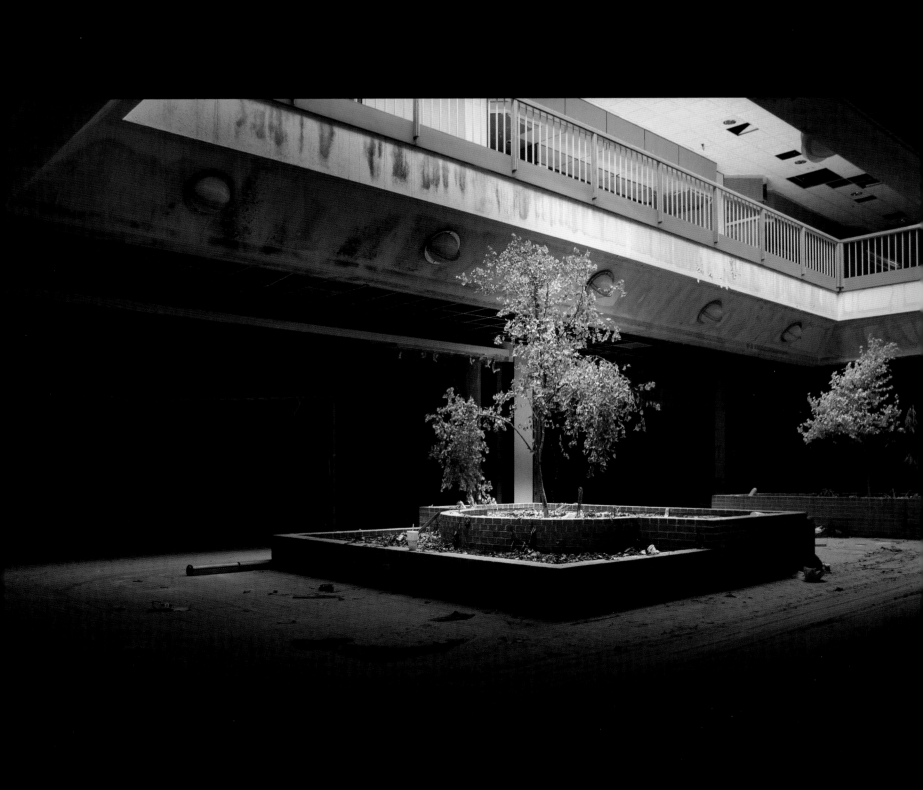

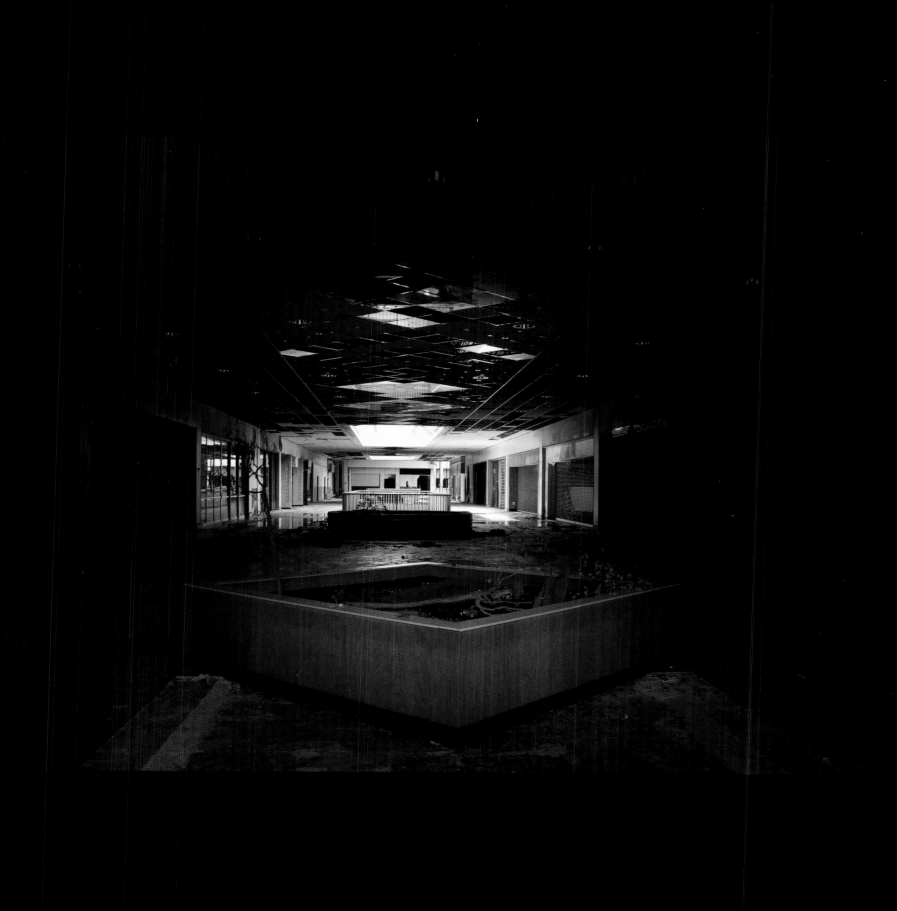

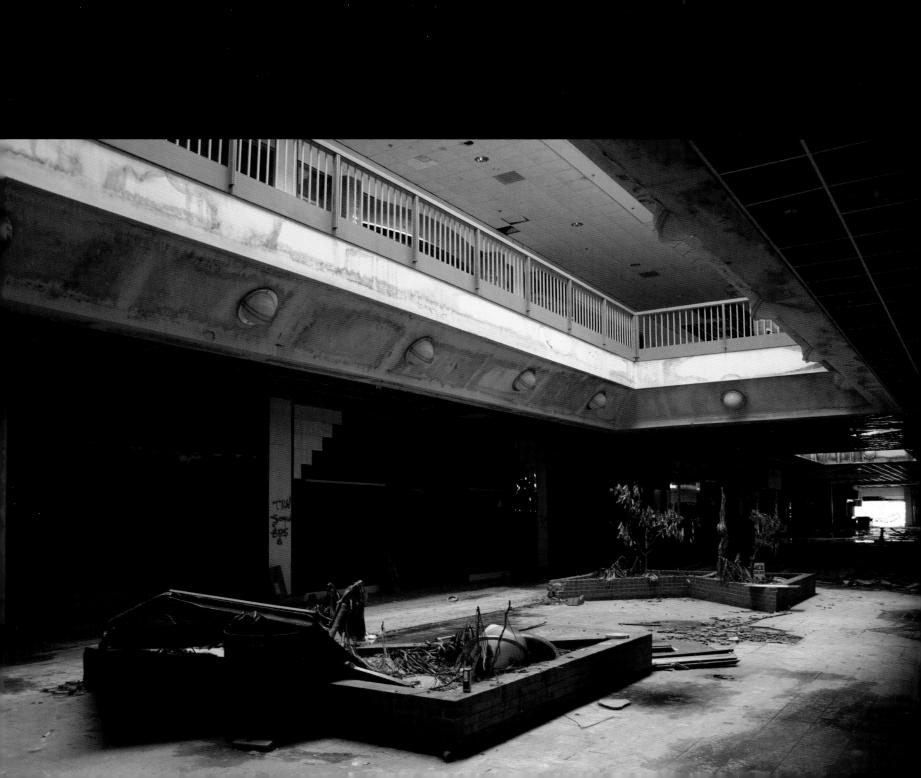

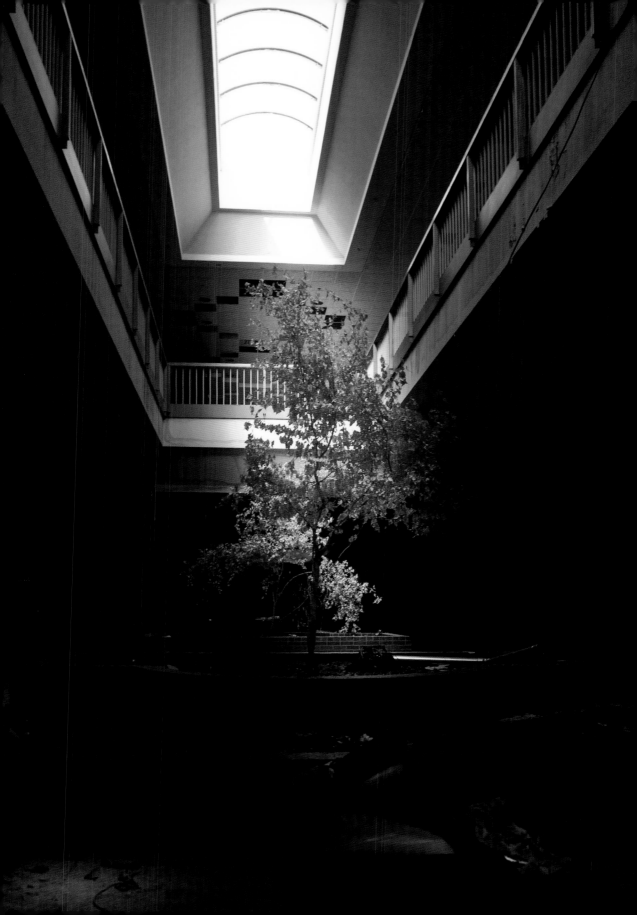

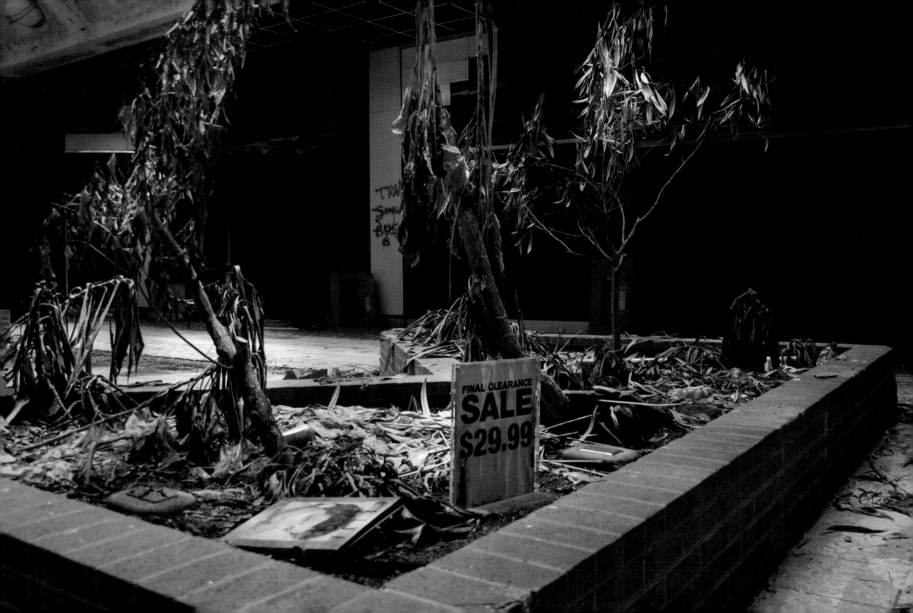

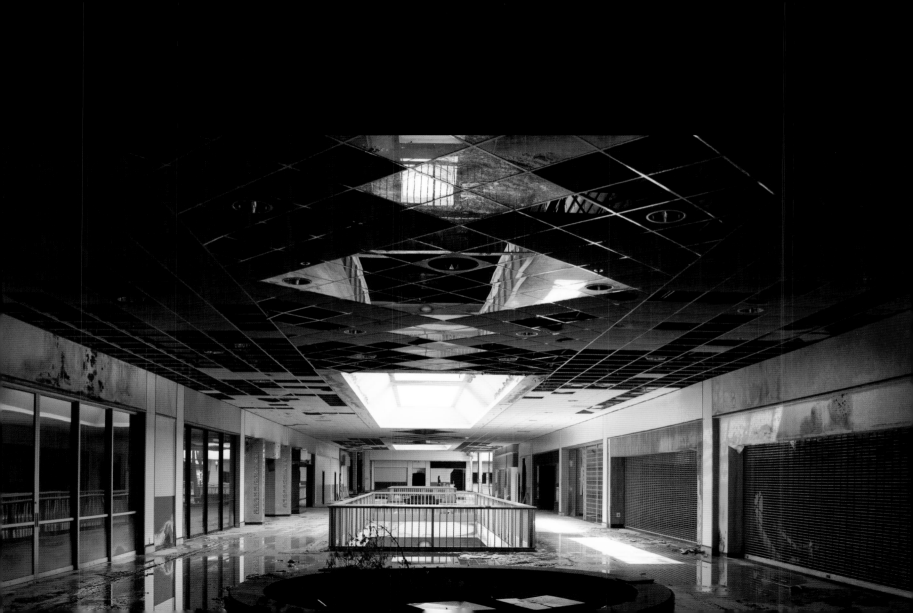

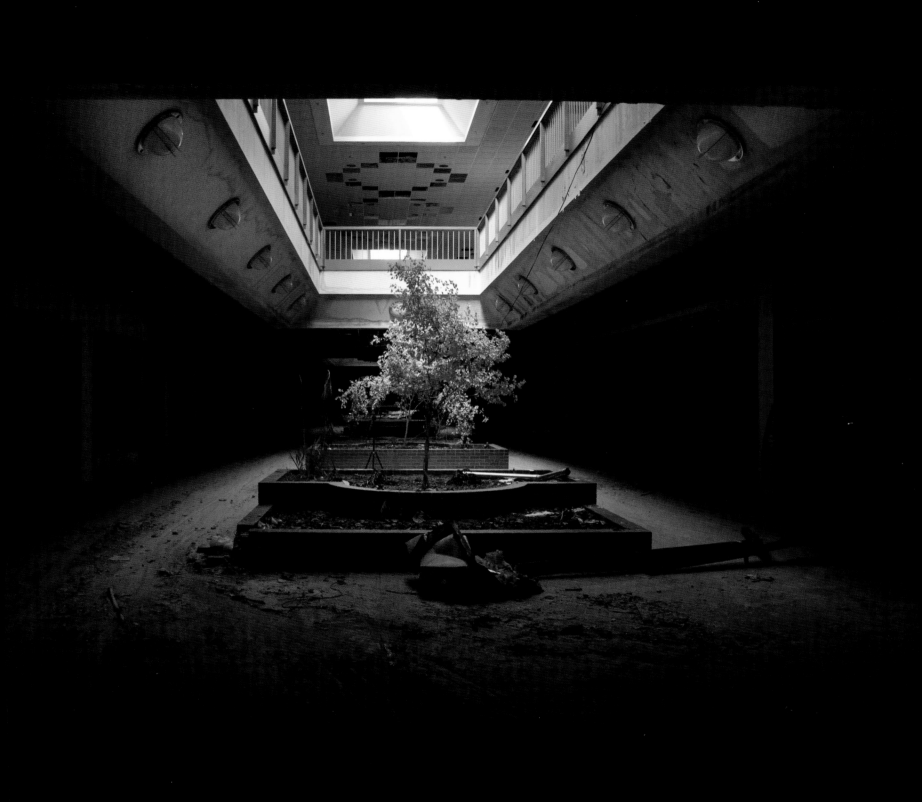

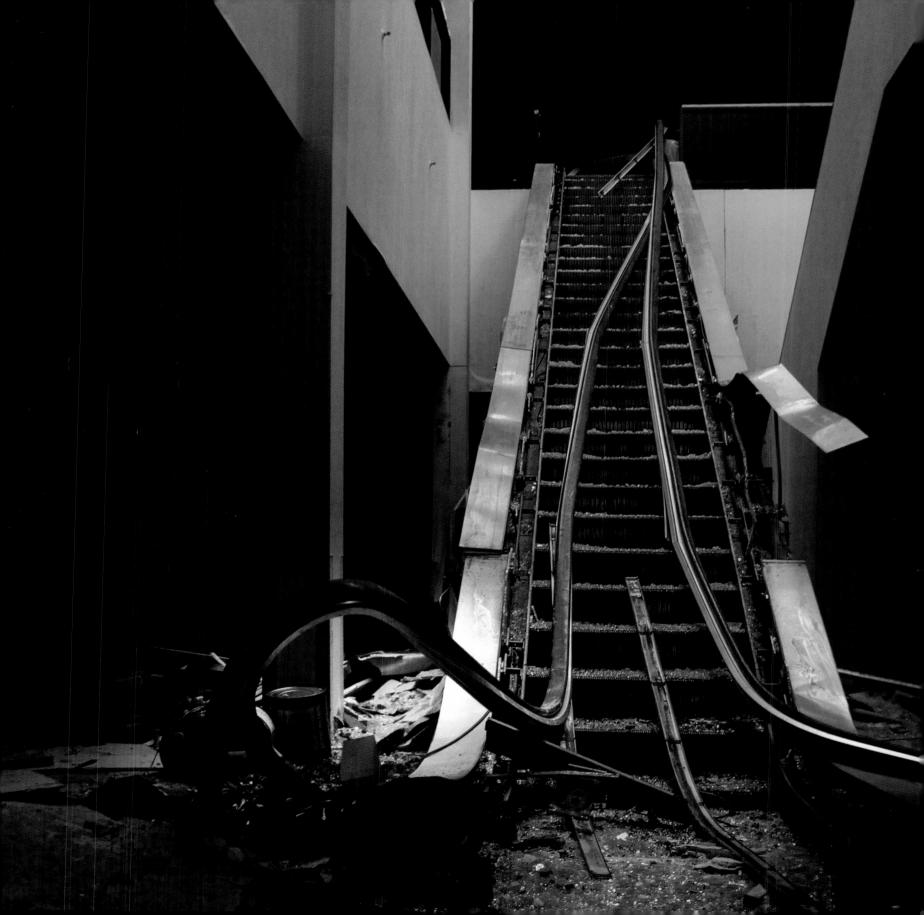

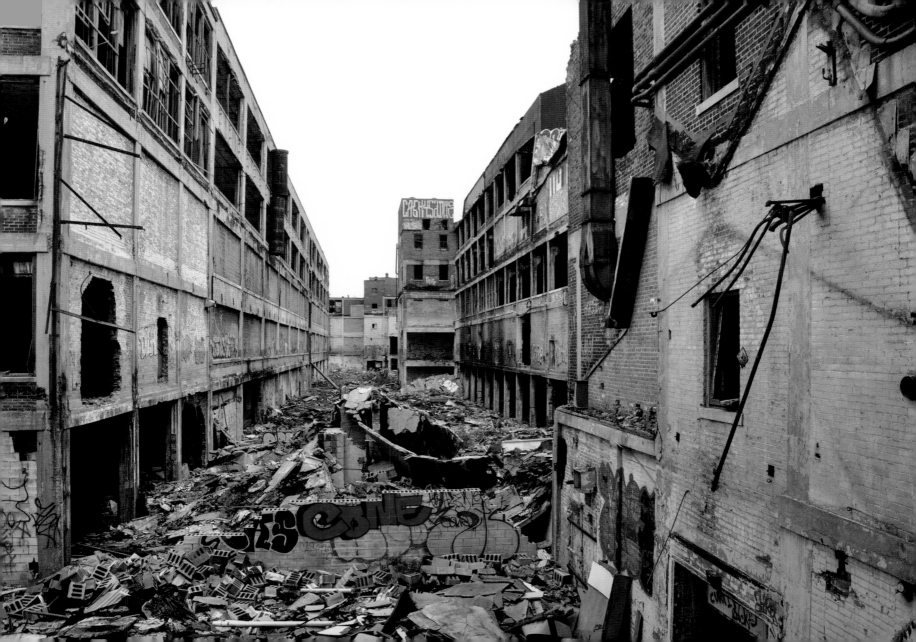

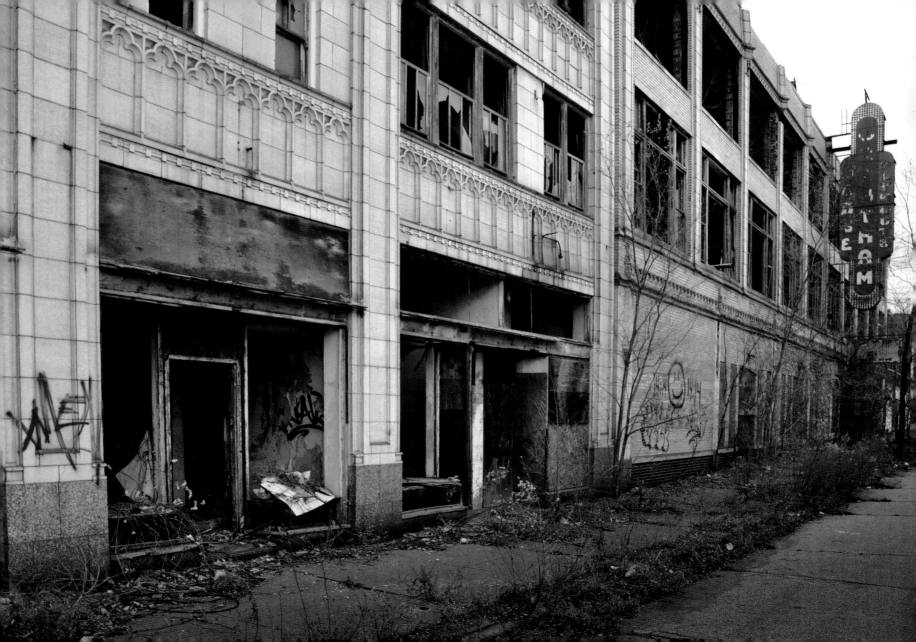

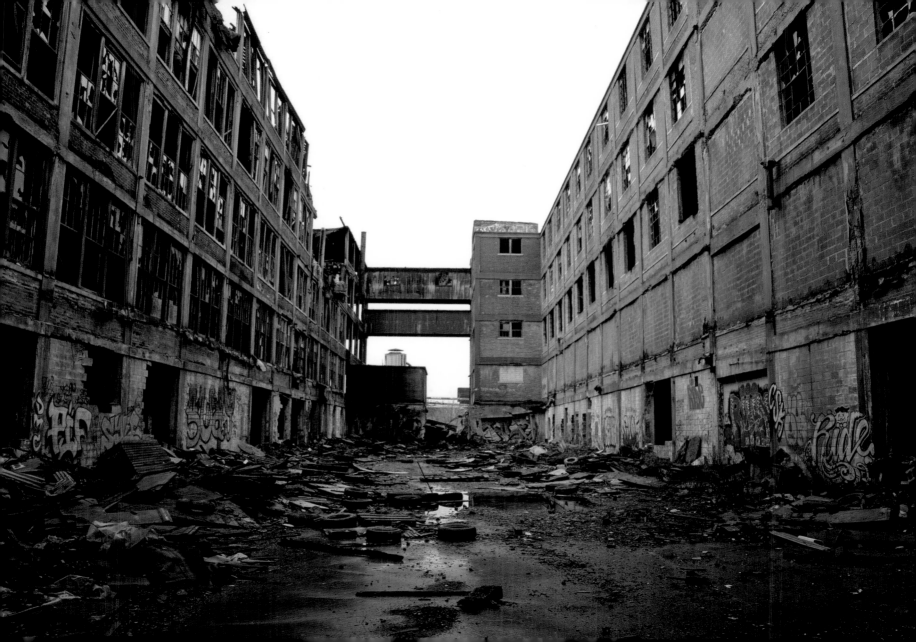

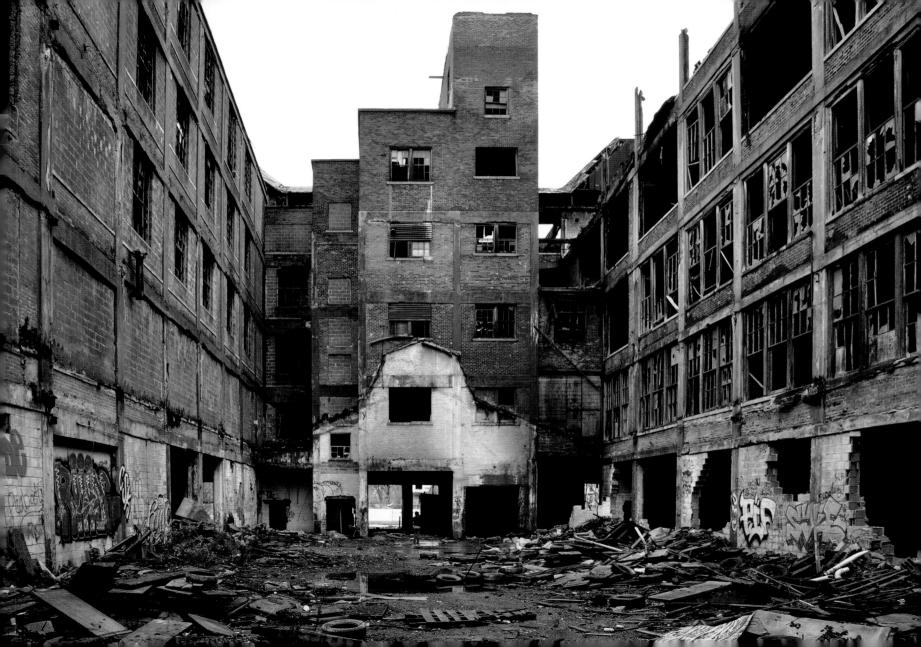

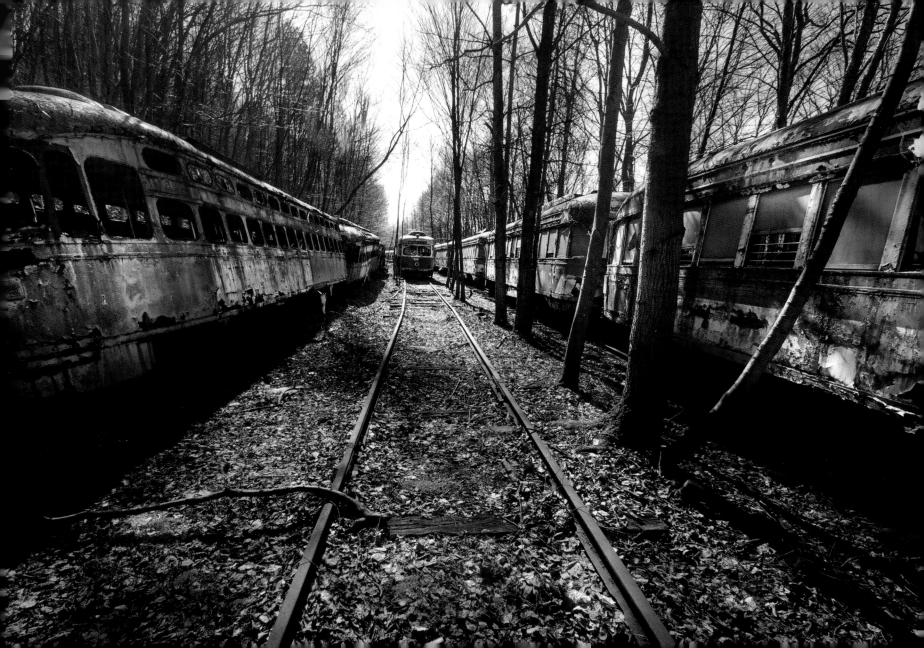

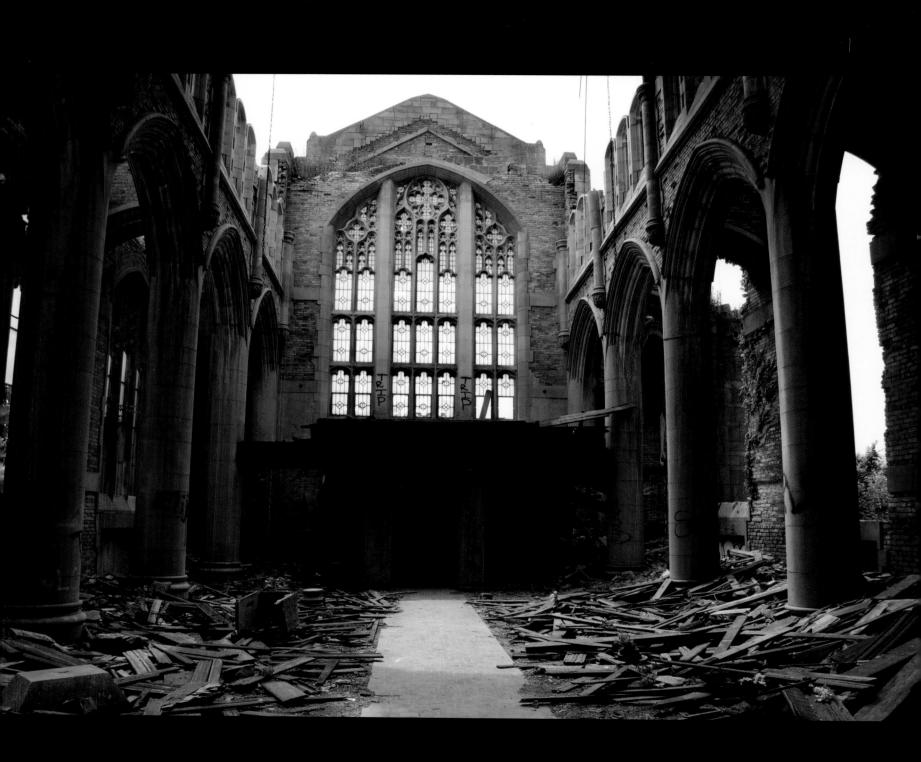

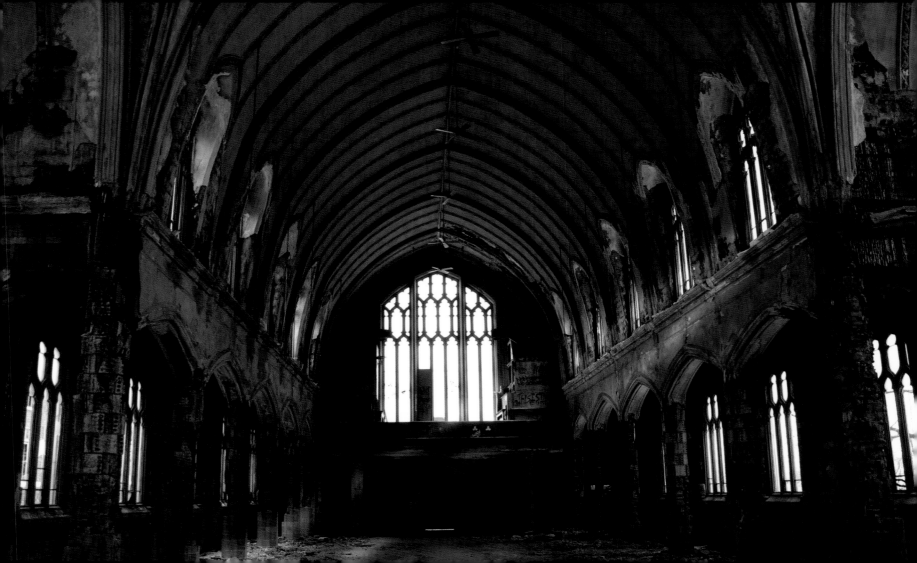

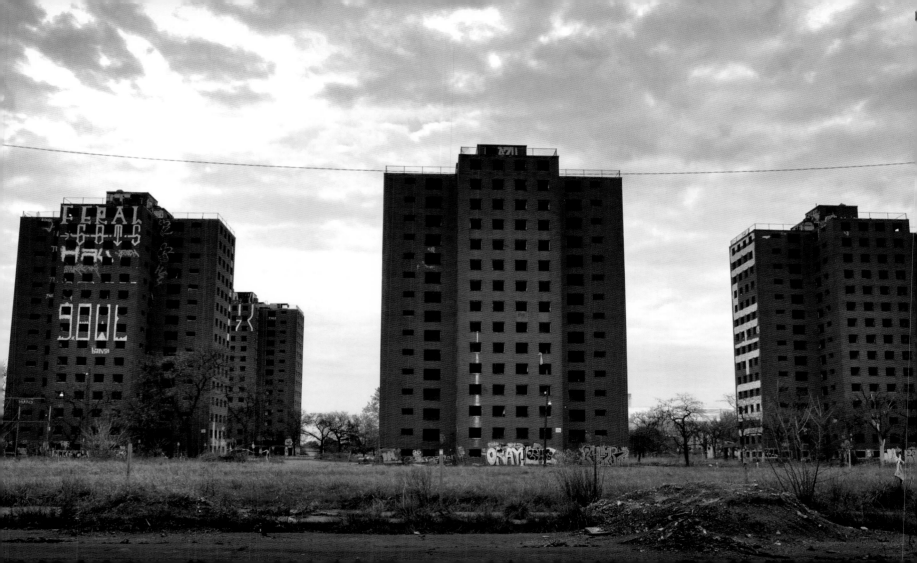

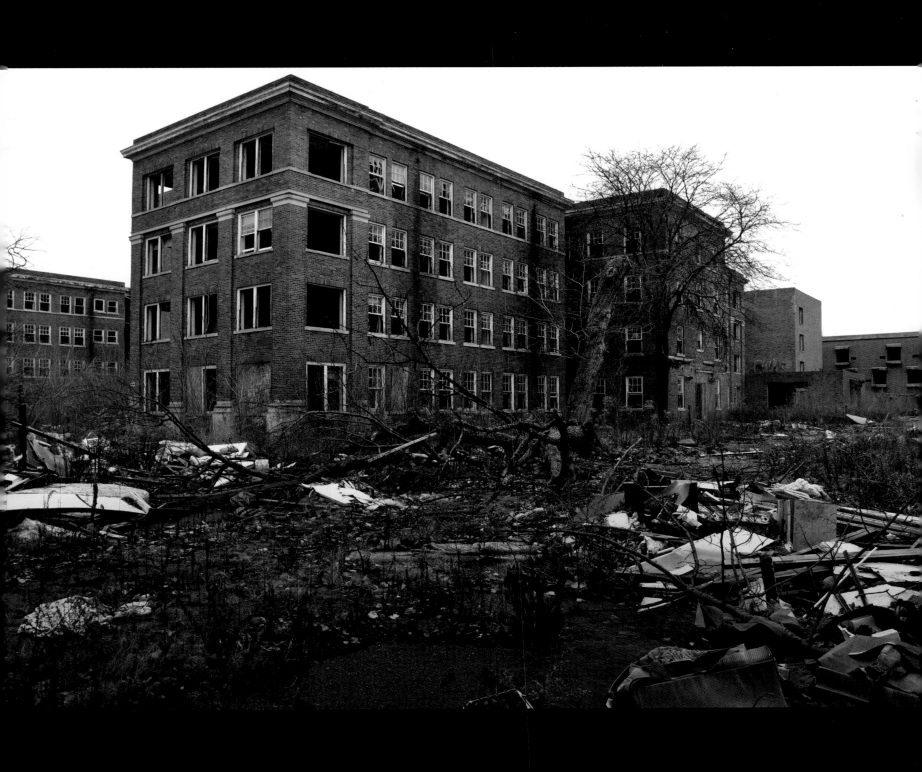

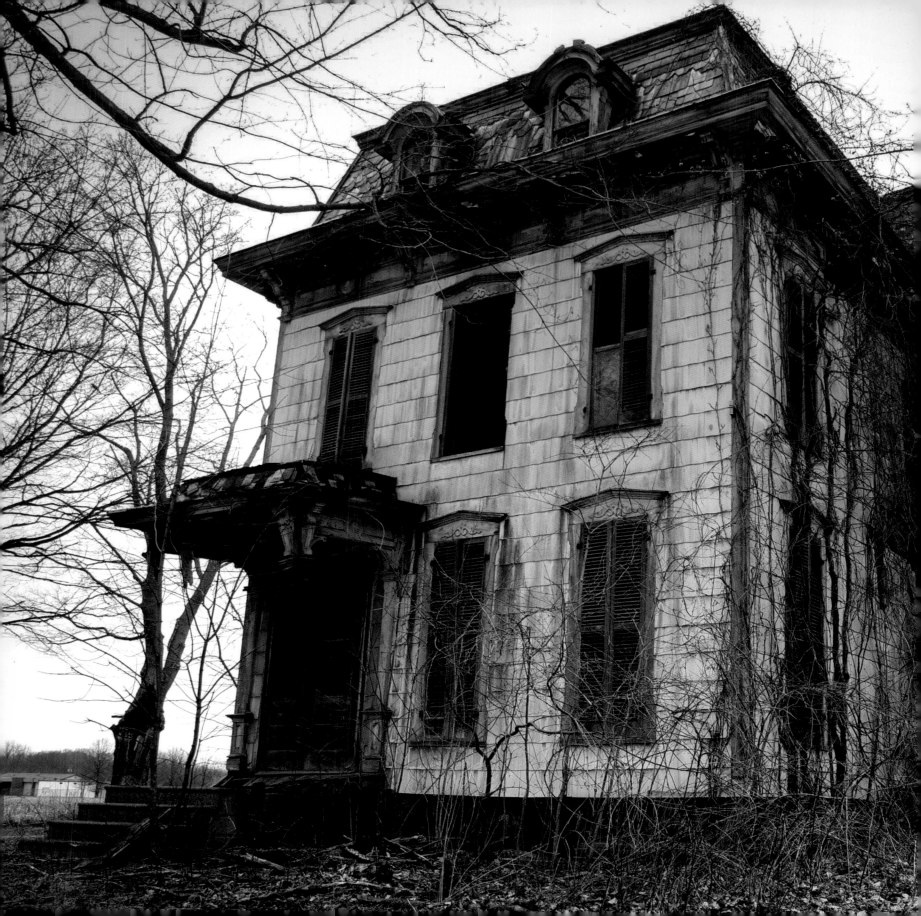

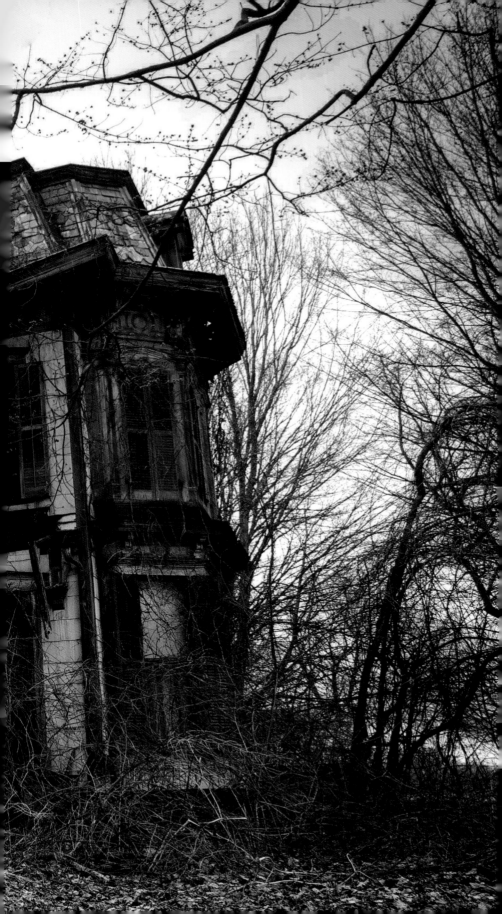

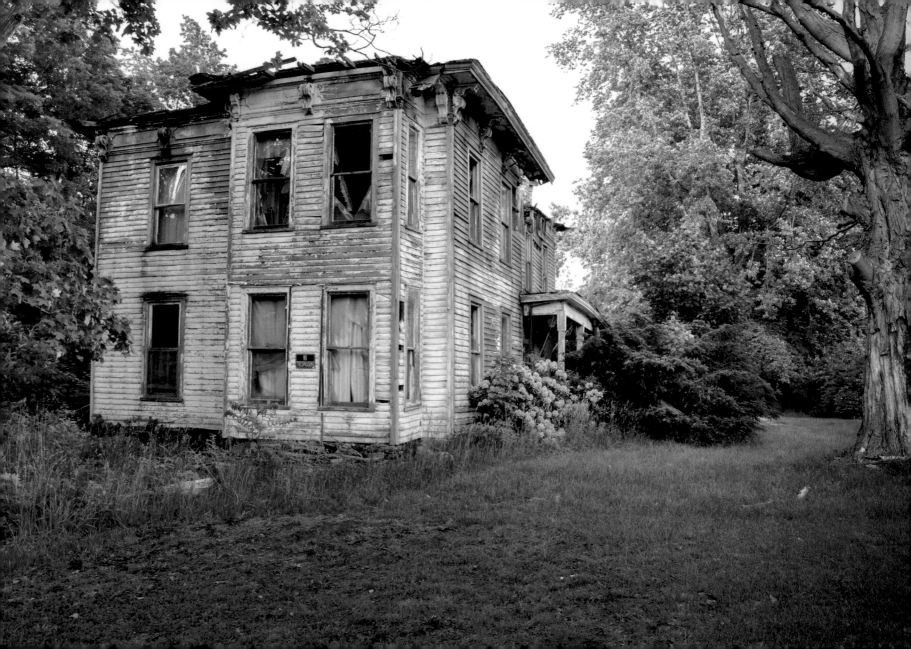

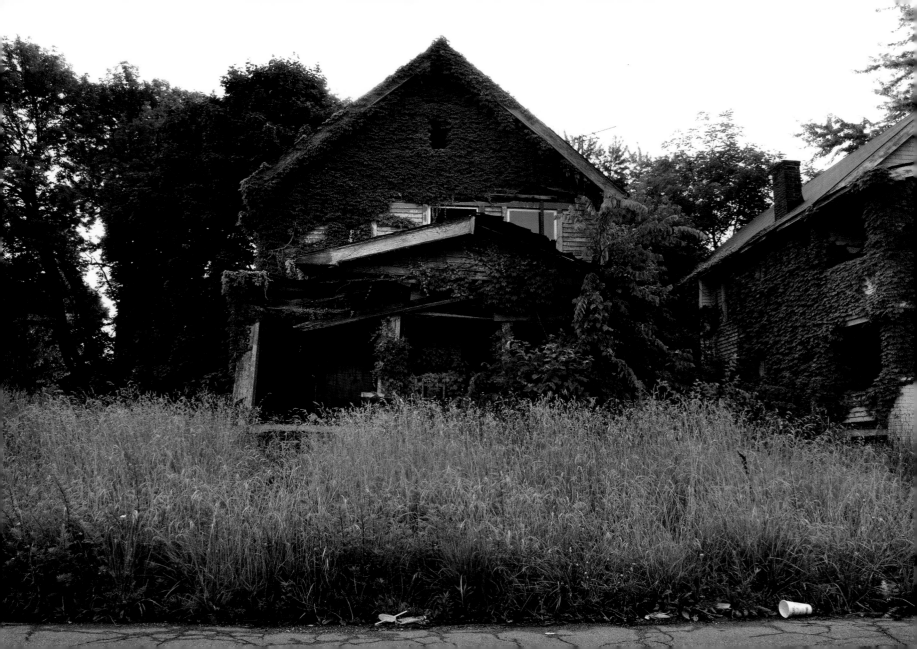

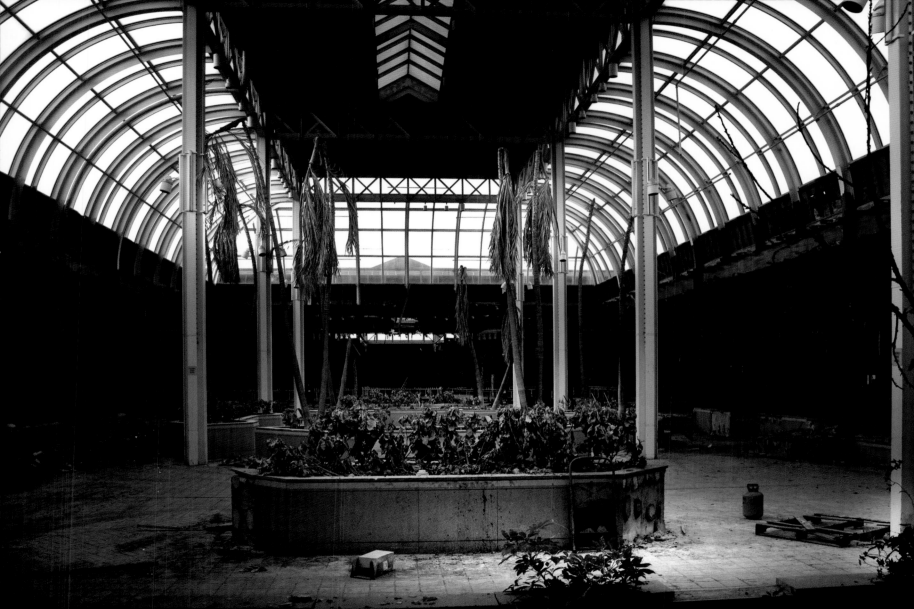

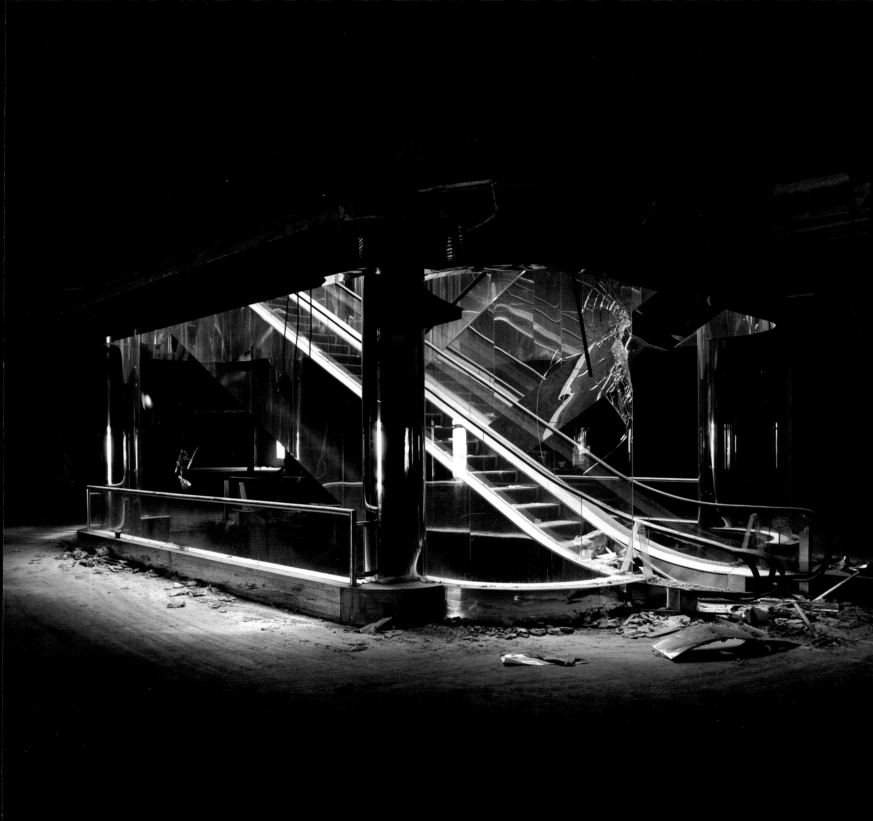

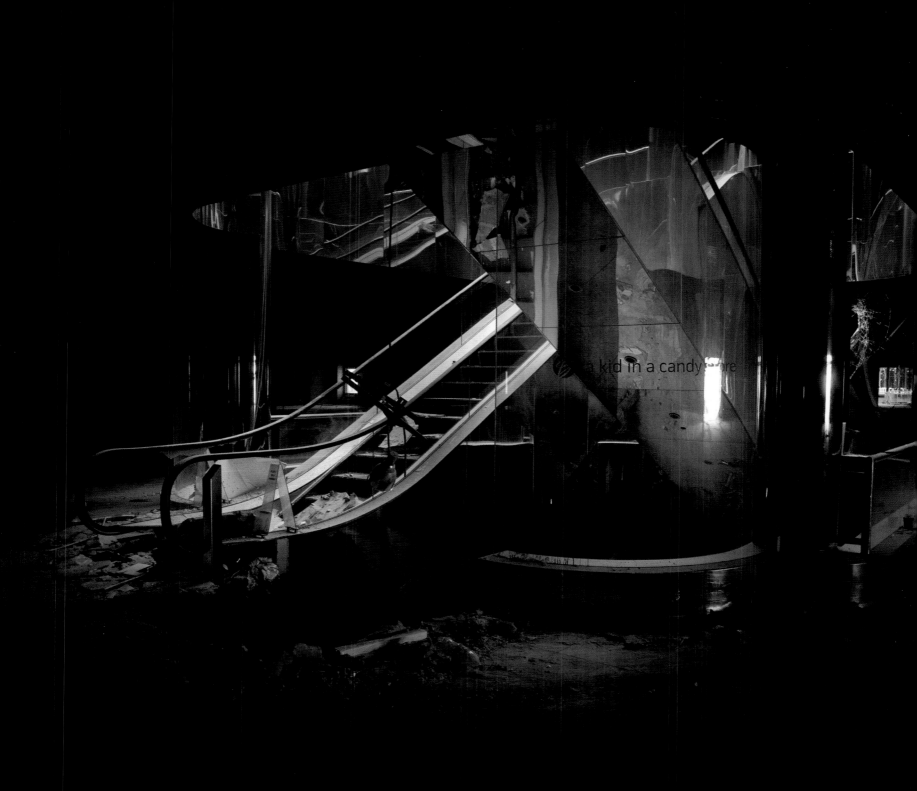

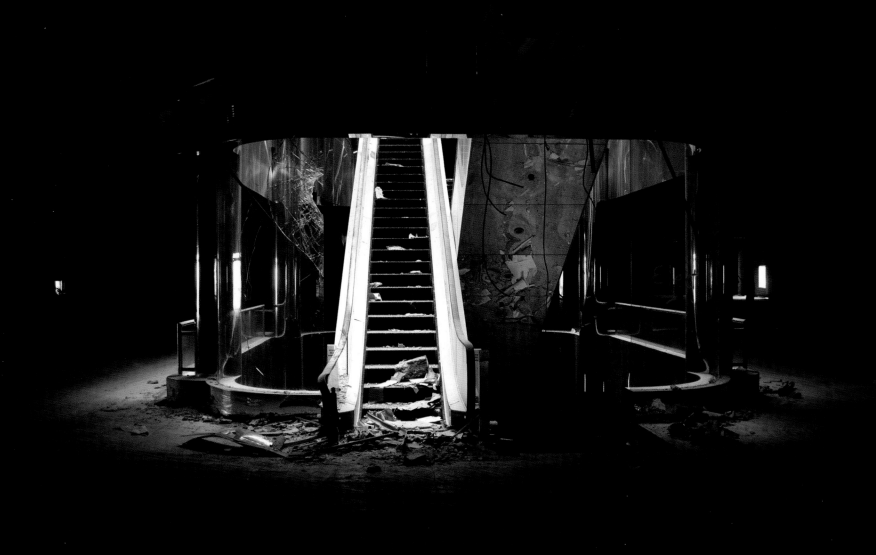

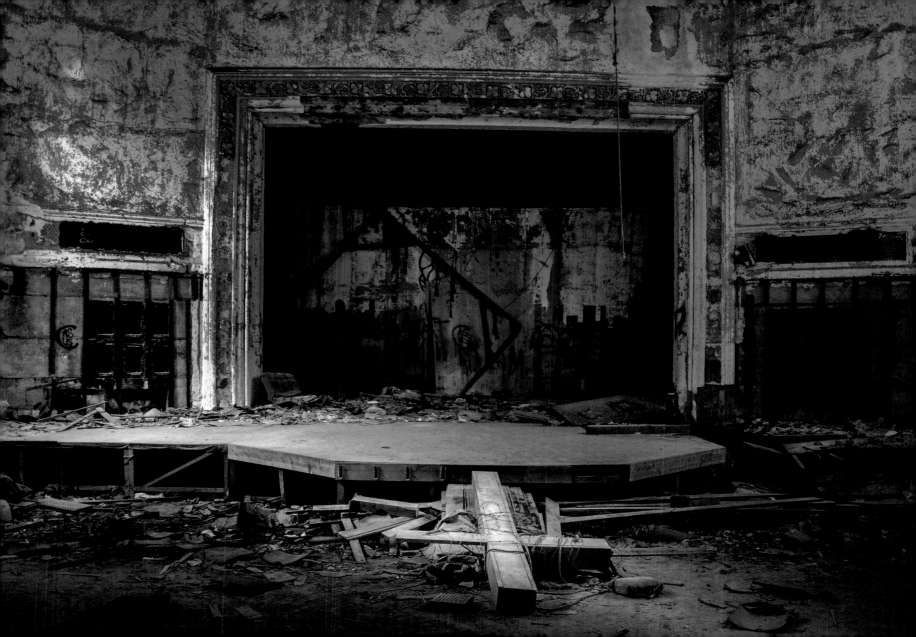

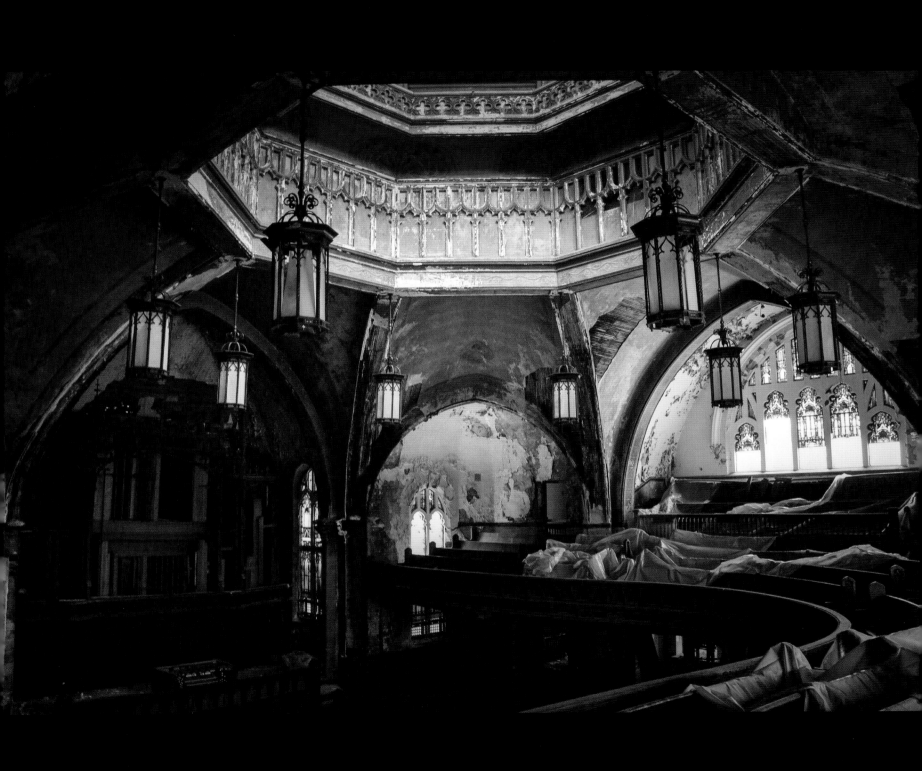

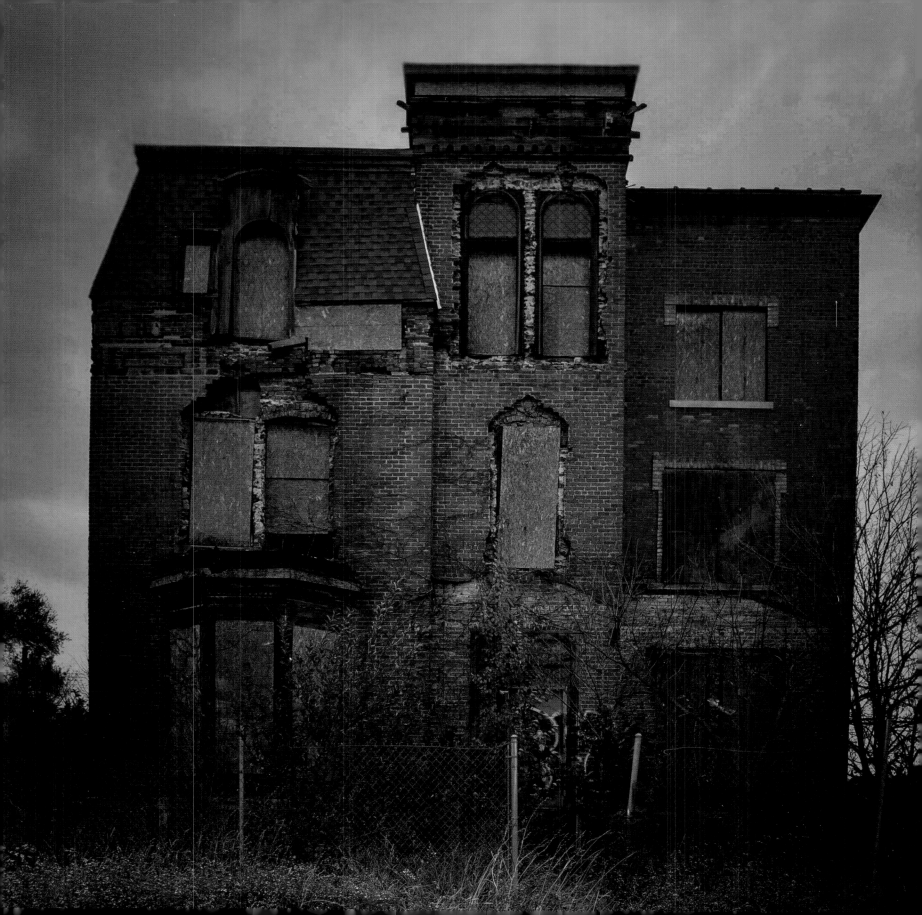

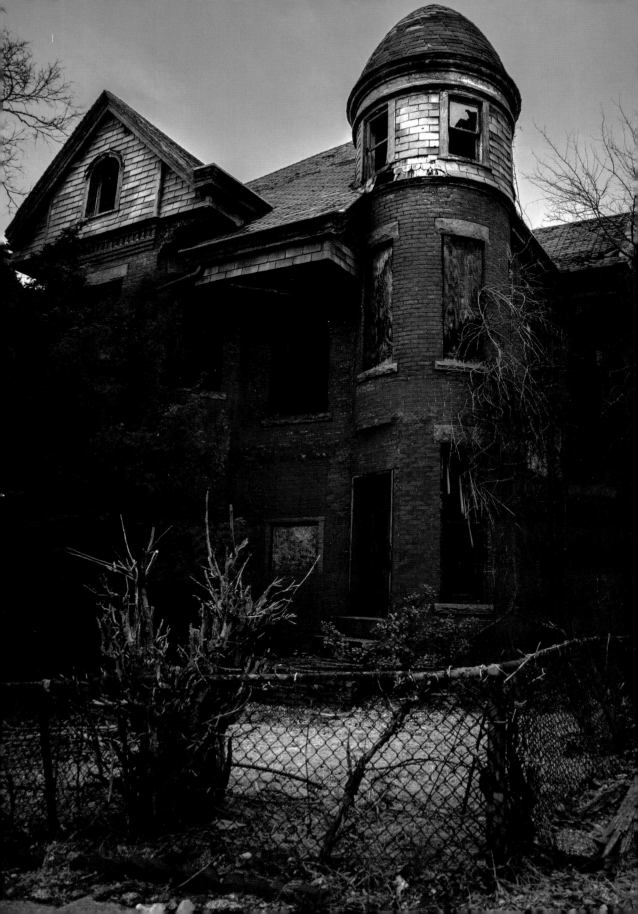

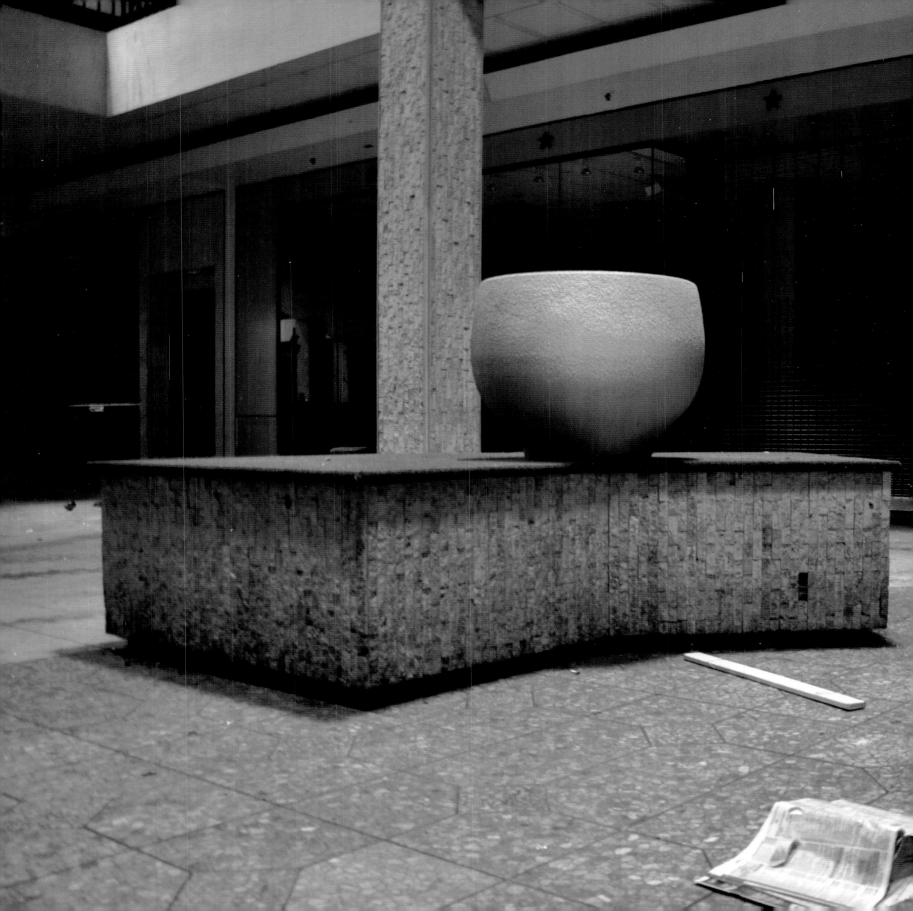

AMERICAN CARNAGE

'The bloody, tattered remains of the "American Dream" lie amongst the "American carnage," and it was corporate greed that slaughtered it.

The root of evil in modern society is the profit motive. The profit motives in a capitalistic system offer no incentive to provide jobs, care for the sick or feed the hungry. In recent years, corporate profits have doubled as the corporate tax percentage decreased nearly in half, while millions of American jobs have been lost.

Americans were a relatively robust people before unregulated free-market capitalism began to destroy their lives. Now, because of this flawed system, they are literally fighting for their lives.

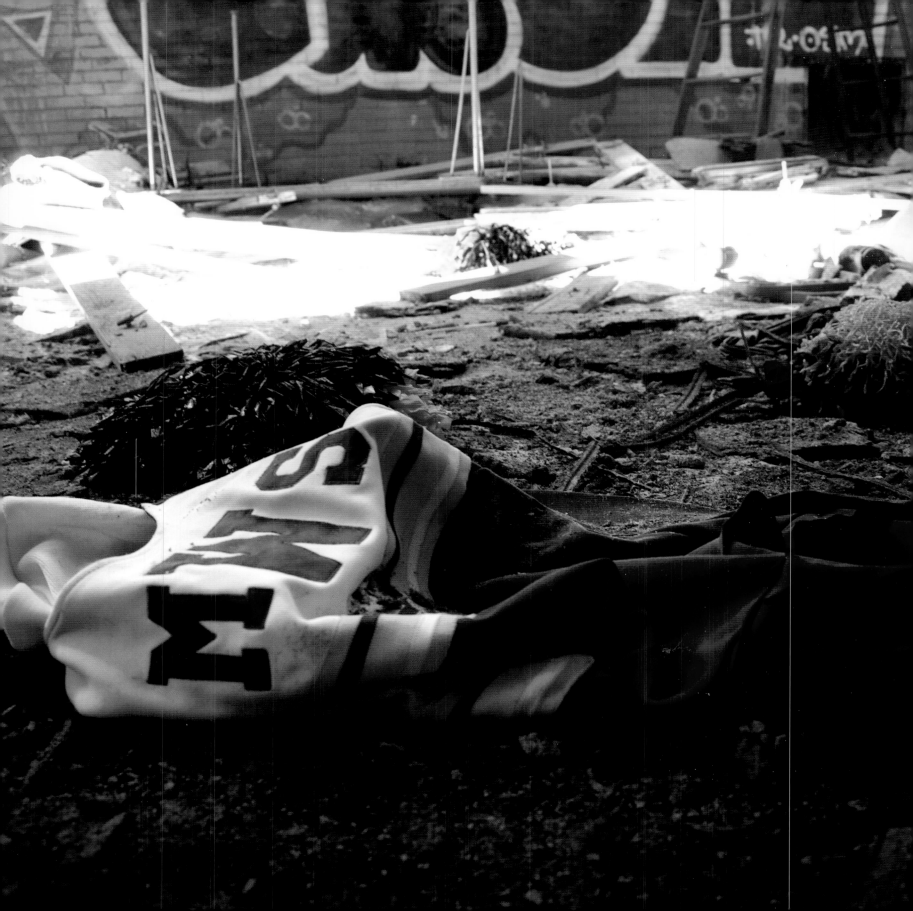